FRONT ROW CENTER

INSIDE THE GREAT AMERICAN AIR SHOW

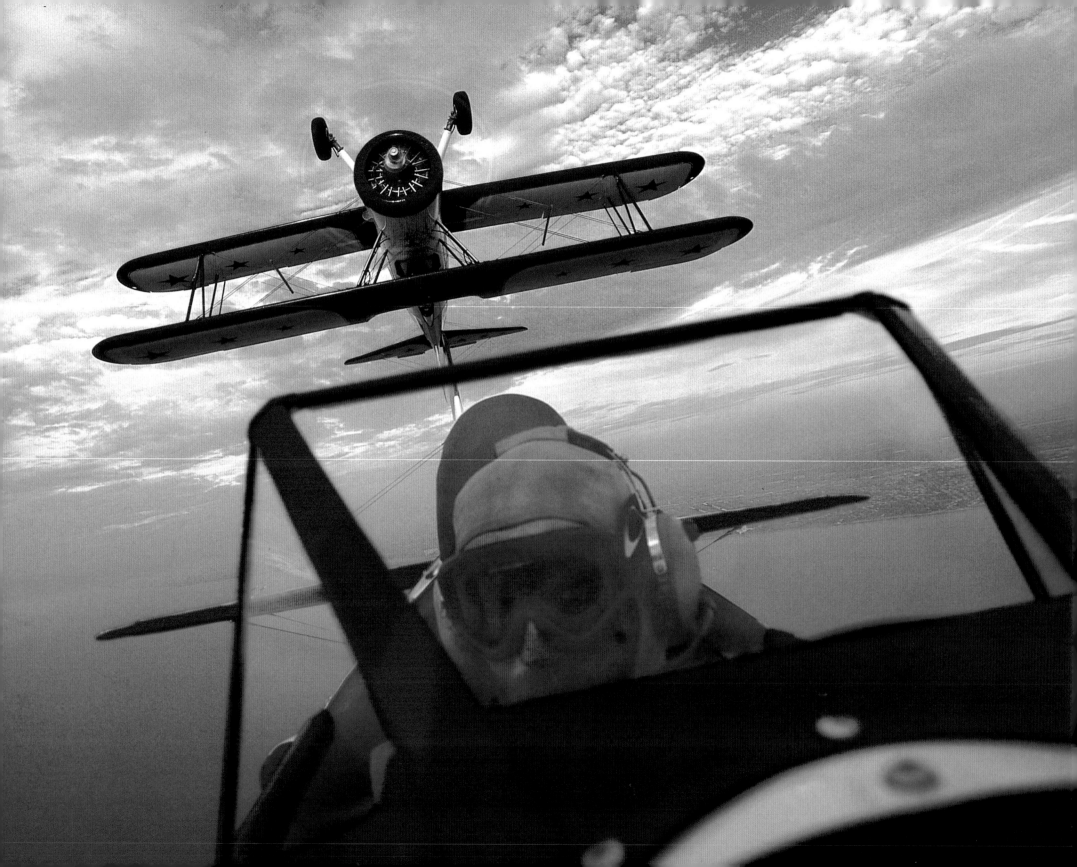

FRONT ROW CENTER

INSIDE THE GREAT AMERICAN AIR SHOW

By Erik Hildebrandt

Front Row Center:
Inside the Great American Air Show
© Copyright 2000 by Erik Hildebrandt.
All Rights Reserved. This book, or any portions
thereof, may not be reproduced or transmitted in
any form or by any means, electronic or
mechanical, including photocopying, recording,
or by any information storage or retrieval system,
without permission in writing from the publisher.

First published in the
United States of America by:
Cleared Hot Media
Minneapolis, Minnesota
erik@vulturesrow.com
612-789-5347

ISBN 0-9674040-2-9

Printed in China.

Designer:
Christopher Sleboda
design@csleboda.com
www.csleboda.com

Front Row Center is

dedicated in memory of

Kieron O'Connor and Kevin Colling,

two outstanding naval aviators

who accepted the risks,

lived for the challenge

and absolutely loved to fly.

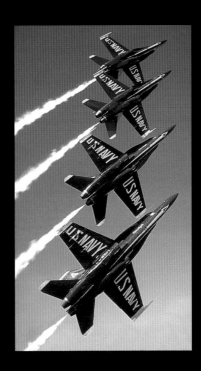

ACKNOWLEDGEMENTS

A book is the result of so many more people than simply the author. From the point of conception until it is finally presented between two covers, literally hundreds of individuals have influenced the final outcome. A few generous and patient friends deserve my utmost appreciation and your acknowledgement of their contributions.

My most sincere thanks go to:

John Cudahy for asking me at Oshkosh '98: "Have you ever thought of photographing a book about air shows?" He is the person most responsible for engineering the success of this project. ICAS is lucky to have such a resourceful advocate at the helm.

Brian Norris for flying the vast majority of photo flights for me this summer in Sean Tucker's Cherokee. His experience and commitment of personal time contributed immeasurably to the look of these images.

Sean D. Tucker for sharing my ambition to create an honest and artful record of this predominantly closed corps of performers. His complete endorsement afforded me a level of credibility without which I could never have succeeded.

Mike George, Doug Rozendaal and Greg Vollaro for flying "Axis Nightmare," the wonderful B-25 photo-ship owned by Mike's dad Don George. The images we captured together from the tail gunner's position at Oshkosh and Quad City helped me define the feel of this book.

Jack Uhl who's professional assistance and that of his generous associates simplified my rigorous travel schedule. Without their support, this book would have been much more painful to produce.

Deb Mitchell, Ken Hopper, Harry Wardwell, Steve Appleton, Jennifer Beazley and Jim Fedderson for having the confidence and guts to believe in a basic idea. It takes visionaries like yourselves to push the industry into uncharted territory. I hope you all feel it was worth the gamble.

Chris Sleboda, the designer of both the calendar and the book. His talent and tireless effort created the structure on which these images ride. Well done!

Mike Maus and CDR Mike Hayes at AIRLANT for pushing all the papers though the system. I am truly grateful to have such a supportive team of believers. Thank you very much.

Richard Parker for helping me to see the difference between being a journalist and an editorialist. His experience on the road allowed me to capture many of the details I would have otherwise missed.

My parents Bob and Judy for understanding that it is genuinely possible to be too busy to talk on the phone sometimes, not to mention take a long enough break to head home for even a quick visit.

The entire Blue Angel Team and especially #2, Mark Dunleavy. Mark went to bat on my behalf to raise support with the Team well before it was evident that their chapter was going to be such an integral part of this project. Their faith and confidence in my ability to capture a glimpse of the world in which they operate is a point of the greatest professional pride I have ever known. It has truly been an honor.

And finally to my beautiful and brilliant wife of over ten years, Christine, who is responsible for instilling in me the determination and drive to selfpublish a project of this size. Her infinite grace and generosity never cease to amaze me.

CONTENTS

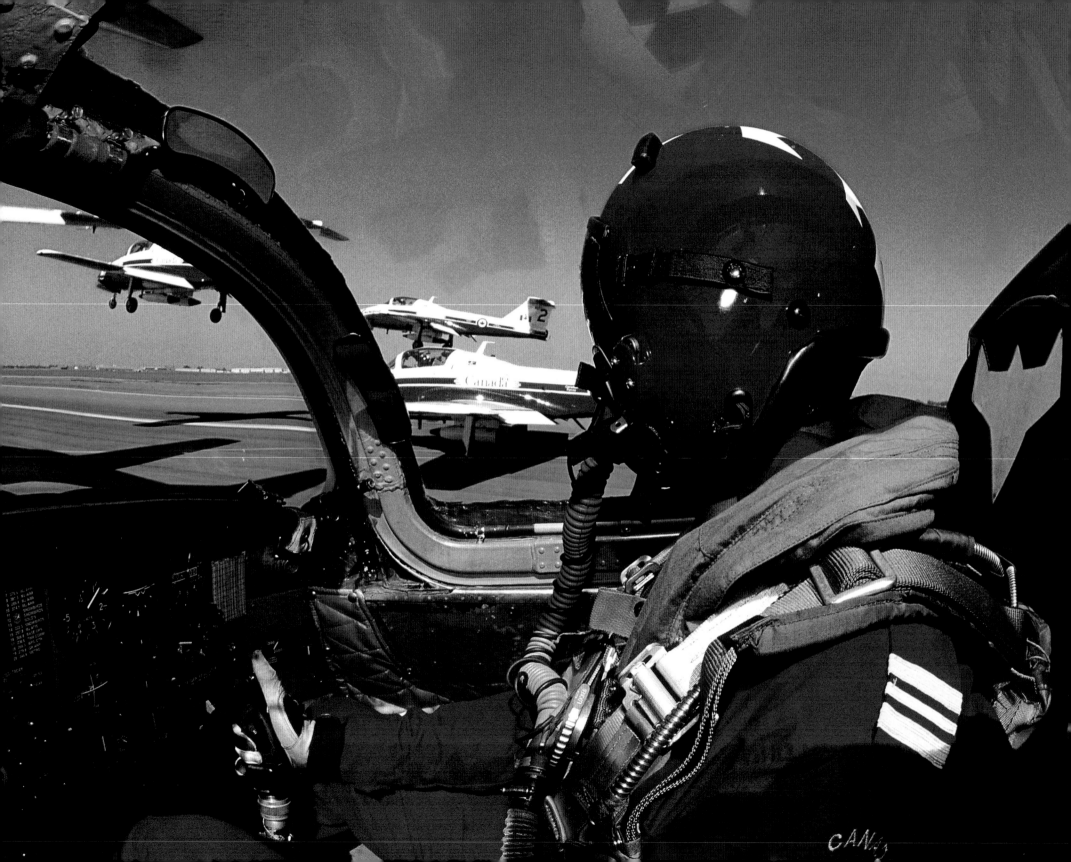

INTRODUCTION

It doesn't matter how often I walk through the admission gates; air shows excite me like nothing else. Like most pursuits in life, aviation has its share of true believers, those for whom an open field and a gentle breeze are ingredients for a daydream. The folks who wishfully glance up at every Cessna that buzzes overhead. The faithful minions who gather in huge crowds throughout the summer to rub the touchstones of flight and refresh a memory that will carry them through the daily grind. I graciously include myself with this bunch.

Until I set out on my mission to produce this book, I had mostly just experienced these events as a curious member of the aviation public. But working the other side of the fence this season meant arriving on Thursday, staying through Sunday and hanging out for everything in between, rain or shine. What you realize when you spend so much time on location at these events is that this air show stuff is serious business.

The flight line that you and I walk through on a single Saturday afternoon takes show organizers a full week to set up. The administrative planning required to pull off a world class air show these days takes upwards of a year, not to mention a budget of well over a million dollars. Seeing first-hand how committed air show organizers are to an event that hangs its life or death on the whim of the weather gave me newfound respect for something I had long enjoyed but taken for granted.

But for as much as I was impressed by the level of effort and imagination put into air show venues around the country, the mass of my deference goes out to the close-knit circle of performers. Here is a segment of our population that millions of Americans know by name, recognize by face and whom most of us have seen perform in person at least once.

Air show performers are not a product of the mass media fame factory. They genuinely earn their celebrity the hard way, one flight at a time. They are not renowned for just a single performance captured and re-run on video like a movie star. Air show pilots demonstrate their craft over and over, on location and in person, in front of anyone who will watch. That takes true talent.

Beyond being great pilots, the air show performers and support crews I came to know this summer were generous and caring people who offered me an unfiltered view of their world. By virtue of how much time I spent on the road with some of them, fast friendships afforded me a level of personal gratification I rarely achieve on such a wandering project.

From a logistical perspective, this summer held some weighty challenges right from the start. Achieving the objective of shooting, writing, and publishing a full-length picture book within the span of a single season has been grueling to say the least. I made the first photographs on May 14th at Andrews AFB, and shot the last few images during the Friday practice flight with the Blue Angels at Little Rock on October 22nd. During those five months, I made fourteen trips to sixteen air shows and exposed just over 450 rolls of film; that's about 16,200 clicks of the shutter.

To capture these performers in their element, I flew photo missions in anything that could get me off the ground. From a spindly Robinson R44 helicopter to the back seat of an F/A-18 Hornet, this summer has seemed like a grant from the Make-a-Wish Foundation for the terminally plane-sick. I could not have dreamed up a more rewarding endeavor on which to work so hard.

Please keep in mind as you thumb through these pages however that the pilots are the real artists of this book; I was just lucky enough to record their creations with a camera.

I hope you enjoy my view from Inside the Great American Air Show.

Erik Hildebrandt

wonder and awe at the sight of birds soaring through the air he has been enchanted with the magic of flight.

Today, as in the earliest days of barnstorming, we celebrate our freedom to fly with an airborne extravaganza; air shows. In North America alone, hundreds of air shows are produced each year that attract literally millions and millions of spectators. Some call it the Indianapolis 500, Top Gun and the Fourth of July all rolled into one.

The common thread weaving through the souls of both air show producers and performers is an unquenchable passion for this art form called aerobatics. Grandma and grandpa, mom, dad and the kids come to be inspired, thrilled and maybe even a little bit scared. They witness brave men and women willing to risk it all to share their dreams and to express a deep love of the sky. If as performers, we do the job right, these folks leave changed.

Performers are not crazy people; they don't have a death wish. They are aerial artists predestined to create on a canvas 15,000 feet tall and a mile wide. They are ordinary people achieving extraordinary things in the sky with metal and wood machines.

A performer is never more alive and connected to his spirit than when in his "skydance" with everything working, clicking; when man and machine are one, creating

countless hours of training with no one watching pays o You are able to push your airplane repeatedly up to th very edge of control and safely bring it back every tim When the fears that were once so strong that the hair the back of your neck stood straight out aren't the anymore-that's when a pilot feels alive.

When it all comes together and time stops for both the crowd and the performer. That is when you have entere the magic realm of aerobatic performance- and that n friends, is living art. Many of you ask, "Is it all worth it, th travel, the risks?" You bet it is!

The images within this book come as close as any I hav ever seen to capturing the true essence of this sky bour art show we all live to create. Erik Hildebrandt unde stands our craft. He used his own brand of artistry record some of the cardinal moments of air show dram and wonder that usually only performers get to experienc Without actually coming flying with us, his photography as close as you can get.

God Bless America!

OLD RHINEBECK
AERODROME

If ever you wanted proof that time travel is possible,
then you need only go as far as Rhinebeck, New York.
Nestled in the rolling hills of the historic Hudson River
Valley, this mystical oasis of pioneer aviation sits just
over an hour's drive from the frantic pace of Manhattan;
it only seems like a million miles away.

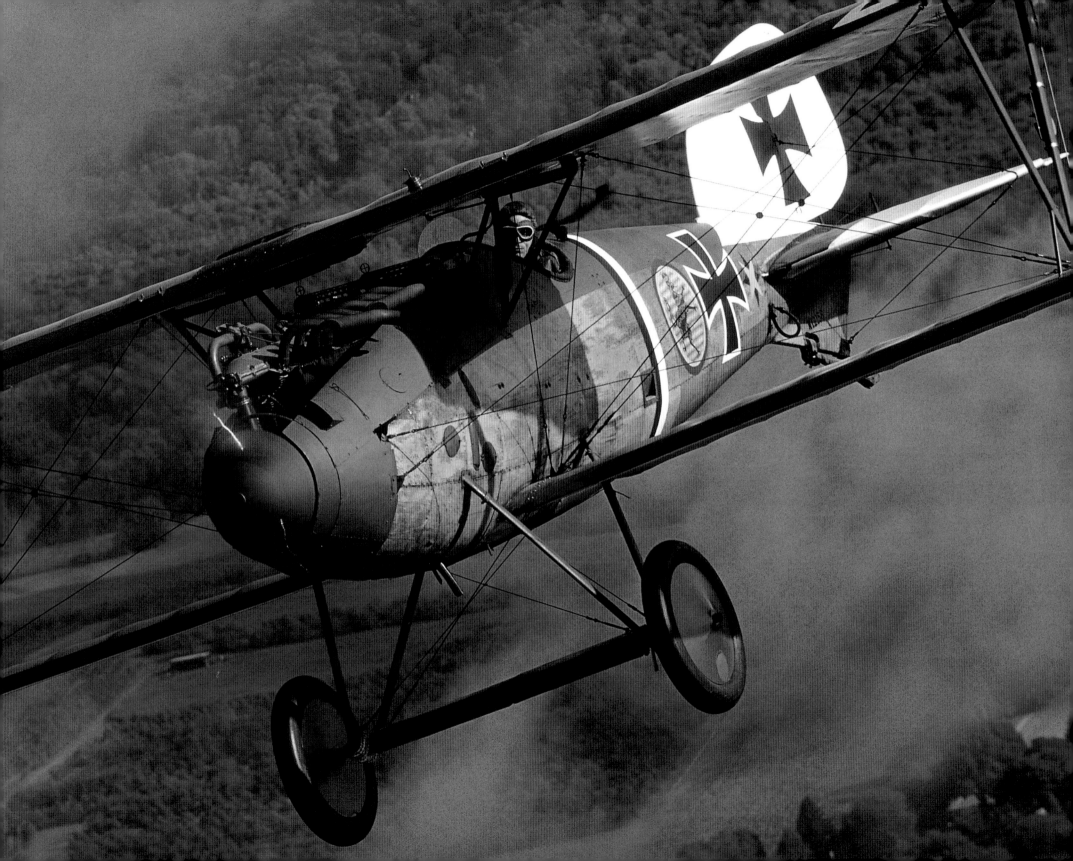

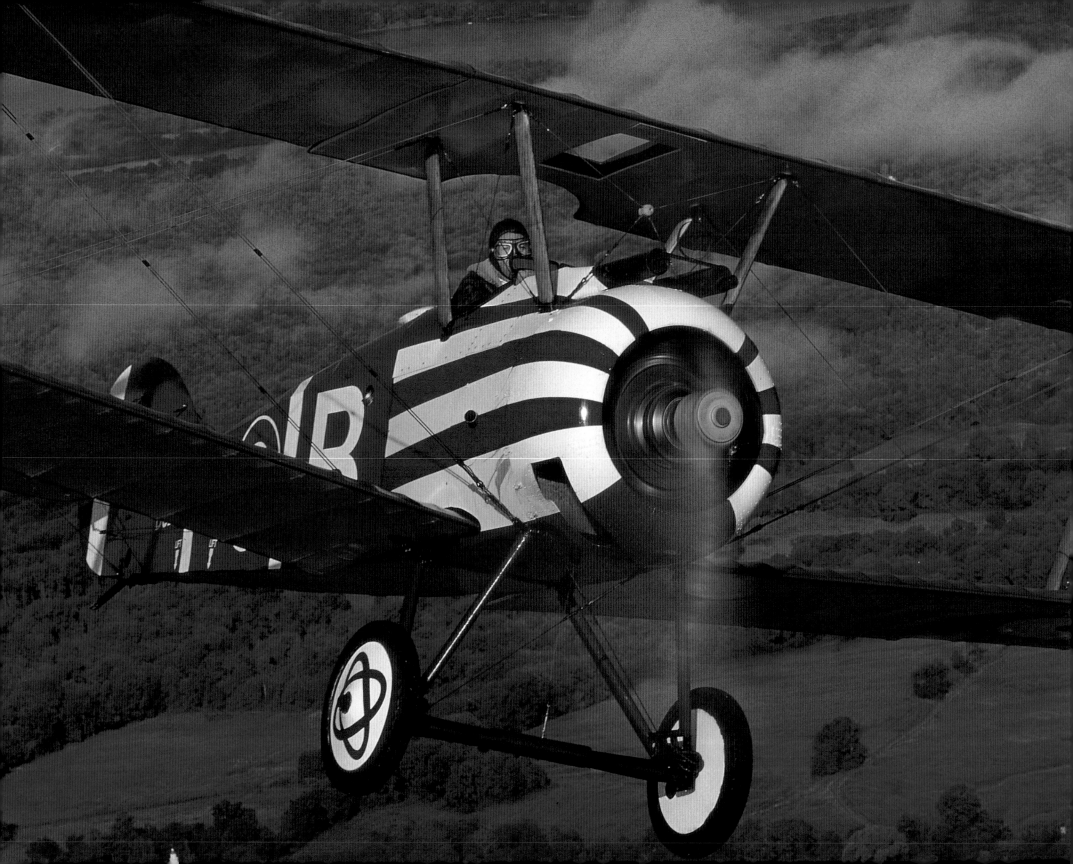

Popularly referred to as the Old Rhinebeck Aerodrome by it's devoted and eclectic community of patrons, this one-of-kind living museum embodies the notion of discovery and wonder that must have inspired the earliest architects of aviation.

The site itself is so aesthetically pleasing that it almost seems as if Walt Disney had a hand in the layout. There is a thrush-lined pond with geese and ducks over which a small covered footbridge leads to an alcove of open front hangers. If you show up early enough in the morning, the rising sun casts its beams through the trees and onto a golden white mist hanging low between the high spots of the simple grass strip.

This is by far the most magical time to wander the grounds. If you are the daydreaming sort, there is scarcely a fixture visible to betray the illusion of preparing for dawn patrol over the fields of France. There are no doors on the most of the hangers, so visualizing a plane in which to launch skyward is hampered only by your ability to choose.

By the time the first staff volunteers start showing up around 9:00 a.m., you will hopefully have returned safely from your imaginary mission, lest you become the subject of odd stares and whispers. Even so, the volunteers are used to outsiders wandering around almost dazed by the enchantment. They go about their business of pushing out the old airplanes and cars hardly noticing. If you are like me, lending a hand allows you the chance to grab hold of these gossamer craft that seem not only too delicate to fly, but far too precious to risk. But fly them they do.

Regularly casting all risk aside, Gene DeMarco, Bill King and his son Dave along with Ken Cassens and Brian Coughlin make up the primary flight personnel at the aerodrome. As long as I have known about Rhinebeck, these five guys have spent their summers living in a world few modern citizens can relate to. I affectionately describe the aerodrome as kind of like the Renaissance fair meets the Great Waldo Pepper. It's kitchy in the most charming sense of the word. The sights and sounds invite you to escape to another place and time and forget about your everyday life.

A core group of players return each summer to revive the seasonal staff of characters at the aerodrome. From handling the planes to selling hot dogs, most of the jobs are filled with young people who are just in it for the fun. The positions are often passed down within the same family from one sibling to the next as each generation outgrows the luxury of having summers off from school. One clan actually comes to the aerodrome each year as their family vacation.

During the warm afternoon shows on Saturday and Sunday, everyone is running around dressed in costumes doing any one of the hundreds of tasks necessary to pull together a two-hour performance. The visitors are invited to participate in a period fashion show where women and kids are outfitted in the accoutrements from the roaring 20's. Antique vehicles as rare as the airplanes parade the winners of the impromptu Charleston dance-step contest up and down the show line.

Opener: Brian Coughlin in the German Albatros DVa. Left: Gene DeMarco at the controls of the Sopwith Camel during the same early morning flight over Old Rhinebeck.

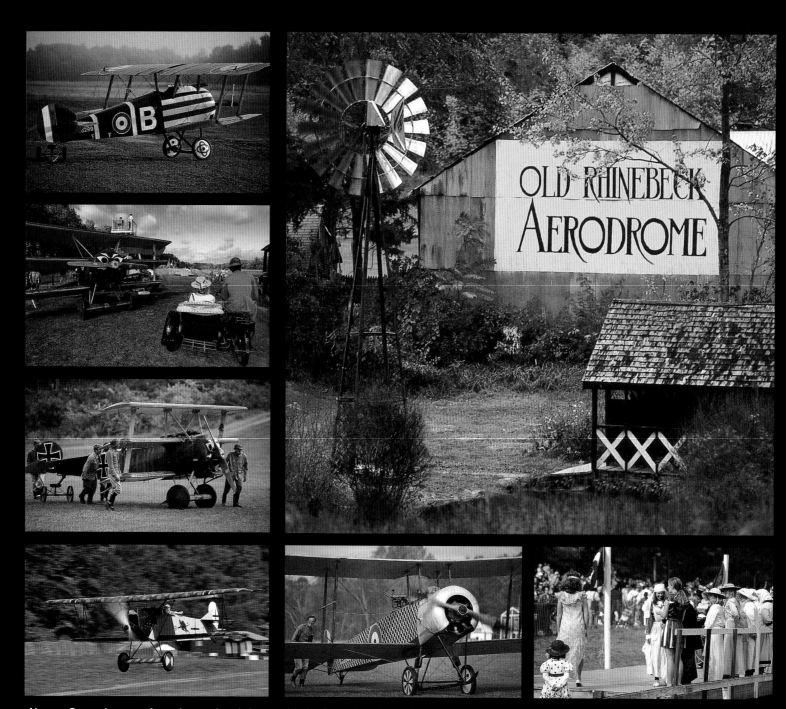

Above: Ground scenes from the weekend shows with the Camel waiting quietly in the morning mist. The old sidecar motorcycle ferries costumed visitors lucky enough to participate in the period fashion show. The Fokker Triplane is moved by hand across the grass as it is readied for flight. The Fokker DVII flown by resident pilot Ken Cassens makes a low pass down the flightline for the crowd. The yellow and black checkered AVRO 504k taxis back with help from the ground crews. Since none of these planes ever had brakes way back then, the Aerodrome flies all of their planes the same way making for some pretty exciting moments on the ground. The fashion show takes place in front of the bleachers for the crowd to enjoy.

Perched high in the wooden announcer's tower sits Jim Hare, the long-time voice of the aerodrome. Jim cracks jokes for the families and couples seated in the bleachers and gets to play the straight man to prankster Stan Sagalla, know to insiders as "the flying farmer". Stan plants himself in among the audience so that he and Jim can pull off some hilarious gags that the crowd thinks are real. The pranks continue when he turns up later in the day for his famous Piper Cub routine which is one of the most outrageous stunt-flying acts you could ever imagine. At least a third of the crowd actually believes he is a local crackpot itching to get tossed out.

While the folks at show center are cracking up with all of the slapstick, the airplane crews have gassed and hand-propped the deHaviland Tiger Moth and Gene's own Belgian-made Stampe. With Bill King in the red Tiger Moth, the two tiny biplanes scoot over the grass and into the air for the traditional show opener: the Delsey Dive ribbon cut. When the pilots have climbed to altitude, which for such an intimate setting is a mere seven hundred feet, Gene tosses out a roll of Charmin's finest…toilet paper. He and Bill then take turns making passes at the unraveling streamer, cutting

it with their wings until there is nothing left but blue sky.

By now, Brian Coughlin has pulled up to the show line dressed in jack boots, knickers and a black waist coat, his face rutted with the exaggerated makeup of the evil Black Baron. He has arrived to abscond with the lovely and talented Trudy Truelove who has historically rejected his amorous advances for obvious reasons. The Baron tosses the melodramatic Ms. Truelove in the back of his Model T, thereby setting the stage for Gene DeMarco to assume the persona of the virtuous Sir Percy Goodfellow.

It is the sheer level of absurdity that gives this show its grand appeal. The zany action on the ground quickly escalates into the excuse to launch the Fokker Triplane and the Sopwith Camel. Gene chases Black Baron Brian down towards the planes and the two of them are quickly airborne. Jim Hare continues to deliver a rousing commentary which effectively shores up the flimsy yet practical story line.

Punctuating the cheesy acting and downright nail-biting flying are big

explosions perfectly timed with the actions of the two dog-fighting airplanes. At one point, the Black Baron drops a charcoal bomb which detonates right between one of the scrambling cars and the crowd. As the massive cloud of smoke and dust settles, players come rolling across the ground as if thrown clear of the vehicle. It is a pretty serious effect for this Keystone Cops style production.

On the merits of the flying alone, the Old Rhinebeck Aerodrome deserves to be included on the American Register of Historic Treasures. As a fun-packed vacation destination, where else can you play a part in an air show, then load up a family of four into the open front cockpit of the Aerodrome's New Standard biplane to go fly off over the Hudson River? But you really shouldn't listen to me, go see for yourself this glorious and wonderful sanctuary of aviation waiting for you at the end of Stone Church Road in Rhinebeck, New York.

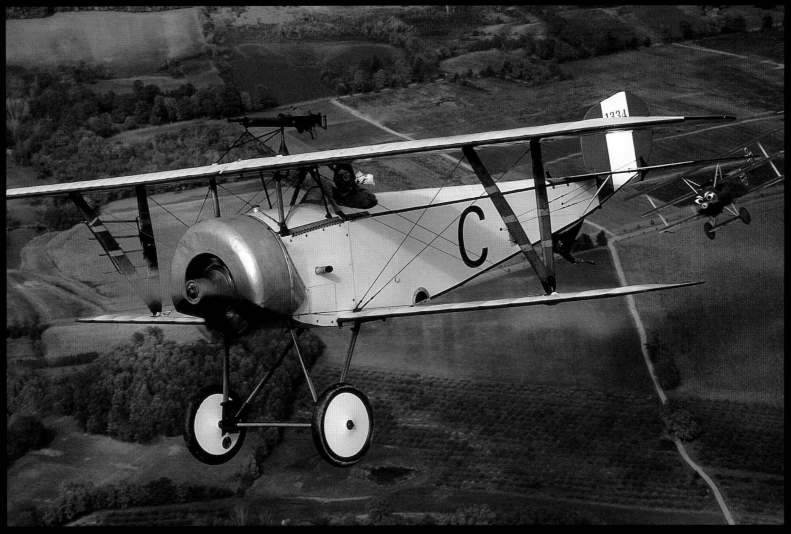

Above: The Baron turns his sights on Sir Percy in the Nieuport 11. Left: Dave King making a diving attack on the New Standard camera plane with the Black Baron's Fokker Triplane.

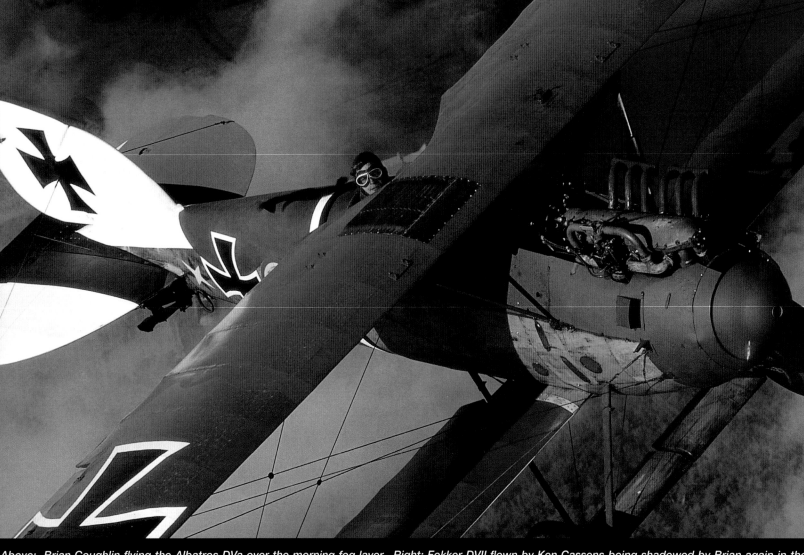

Above: Brian Coughlin flying the Albatros DVa over the morning fog layer. Right: Fokker DVII flown by Ken Cassens being shadowed by Brian again in the Fokker DVIII monoplane.

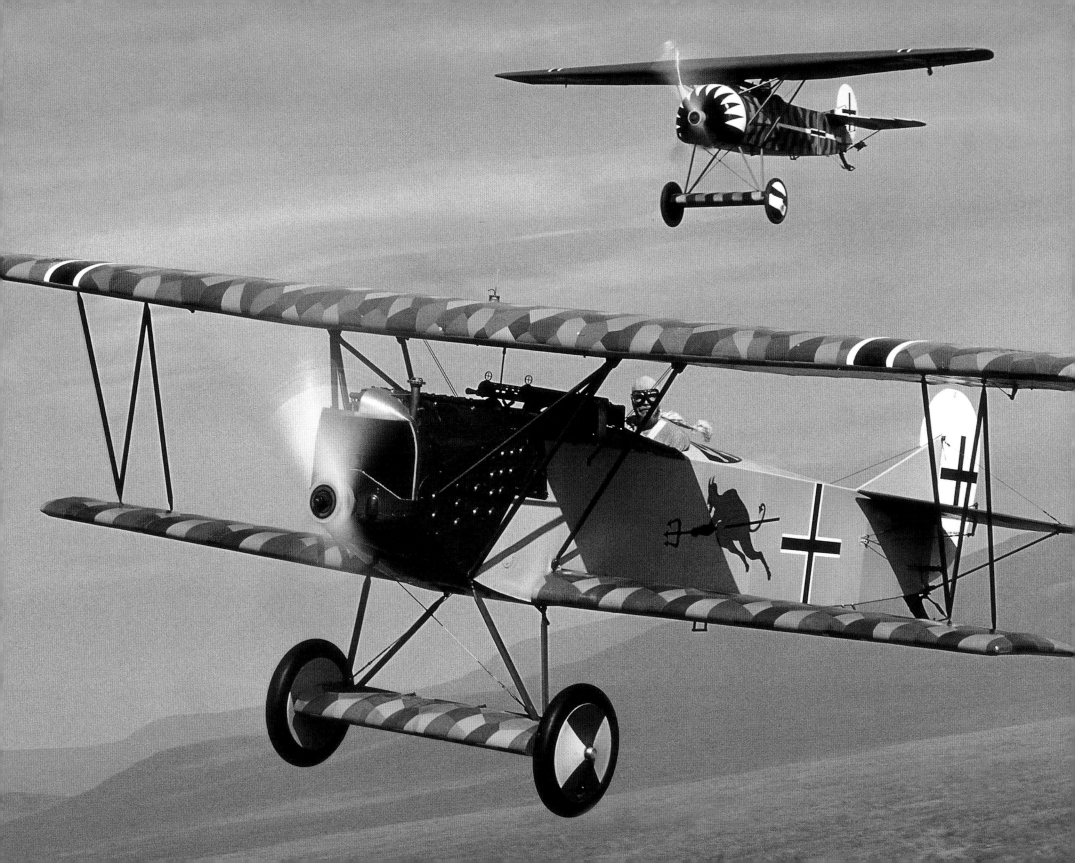

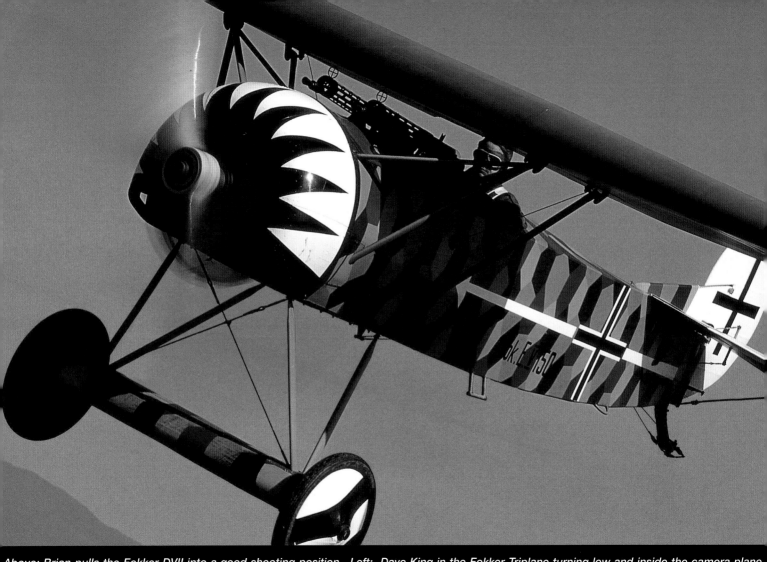

Above: Brian pulls the Fokker DVII into a good shooting position. Left: Dave King in the Fokker Triplane turning low and inside the camera plane. Flying the mosquito looking craft is Dave's dad Bill coaxing the ancient Hanriot down the length of the field. Gene and Brian clearly enjoy getting to

SEAN D.
TUCKER

If you've ever wondered what it would be like to reach out and touch the sun, you might want to ask Sean D. Tucker. His aerobatic talents place him at the top of the air show industry where he has been a pioneer for advancements in air show venues and a trailblazer for mainstream corporate performer sponsorships. And for good reason; no other performer can grip an audience with such charisma and drama as this former U.S. National Aerobatics Champion.

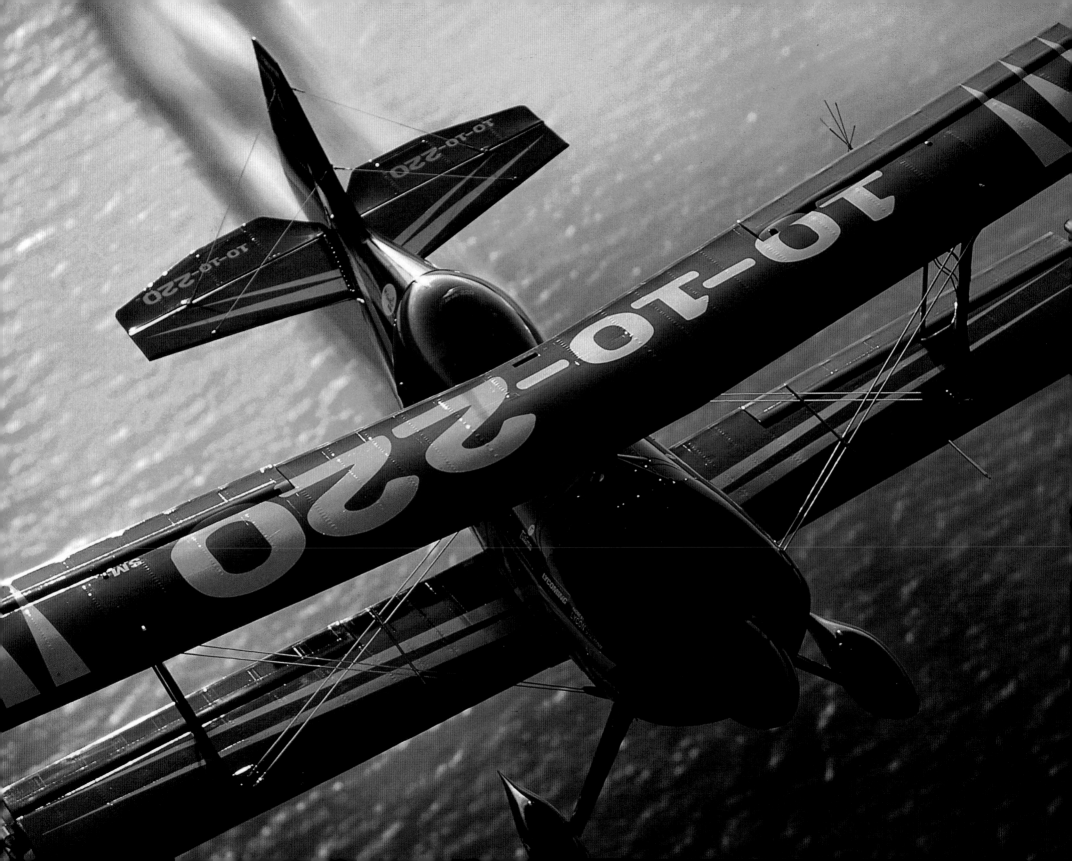

As a kid Sean was actually afraid of flying. At age 17, he began skydiving but gave it up after losing a close friend to the sport. In 1969, determined to overcome his anxiety of flying, he began taking lessons and successfully earned his private pilot's license. Yet his inherent uneasiness in the air persisted, preventing him from truly enjoying the sense of independence flying offers.

In 1973, in a final push to dispel his fears, Tucker enrolled in an aerobatic training course at the Amelia Reid Flying School in San Jose, California. It was during these lessons that Sean first felt truly in command in the air. That sense of control ignited a passion within that fuels him to this day-the burning desire to fly the perfect show.

For years Sean practiced tirelessly, honing his aerobatic skills in his time off from flying hundreds of hours annually as an aerial sprayer over the agricultural fields in the Salinas Valley where he grew up. By 1988, Tucker had flown his way straight to the top of organized competition by winning the US National Aerobatics Championship at age 37.

Since then, Sean D. Tucker has become one of, if not the most recognized pilots on the air show circuit in this country. In 1992, he became the first aerobatics performer to win the Art Scholl Memorial Showmanship Award and the Bill Barber Award for Showmanship in the same year. Still Tucker continues to raise the bar of personal best. This year, he won his second "CASPA Challenge" organized by the Championship Air Show Pilot's Association. But reciting his litany of accomplishments actually seems to reduce Sean to a stale catalogue of statistics. And the Sean Tucker I came to know this summer is a man of unparalleled energy; a man of vision who truly sees the best in everyone he meets and who draws out the maximum potential from every situation he encounters.

On the ground, as in the air, Sean D. Tucker is a man of action. He rarely sits still. At any given air show, you'll find him working the crowd, catching up with long time fans or running off to an autograph session at the 10-10-220 promotions booth. He is a consummate professional whose electricity is contagious; you simply can't help but feel his energy. Whether you're standing right next to him or

watching him wring out the 10-10-220 Challenger II, you will not forget the time and place you first saw Sean Tucker.

In the air, Tucker is a true innovator. Back in the late eighties, he developed and perfected several maneuvers that previously had been thought impossible. Most of his signature moves like the incredible Centrifuge have since been copied by less original performers out to exploit the leader. But while other pilots may be able to pull off one or two of his moves, few come close to matching Tucker's total picture. Part of the reason Sean is virtually untouchable is the physical abuse he has conditioned himself to endure in order to maintain the frenzied pace of his act. Sean keeps himself in top form with a daily regimen of aerobic exercise, weight lifting and flying designed to keep his body in the shape necessary to withstand the tremendous stresses of aerobatics. And while a military jet demo pilot may encounter forces as high as 9 Gs, Tucker repeatedly hits a brutal 12 Gs throughout his routine.

Sean's airplane, the 10-10-220 Challenger II, is a one-of-a-kind 400 horsepower black biplane that actually borrows

Opener: Tucker riding the sunset near Woods Hole during the Otis AFB show. Right: Overhead shot of Sean tumbling towards earth is near his home in Salinas.

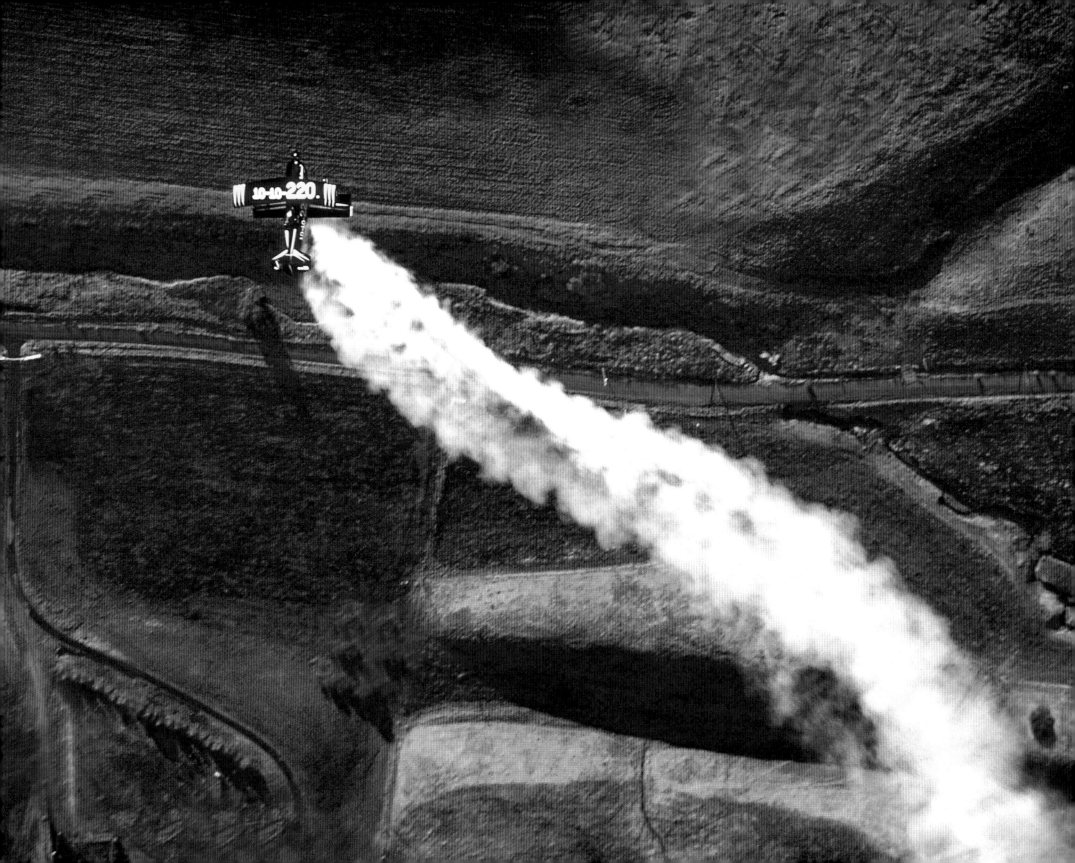

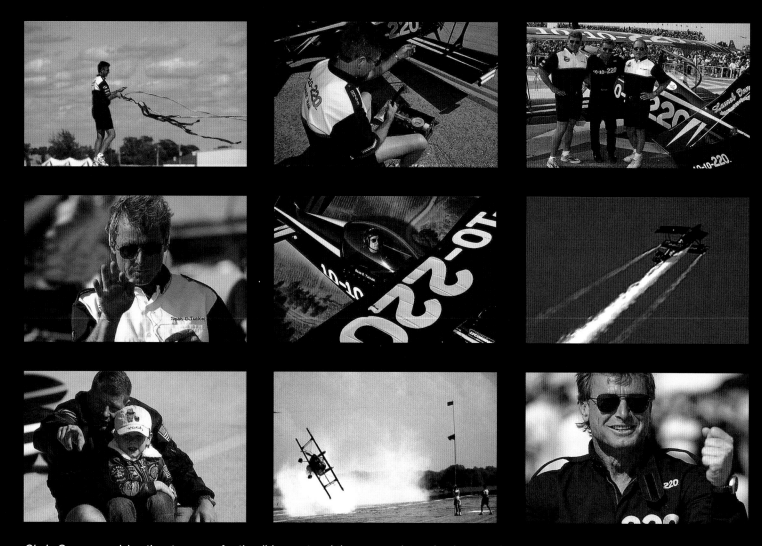

Clyde Greene readying the streamers for the ribbon cut and the pyro canisters for the wing tip smoke charges. Top right is a team shot with Brian, Sean and Tom Dygert at the home show. Tucker listens to the soothing voice of singer ENYA on his Walkman before every performance simply to put himself in a calm, familiar place in which to visualize each maneuver. Brian Norris enjoys a fatherly moment with a family friend. Cutting the ribbon at Oshkosh got just a bit low for Clyde-O. Run away!

design elements from five different aircraft. The plane is so specifically customized for Tucker's famous "Sky Dance" performances that the first step in the construction was to measure Sean's physical dimensions so that the plane could be built around the man.

As a result of the intensity with which Tucker flies this craft, its engine is completely overhauled and the airframe rebuilt at the end of each season. The internal wing structure is made of wood and must be torn down and scratch built every season. When you see Tucker fling himself through the air in directions and at angles an airplane was never meant to go, it is hard to believe that the plane stays together at all. The engine, like the rest of the plane, is intended for one hard charging summer without much more than regular oil changes planned for maintenance. It too is torn down to the bone and rebuilt each winter.

While the mechanical elements of Tucker's road show get the bulk of their attention at the end of the year, the personal side of his life is meticulously maintained throughout the grueling schedule of appearances. Sean deals with his unconventional summer cycle of weekends away from home by simply reversing the norm. He is so fanatical about his personal time with his family that he travels by commercial airline to the show sites just in time for a practice hop on Thursday. When he finishes with the performance on Sunday, he jumps the next available flight to Monterey, essentially splitting his time weekly between the road and home. Not bad for a job that usually requires performers to stay away for weeks at a time.

Tucker is able to achieve such a near normal personal existence by employing two of the most experienced and capable crew chiefs in the business. Brian Norris and Clyde Greene are Sean's full time road dogs who attend to virtually everything but the performances themselves. Tom Dygert began the team with Sean back in the early days and continues to support his partner by staying on top of the latest technological advances to ensure that the 10-10-220 Challenger II is in peak form. During the week, Tom works as a design engineer for Lockheed Martin's Missile and Space vehicles division.

Between show sites, Clyde ferries the show plane while Brian drives the team's aerial station wagon, a Cherokee-6 loaded to the gills with spare parts, dirty laundry and Gatorade. Once on location, the Cherokee serves as the unofficial camera ship for the local newspaper photographers who come to capture images that will run on Friday's front page. Ever the industry advocate, Tucker invites all of the show's performers to fly along in formation to equally spread around the valuable media exposure. After all, what's good for air shows is good for Tucker and he figures the more the merrier. It is an uncommon perspective for a man who is essentially engaged in one of the most cutthroat businesses in terms of publicity and gimmicks. He is genuinely out to promote air shows in general and along the way if he can help out some other performers, he does so happily.

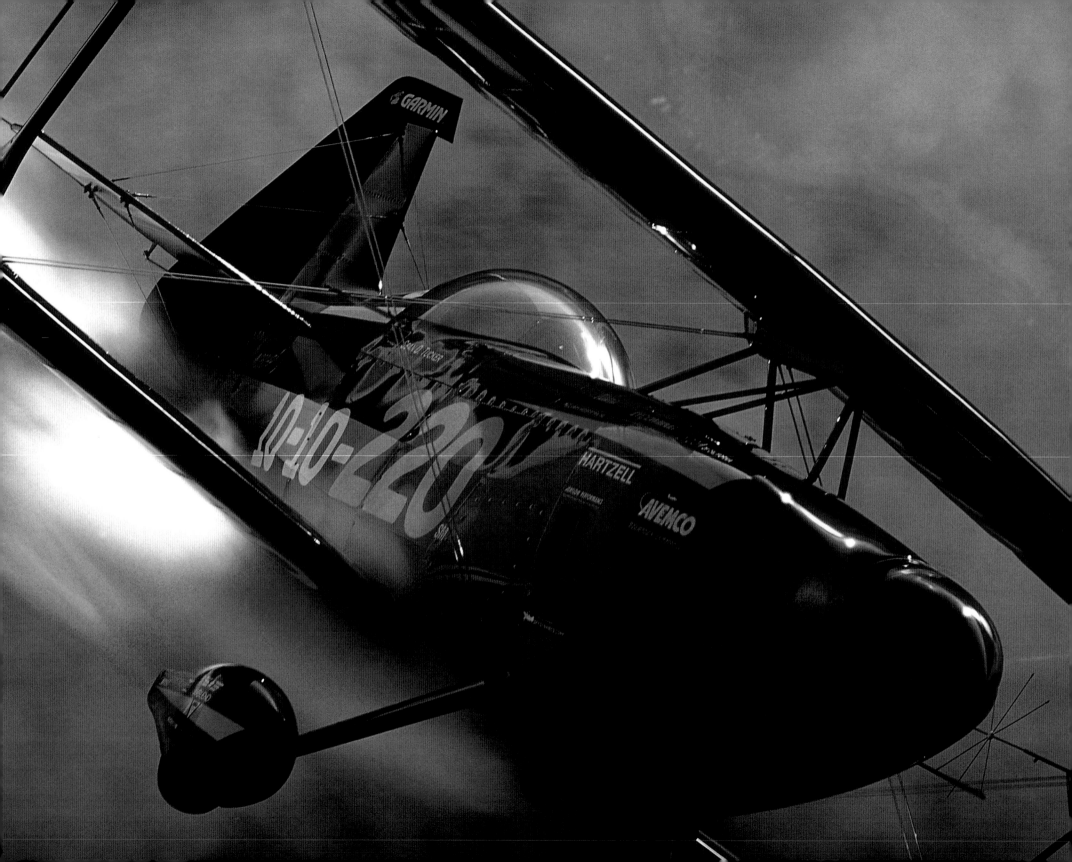

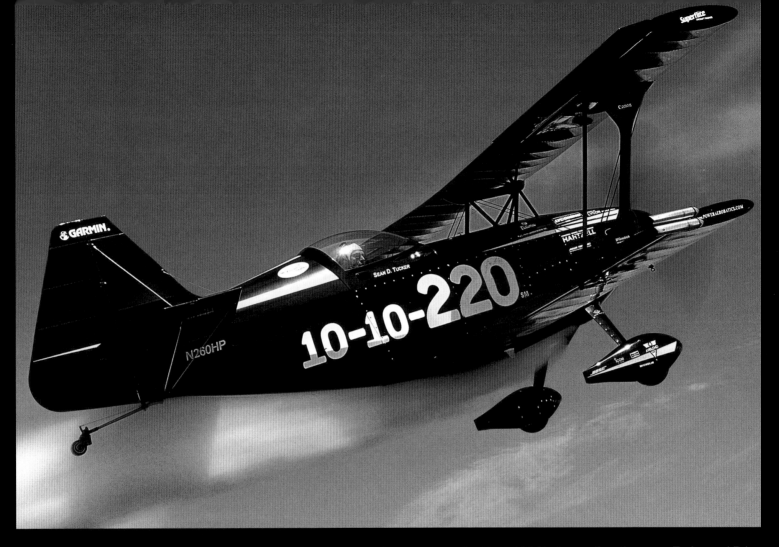

Left: Powering through clouds of his own smoke this shot shows how Sean can hang the 10-10-220 Challenger II on the prop. Tucker and Brian have nearly perfected this formation for photos, the side door of the Cherokee can be removed entirely to provide a great vantage point for shooting. Both of these images were shot over Woods Hole, MA. Right: Tucker starts one of his freaky barrel rolls around the Cherokee. It's quite a sight for the passengers.

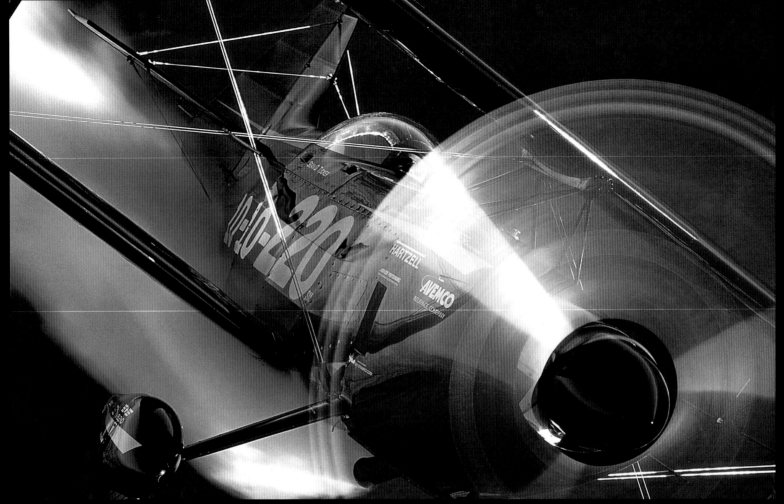

Shot during the very first photo mission of the book, this image set the tone and feel for the entire project. The graceful rotation of the propeller is captured using an extremely slow shutter speed of less than 1/30th of second. To maintain stability so that the whole picture isn't blurry from the camera shake, a gyro-stabilizer is used. This softball-sized device has two high-speed wheels inside that spool up to rotations in excess of 16,000 r.p.m. The internal inertia creates a localized force similar to spinning a bike wheel that holds the camera steady in space. Both of these pictures were shot over the rocky hills south east of Salinas.

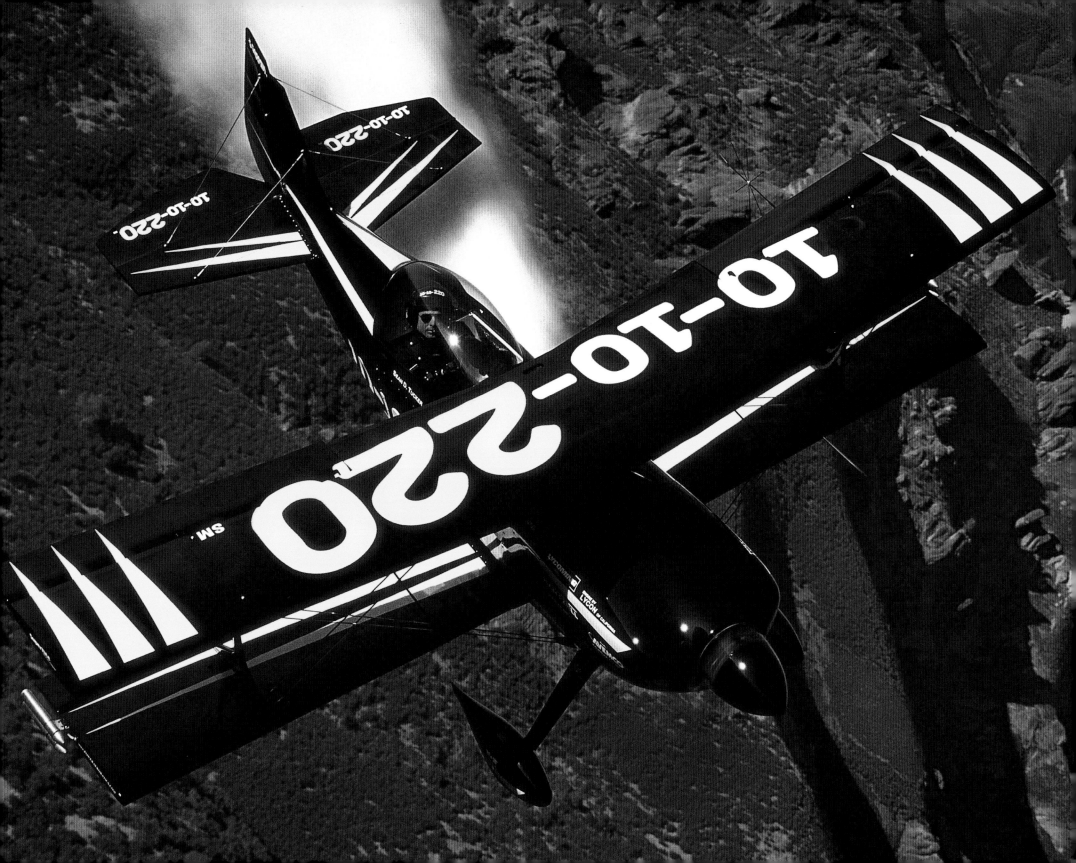

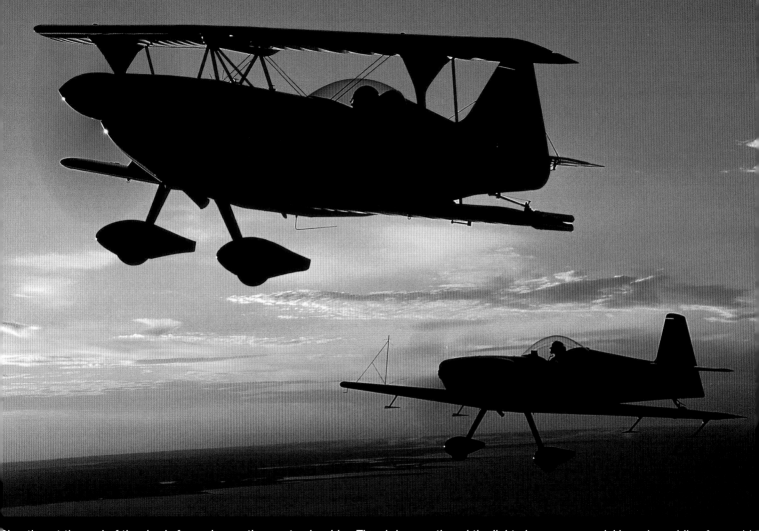

Shooting at the end of the day is far and away the most enjoyable. The air is smooth and the light changes very quickly and providing for a wide variety of beautiful situations. These pictures were both shot during the same flight over Martha's Vineyard while on location for the Otis AFB show.

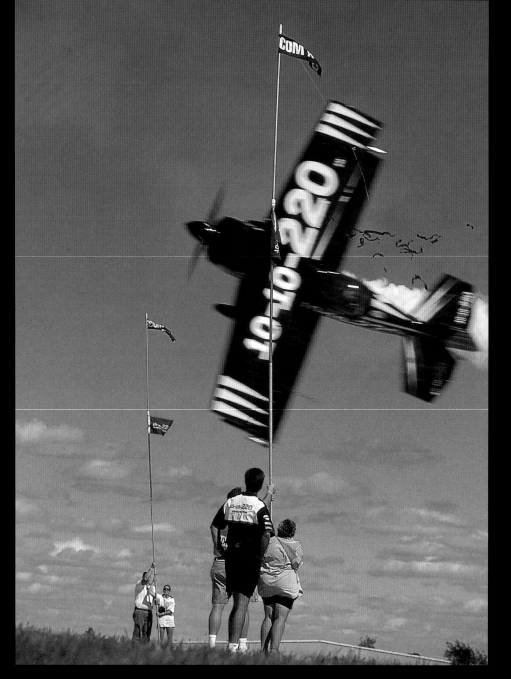

Left: Tucker dramatically demonstrates the dumb luck of capturing a ribbon cut using the motordrive in this sequence. Right: Shows the raw power of the 400 horsepower 10-10-220 Challenger II as Tucker climbs right past the Cherokee over Lake Winnebago.

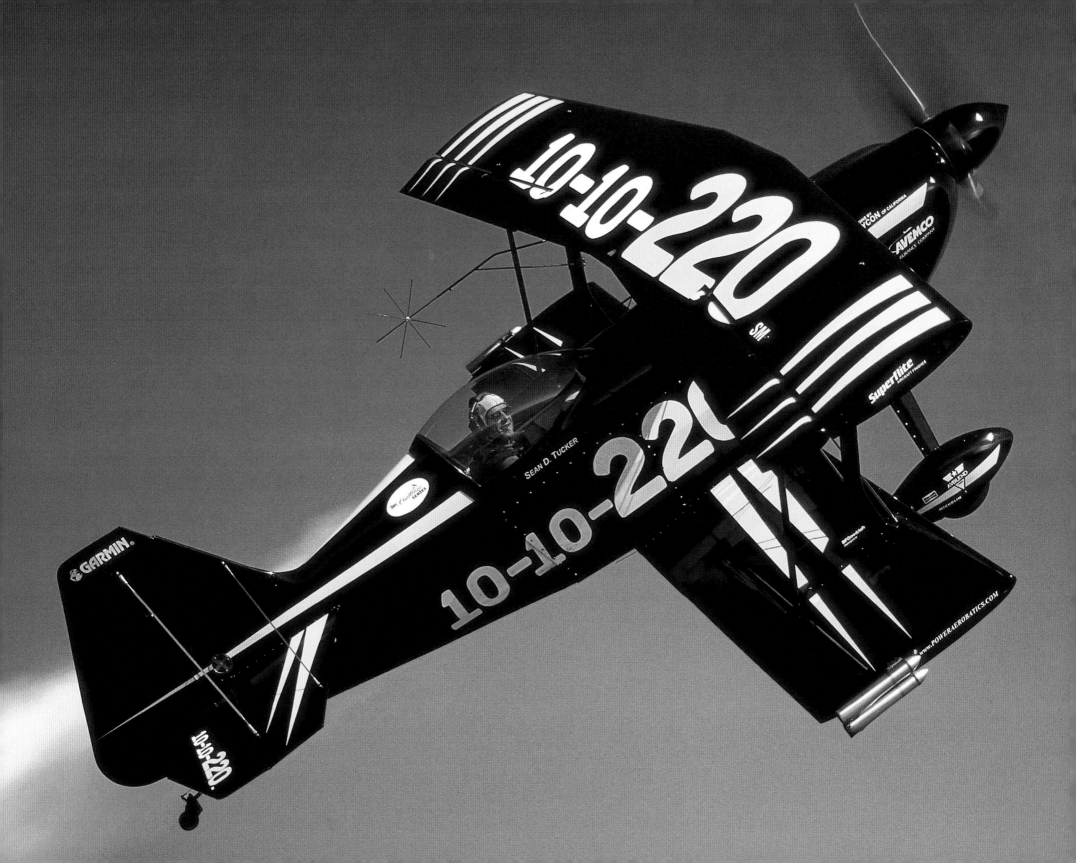

RED BARON STEARMAN
SQUADRON

With all the romance and sentiment of years gone by, Red Baron Stearman Squadron pilots evoke the glory of the 1930s in a weekly tribute to aviation's golden years.

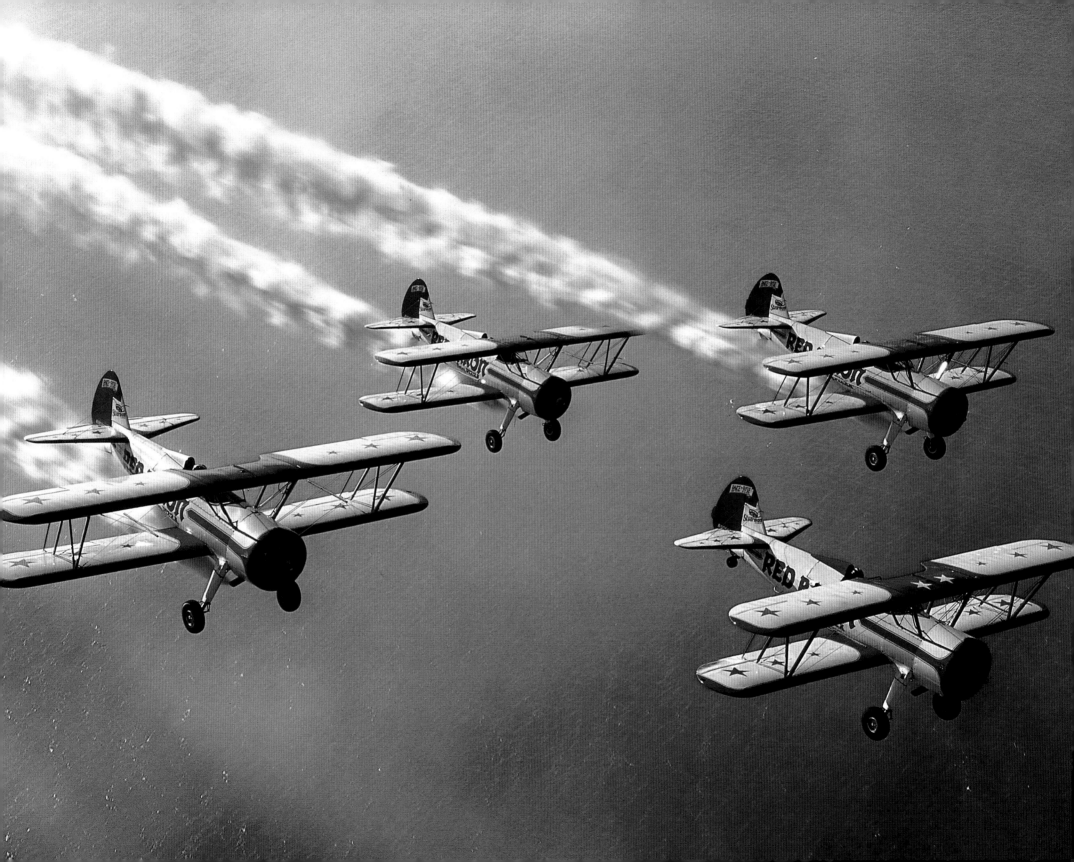

The biplane formation team has been around since 1979 when it first began barnstorming across the country raising money for children's charities. Over the years, the organization has become recognized as a first class performance flight operation. In 1984, the Squadron started regularly appearing at air shows and is now one of the most widely recognized teams on the circuit, performing in twenty-five shows each season.

Today the Red Baron Stearman Squadron consists of the four performance pilots, flight lead John Bowman, left wing Tom Womack, right wing Travis Aukes and slot pilot Bryan Regan. In addition, there are six highly skilled company ferry pilots–Steve Thompson, Steve Elm, Bob Johnston, Jim Keller, Kurt Anderson and John McMurray, whose jobs are to transport the planes between shows, and to give thrilling aerobatic rides to media and VIP clients.

On the ground there are six maintenance crew chiefs led by Jim Carlson-Merlyn Learing, Jim Wright, Todd Kurth, Brad Elsing, and Ryan Dulas who follow the team from show to show with a custom-built support rig that carries everything from spare engines to spark plugs. Maynard Kruse provides management of the ground and air operations department. And just as integral to the team's success is Jim Fedderson's leadership of the group's marketing efforts, sharing news of the team's upcoming performances and charitable contributions.

The air show public have become avid followers of the Squadron performances. Another important role for the pilots is to provide entertainment and express appreciation to the national network of frozen food distributors and grocery store managers who carry the Red Baron Pizza Services product line. VIP flights with local Red Baron customers precede each air show. In addition, Red Baron hosts a corporate chalet at each event, characterized by seasoned performers as the best in the business.

While the Red Baron pilots are thrilling audiences at air shows, they also are busy raising money for children's charities. Giving back to communities has been a cornerstone of the Red Baron Stearman Squadron mission. In fact, the Squadron has donated millions of dollars from its biplane fundraiser events to children's charities. Now they are embarking on a new program to raise funds for ©Miracle Flights charitable services. This nonprofit organization provides free air transportation to seriously ill children and their families who need to reach specialized medical treatment centers throughout the United States.

Leading the Red Baron Stearman Squadron is John Bowman, the senior aviator of the program having joined the team back in 1982. He has logged over 11,500 hours in the air and leads the team with the smooth cadence of a country gentleman. During the week when he's not flying end over end in a red and white Stearman, he withdraws up to his remote cabin in the Colorado wilderness.

Tom Womack is a career pilot who first took to the winds in a sailplane at age twelve. He has since logged time at the controls of more than 145 different kinds of aircraft. Recently he got married to another experienced pilot named Kimberly and the two of them are now the proud parents of a J-3 Cub they keep near their Austin, Texas

Opener: Four-ship formation of the Squadron shot from the Tucker Cherokee over Lake Erie during the Cleveland air show. Right: Shot from Bryan's #4 front seat of the finger-3 formation passing through the late day sun over the lake.

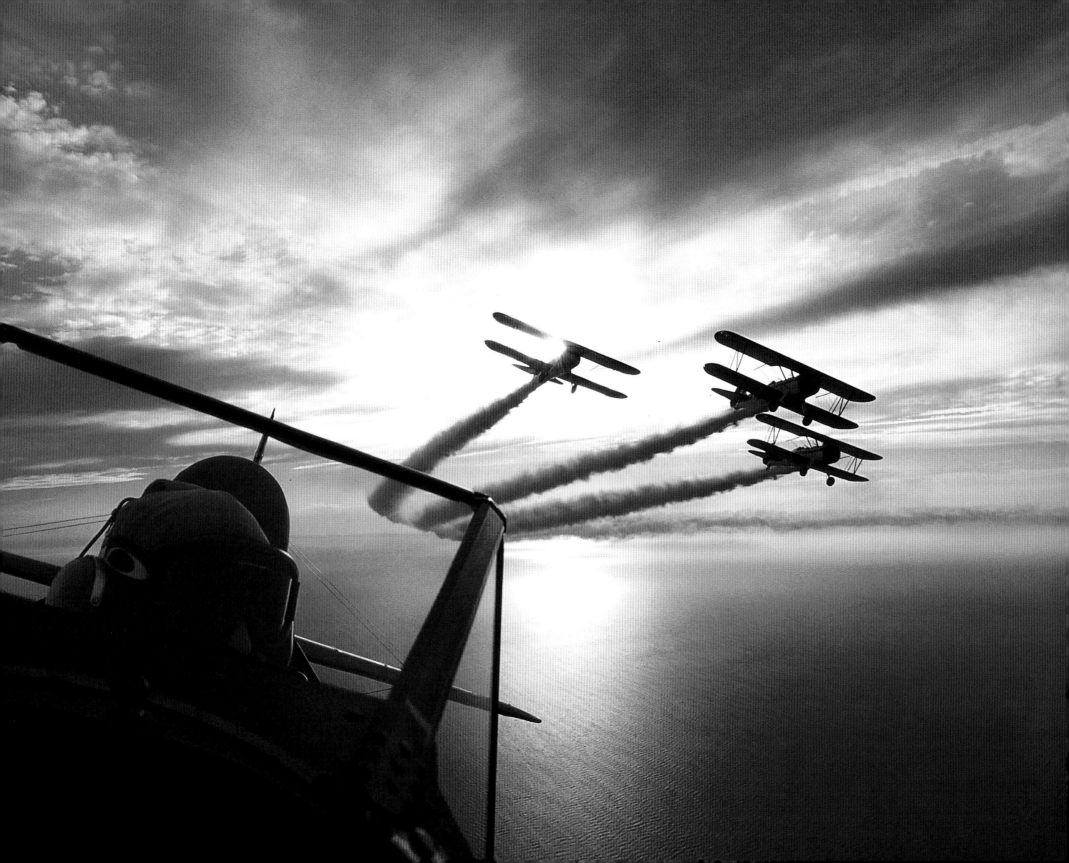

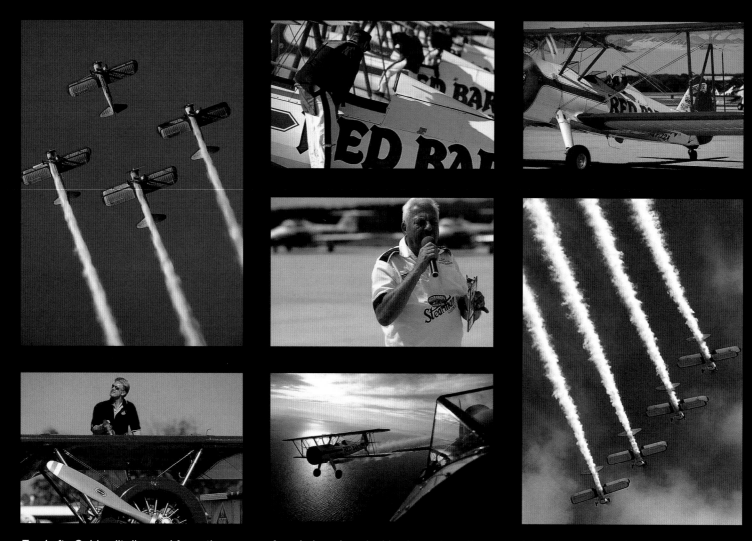

Top Left: Golden lit diamond formation as seen from below. I made this picture from the back of Dale Snodgrass's T-6 after the first day of the Oceana show. The three following images show Jerry van Kempen doing his thing at the Neptune Festival and the team manning up for the same show. Bottom Left: Todd Kurth gassing up one of the Stearmans at Cleveland. Tom Womack flies the silhouette position off of #4 over Lake Erie . Tom waves triumphantly as he returns to earth at Andrews AFB way back in May.

homestead. Tom was invited to become a Red Baron pilot back in 1992.

Flying opposite to Tom Womack is #3 Red Baron pilot Travis Aukes, a 4000-hour pilot with the team since 1993. He is a long-time Stearman enthusiast, having restored one to near museum condition with his brother back in Iowa.

Bryan Regan flies the challenging #4 or slot position in the formation. He joined the team in 1992 and currently shows more than 4500 hours in his logbook. As slot pilot, Bryan has arguably the toughest job in both the diamond and echelon formations. In the diamond, he is surrounded by his teammates and is constantly doing battle with the prop wash of Bowman's lead aircraft. On the outside of the echelon formation, Bryan must make corrections over the entire length of the lineup which often translates into a "crack the whip" phenomenon for which it is very difficult to compensate.

As all great aerial acts must have, the Red Baron pilots are blessed with one of the best narrators in the business, Jerry Van Kempen. Together with his wife Maggie of 50 years, the two have become synonymous with the team. Since the team's inception, Jerry has been out walking the crowd line with a microphone, belting out by far, the most enthusiastic descriptions ever delivered by a front man. He begins by turning back the clocks to pre-war America when the times were much simpler and aviation was just starting to catch on.

Jerry describes the atmosphere leading up to the Second World War and how men by the thousands volunteered themselves for pilot service in the Army Air Corps and the Navy. The Red Baron pilots fly one of the original military primary flight trainers of that time, the Boeing Stearman model A-75 and with Van Kempen's narration, the crowd becomes entranced by their gentle aerobatics. He colorfully describes each maneuver and the significance it had in the training cycle of the young teenage cadets. The Squadron pilots expertly trace invisible figures through the airspace with white plumes of smoke that drift slowly downwind from the action.

The planes are all freshly rebuilt originals that have been restored to their standard configuration at the team's operation base in Marshall, Minnesota. There are only a few modifications made for their air show roles, most notable of which is the installation of the 450 horsepower Pratt & Whitney Wasp Jr. engine that produces more than double the design's original powerplant. Smoke systems have also been added to provide the essential ingredient of any air show performance.

By the time the team circles to land, the audience has been transported through nearly fifty years of aviation history and back again. As a final gesture that reminds us all of a kinder and warmer America, the pilots make one last pass down the show line in a golf cart this time. They stop every few yards and hand each of the nearby ladies in the crowd a single long stem rose. Such an elegant touch of style by the team famous for being a real class act.

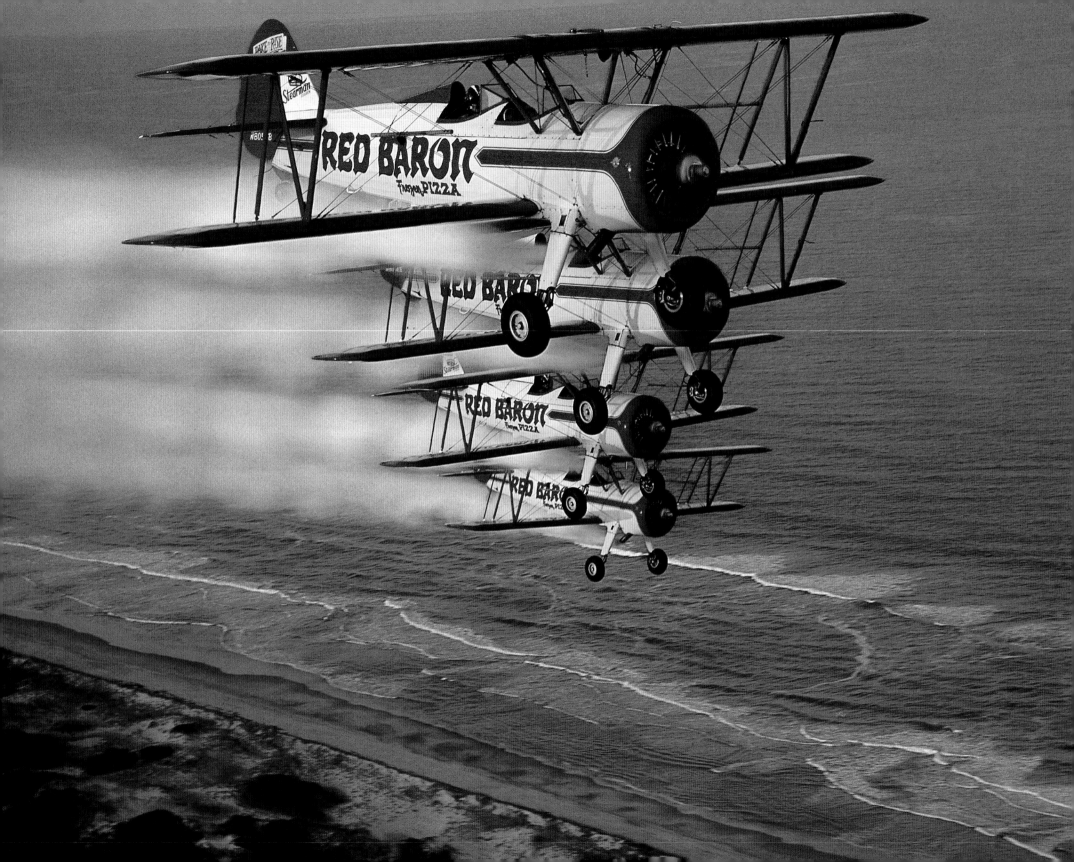

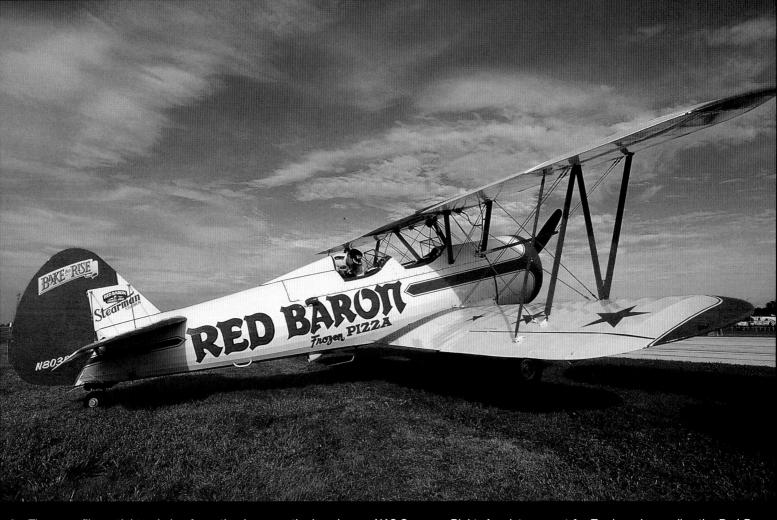

Left: The team flies a tight echelon formation low over the beach near NAS Oceana. Right: A quiet moment for Travis as he readies the Red Baron Stearman for another flight at Cleveland.

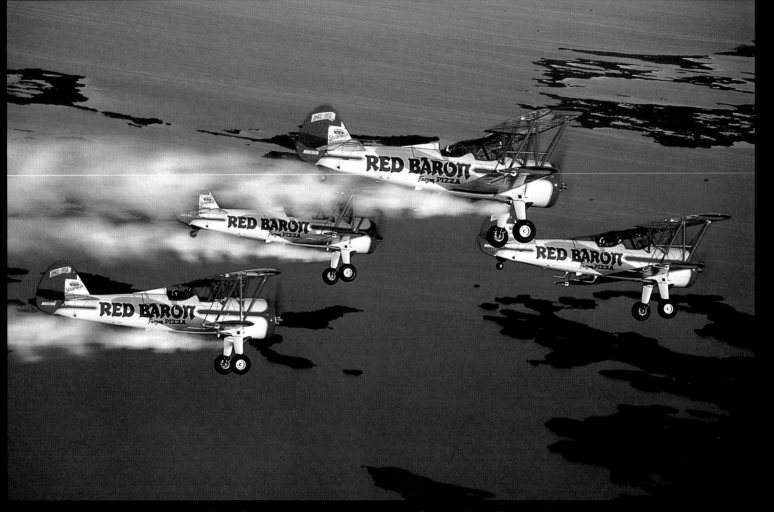

Left: Shot during a late day flight with Snort Snodgrass over the surf of Virginia Beach. Right: The team is formed up on lead John Bowman over the thick marine layer of fog near Salinas during the California International air show. The thick orange glow of the light was caused by chronic wildfires that spilled smoke and haze up the valley.

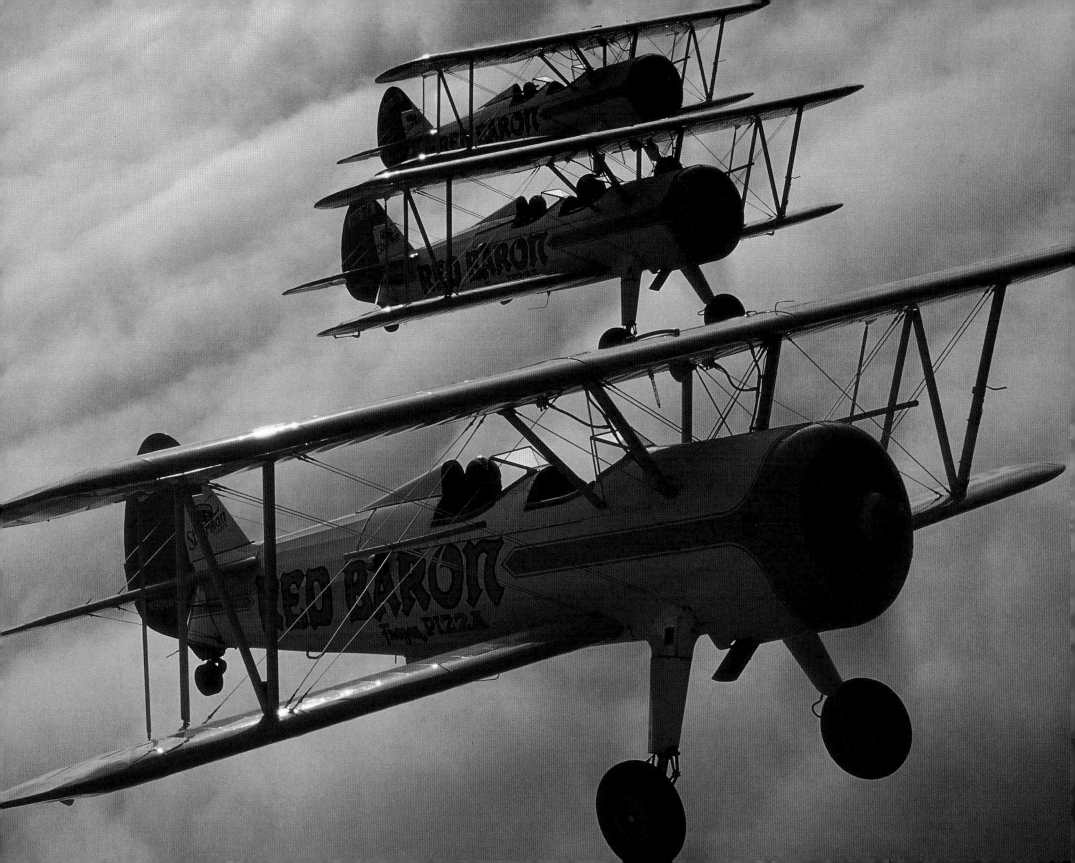

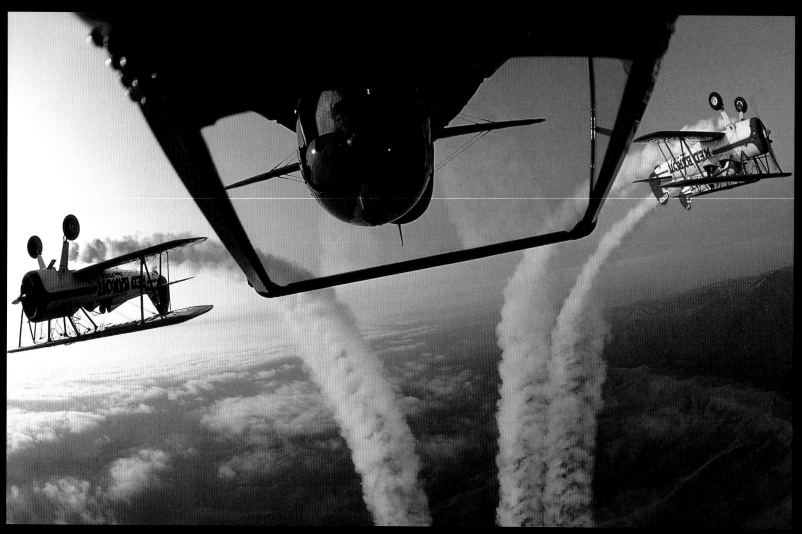

Above: We roll over the top with John Bowman leading the team through a finger-four loop. Right: An almost surreal vision of Tom Womack turning his world upside-down for the camera. Next: Bryan Regan in the #4 position as the team does turns for the light over Lake Erie. The lower left shows Todd Kurth in Cleveland waiting patiently for the next move on the teams atv tug. Bottom Right: Another view of the echelon formation over the waters of Lake Erie as the sun starts getting low.

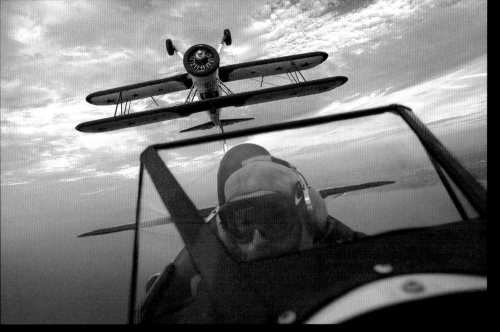
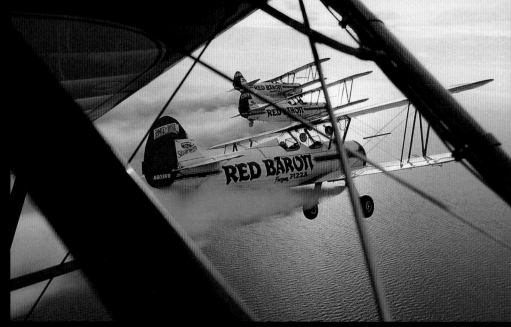
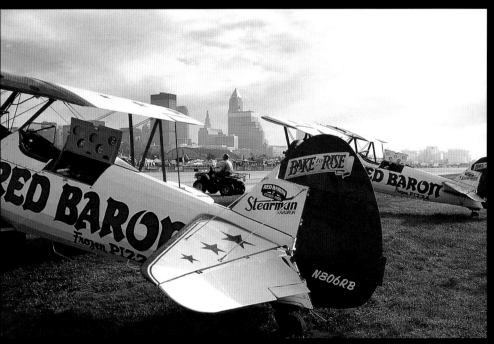
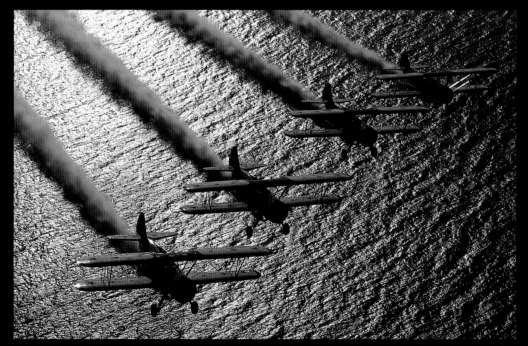

QUAD CITY
AIR SHOW

Over the green cornfields of Iowa, mighty Blue jets roar and aerobatic pilots tumble biplanes through the sky. On the ground below, couples and families watch and play and wile away an early summer weekend. This is the heart of the Great American air show.

The Quad Cities are four Mississippi river towns: Davenport and Bettendorf in Iowa, and Moline and Rock Island in Illinois. Their confluence is a place where a historic tradition of aviation still thrives. Industry giants like Alcoa, which has supplied this country with most of its aircraft aluminum since World War II, and Rockwell Collins, the maker of communications and avionics, remain the cornerstones of the area's proud contributions to American aviation.

Another offering in more recent years is the Quad City Air Show. Founded and directed by Kenneth W. Hopper, an accomplished pilot himself, this air show has come to embody the quality of life with which the Midwest has so long been identified. Designed in 1986 to rival the excitement and thrills of better known mega shows like Oshkosh and Miramar, this event at its heart is a family-oriented venue which appeals to folks well beyond the routine air show enthusiasts.

Like the enchanted baseball diamond in the movie "Field of Dreams," the Davenport municipal airport seems to have been carved from rows of corn rising head-high on every side. Scattered along the walk to show center are the usual vendors hawking brats and corn dogs.

Most refreshing, though, is the feel of the place. Not far from the flight line, the scene is that of a country fair sprawling across acres and acres. Children drag parents through the crowds towards carnival-like attractions. Would-be mountaineers dangle from a temporary climbing wall. Kids thump each other with hilariously overstuffed boxing gloves while bouncing on an inflatable ring. Gunnysacks tumble from a huge, yellow slide, emptying the giggling cargo onto the infield grass.

While Hopper has made thoughtful provisions for the general public to enjoy themselves, his forte is pulling together a line up of top-notch performers to satisfy even the most seasoned air show fan. The annual goal of any show organizer is to lure a military jet demonstration team as the main attraction. This season, the U.S. Navy Blue Angels have come to town and the traffic out on I-80 heading to the show is proof that the word is out.

But Hopper knows that no single performance can carry the event, and for this year's three-day spectacle, he has assembled a virtual who's who of the hottest performers. For the warbird enthusiasts, Quad City draws the Midwest's rarest ex-military showpieces. The Lone Star Flight Museum has brought its B-17 Flying Fortress all the way up from Galveston and the St. Louis chapter of the Confederate Air Force unveiled its newly re-painted B-25 "Show Me," fresh from the paint shop at the Boeing facilities on Lambert Field.

Mike George from Springfield, IL shows up with the only Corsair around and brings along "Axis Nightmare," a B-25 Mitchell he graciously flies as the camera platform for our photo missions each evening. The Air Force dispatched Capt. John York and Maj. Mike Chandler in a pair of F-15C Eagles to demonstrate the unbelievable capabilities of their front line air superiority jet. And as an added bonus, the pair flew a Heritage Flight with retired Air Force General Regis "Reg" Urschler in the spectacular P-51 Mustang he calls "Gunfighter."

Fans of more modern warbirds drop their jaws in awe when an F-86 Sabre screams in from the right, glued to the tail of a genuine Russian MiG-15. For about ten minutes the two jets flown by Mike Kennum and Terry Klingele duke it out in the skies overhead, reversing the advantage several times before Kennum "smokes" the MiG to the delight of the crowd.

Opener: Blue Angels making their dirty flat pass with all the gear they need to land aboard a carrier hung out in the wind. Above left: Fire support dressed to the nines in the 100-degree heat. Capt. John York, the F-15 Demo pilot ceremonially swears in a group of fresh AF enlisted folks-to-be. The St. Louis CAF flies their fresh B-25 "Show Me" with Tim Jackson in the left seat. Maj. Mike Chandler flew the Heritage Flight with Reg Urschler in the Mustang. Floating on a sea of corn stalks, the Lone Star B-17 sits ready to go. Delmar Benjamin keeps the cockpit door cracked open to let in some cool air. Comic relief from the heat. Judge and Iron do their thing for the crowd as the Blues defy gravity.

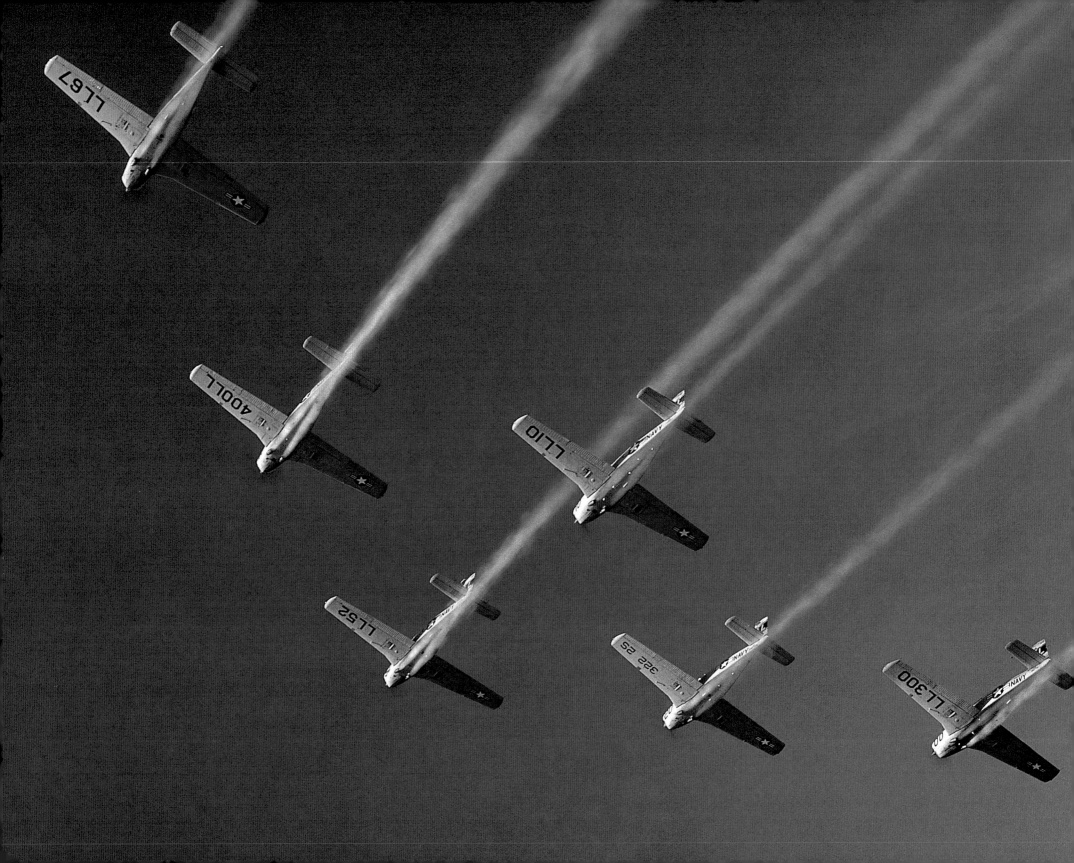

Next comes a gentle contrast: a precise and graceful six-ship formation of T-34 Mentors known on the circuit as the Lima Lima Flight Team. To fly such modestly powered aircraft in tight formation through the steep maneuvers of their performance is a testament to each pilot's skill and dedication.

Every year, well over 21 million Americans walk through the gates of an air show. Many will witness the biggest and most spectacular shows: 1.2 million will watch the skies over Miramar, California, another 1 million will witness the show in Chicago. But it is in the in-between places from Utah to Maryland where most Americans will catch a glimpse of daredevil pilots and fire breathing jets.

"These small shows, of 6,000 people coming in at ten bucks a carload are still 80 percent of our audience," says John Cudahy, the 38-year old president of the International Council of Air Shows in Leesburg, Virginia, "So much of this is about the little shows and the air show industry needs to keep its eye on these growing families."

Trying to appeal to a wider audience, Hopper spices his show with aerobatics. In 1999, Jimmy Franklin unveiled his jet-powered Waco biplane. Previously know for his daring low-level passes and knee-knocking wing walking act, Jimmy Franklin took it up a notch this season when he slung a Lear jet engine to the belly of an antique Waco biplane. The sheer spectacle of noise and speed sends the crowd into fits of laughter and cheers as the biplane shrieks into unlimited and effortless vertical climbs.

As if the speed isn't enough, the Waco returns later in the show. This time, Franklin's son Kyle is walking on the wings. Slicked smooth in leather and Lycra like the Rocketeer, Kyle moves from the outer wings up to the topside post rig for a series of loops and rolls at which people can only nudge each other and mumble "better him than me."

Rounding out the acts is Delmar Benjamin in his exact replica of a 1932 Gee Bee R-2, a one-of-a-kind snub-nosed monoplane produced by the Granville Brothers Aircraft Company. Benjamin flies a wonderful, high speed, low level show for which the original R-2 was never really intended. Originally designed around the massive Pratt & Whitney R-985 radial engine as a contender for the 1932 Cleveland National Air Races, the Gee Bee R-2 was made to race.

By 3:00 p.m., the crowd is primed. Everyone stands in the clear afternoon sunlight and presses up against the snow fence to watch a lumbering cargo plane perform a nearly unbelievable maneuver. US Navy Lt. Keith Hoskins is Blue Angel #7 and the team's narrator. "Judge" as he is called has taken command of the public address system and his rhythmic voice thunders with distinction. He is describing a US Marine C-130 Hercules at the far end of the field that has begun a slow take off roll towards show center. Just as the big bird called "Fat Albert" reaches the show's midpoint, its aft end erupts in a deafening roar of smoke and flames. Marine Capts. Dwight "Squeely" Neeley and Andy "Poser"Hall reef back on the control yoke and the massive transport leaps skyward with the agility of a fighter one-fifth its size. The secret is found in the rear where six solid rocket fuel motors are attached.

Finally, the air comes alive with six blue and gold Boeing F/A-18 Hornets. For 45 minutes, the Blue Angels demonstrate maneuvers and formations that seemingly defy possibility. When the Blues depart, the crowd is satisfied. An army of volunteers lets out a sigh of exhaustion and vendors break down their booths and start to count their receipts.

But already, Ken Hopper is campaigning for next year's show. He shakes the hands of all the performers preparing for the flight home and says to each of them, "Same time next year…right?"

"You bet Ken" they all reply, "The Quad City Millennium show on July 14th…I wouldn't miss it."

Left: A great view of the Lima Lima Flight demonstration team shot from Hank Krakowski's #7 T-34 Mentor in the "floater" position.

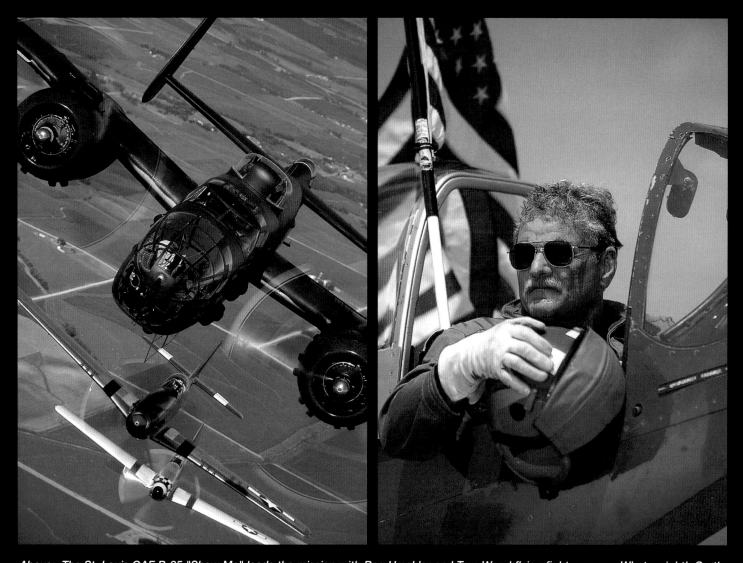

Above: The St. Louis CAF B-25 "Show Me" leads the mission with Reg Urschler and Tom Wood flying fighter cover. What a sight! On the right is the man himself, retired USAF General Regis "Reg" Urschler. Opposite: The wacky and wonderful Jimmy Franklin with his son Kyle in the incredible jet-powered Waco doing a high-speed climb.

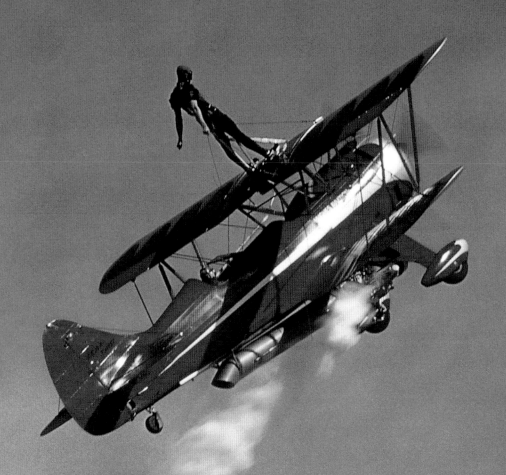

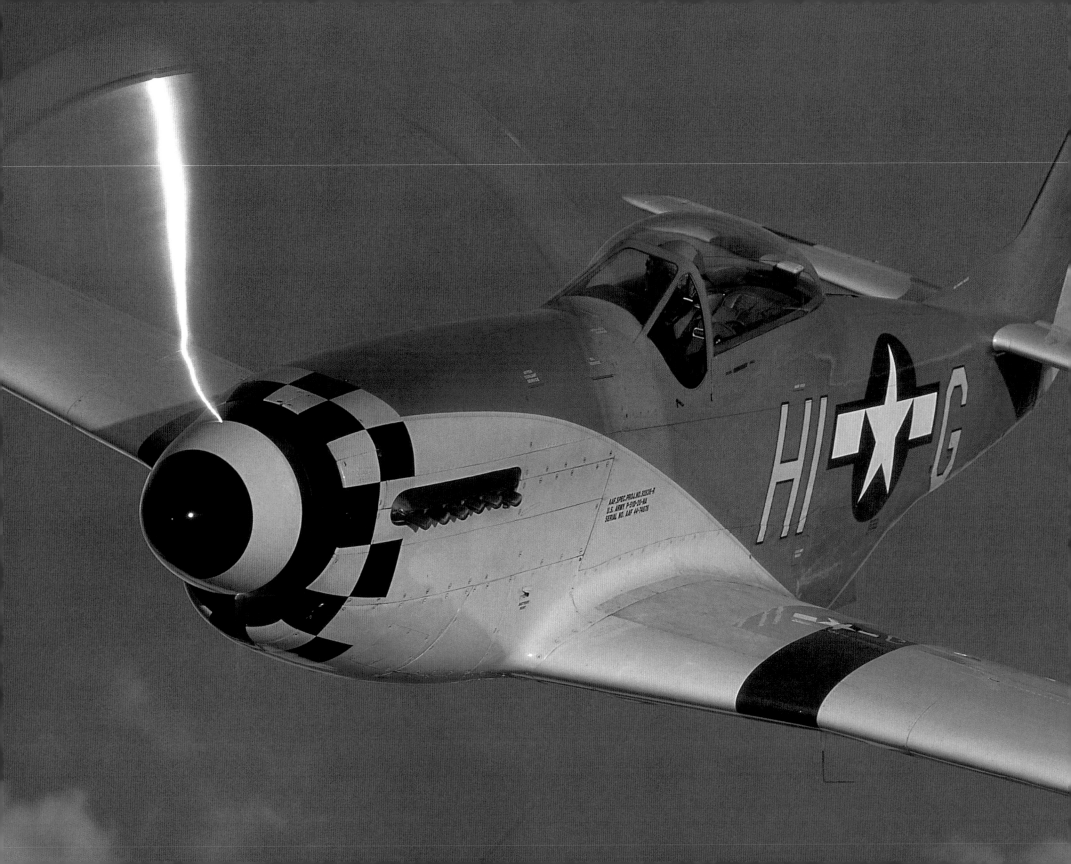

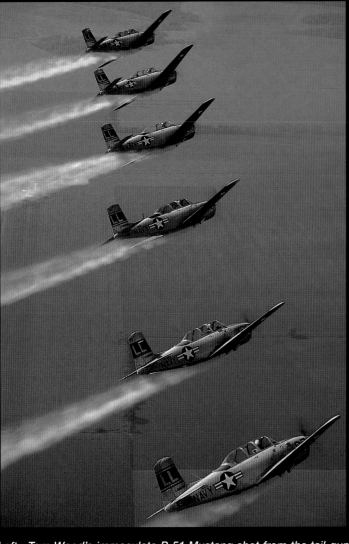
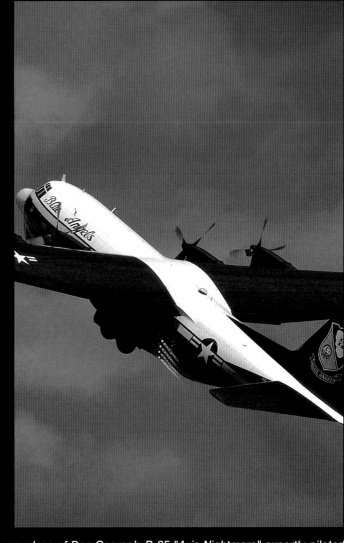

Left: Tom Wood's immaculate P-51 Mustang shot from the tail-gunners place of Don George's B-25 "Axis Nightmare" expertly piloted by Doug Rozendaal and Greg Vollaro. Above: The Lima Lima guys peel off to the left with a load of VIPs in the back seat. Fat Albert demonstrates the awesome spectacle of the JATO takeoff.

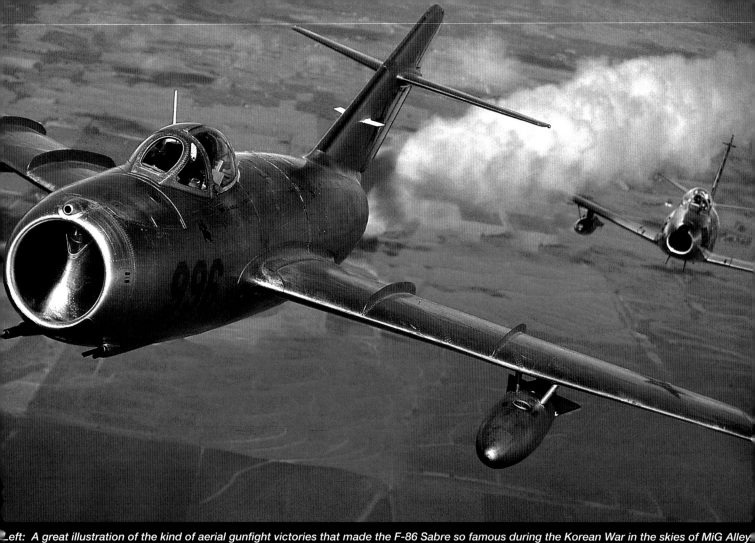

Left: A great illustration of the kind of aerial gunfight victories that made the F-86 Sabre so famous during the Korean War in the skies of MiG Alley. Against the MiG-15, the Sabre was almost identically matched in performance, but an inferior cockpit design of the MiG helped the Sabre to achieve a better than 4 to 1 kill ratio. Here Terry Klingele and Mike Kennum stage a MiG splash for me shooting out the back of "Axis Nightmare." Right: The moment of truth for the Blue Angel opposing solos, #6 and #7, when Doug "V8" Verissimo barks "HIT IT!" to Scotty Ind, callsign "Banker."

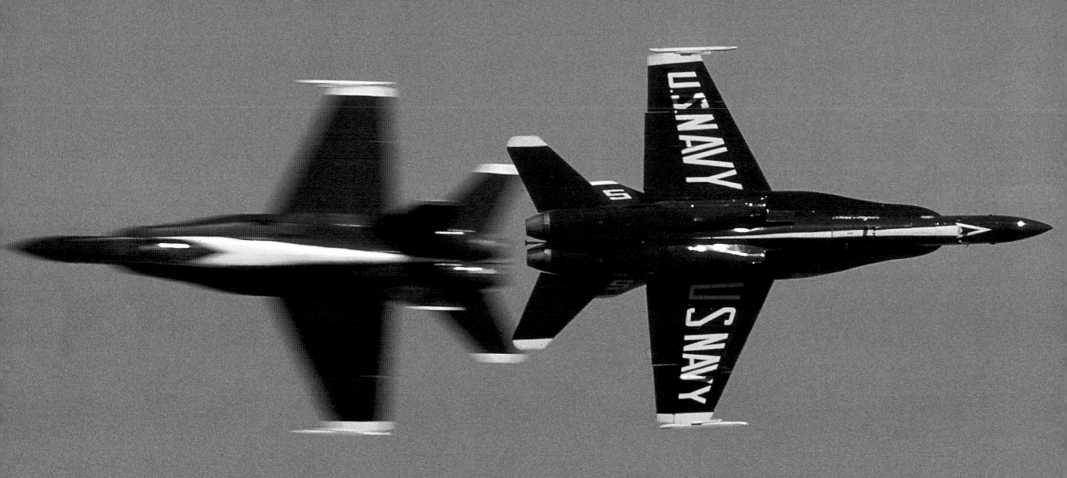

NORTHERN
LIGHTS

Of all the formation demonstration teams on the air show circuit today, the Northern Lights fly one of the highest energy performances ever attempted with five piston powered aircraft.

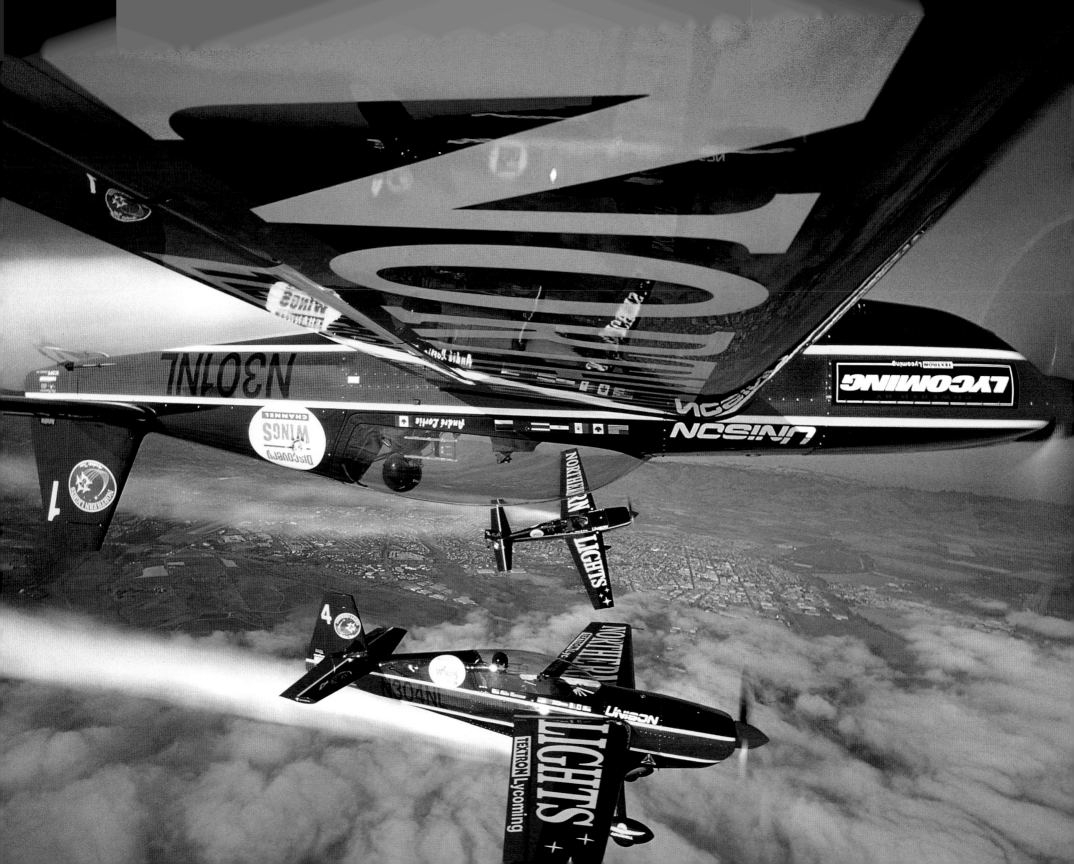

With five brilliantly painted Extra 300s, this flying circus of international extraction has the kind of innovation and business practices that you'd expect from a much larger team. Founder and leader Andre Lortie runs the group like a miniature corporation with grand plans that will ensure the team's success well into the next century.

Andre Lortie has flown for one of the world's greatest military aerobatics teams and it is with the proficiency and determination he could have only learned in the military that he built North America's largest civilian aerobatic team. But more than being a great pilot and effective motivator, he's an ambitious businessman and restless revolutionary bent on changing air shows.

At 33, Lortie has the resume of a world-class pilot. After joining the Canadian Armed Forces in 1987, he earned his pilot's wings two years later at Moose Jaw, Saskatchewan, where he also became a jet instructor in the CT-114

Tudor. Three years later, he was tapped to fly with the Canadian Forces jet team, the Snowbirds. While touring on the team, Lortie was exposed to the air show community from top to bottom. Andre came to understand the inner workings of the industry and soon began thinking of ways to capitalize on the opportunities he saw while still satisfying his passion to fly.

After leaving the military, Lortie launched an enterprising plan to build a world-class aerobatic team. In 1995, with five brand new Extra 300s, Andre's new aerial obsession flew 16 performances based largely on the maneuvers he learned back in the Snowbirds: the "Roll Over," the "Back Cross Split" and the "Crazy Diamond."

The team was an instant success with air show fans hungry for such a high power act. Never before had there been this many aircraft executing the types of difficult maneuvers that were previously only attempted by military jet teams. Lortie had a major hit on his hands and he was determined to maximize every opportunity.

The Northern Lights were in high gear flying virtually every weekend in front of millions of people. But the breakneck schedule of performances and the roller coaster of emotions inherent with any team made the initial seasons hard. Team members came and went. "I guess not everybody knew what they were getting involved with," says Lortie. "Trying to find good pilots and people who want to be out on the road, that's not easy. The goal now is to keep the same five people for the next 10 years."

Co-leader Mario Hamel has a complementary quiet and smooth personality that works well to balance Lortie's constant forward sprint. Mike Mancuso from Westhampton Beach, #4, is the team's only American and he has one of the toughest jobs flying slot. The most recent addition to the Northern Lights is Ukrainian aerobatic phenom Azat Zaydullin who flies in the #5 position.

Almost five years after getting started, it is smooth, but still not easy. Michele

Opener: An awesome remote camera view from the wing of Andre's Extra 300. For the shot, Andre rolled inverted over #4 Mike Mancuso and then positioned Mario Hamel into the narrow space beside them. Right: Look-back view of flight lead Andre during takeoff from Salinas.

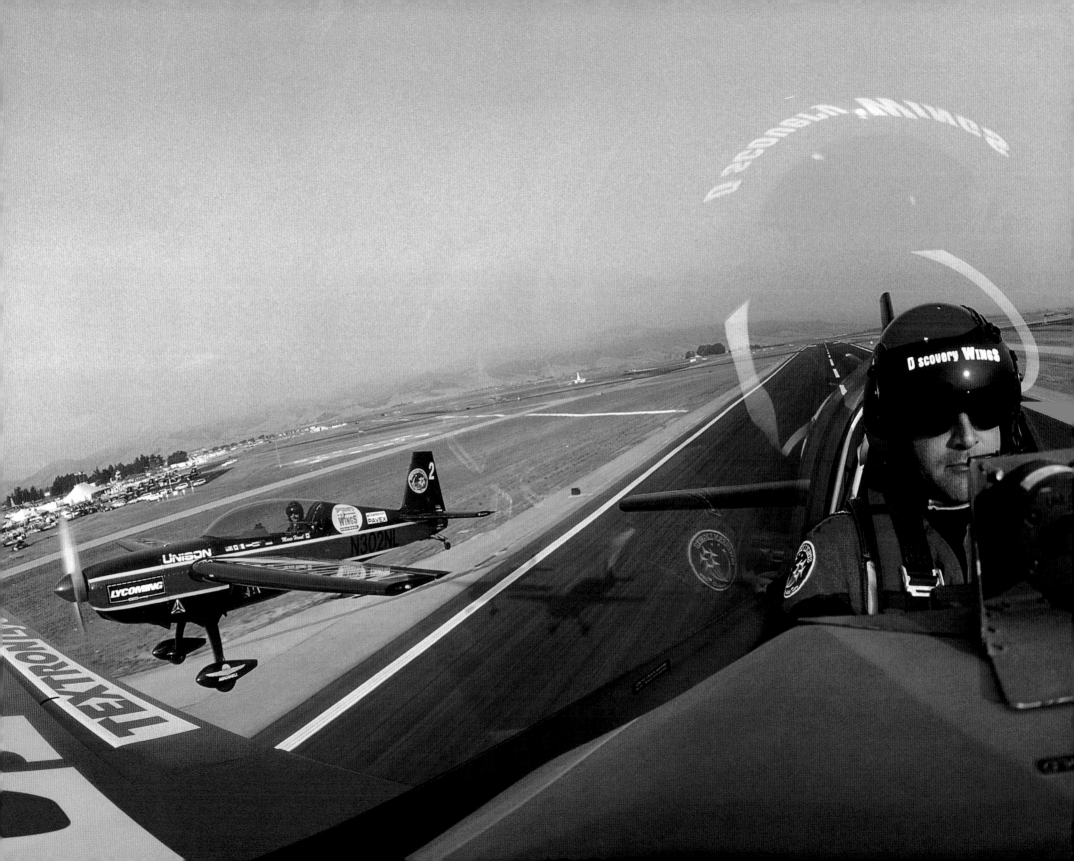

Above: The five Extras cruise over the Atlantic Ocean just off of Montauk Point. The traveling HQ set up at Quonset Point, RI. Echelon four over Salinas. Mario readies for the show. Five from above. Andre moving at his usual pace. Mike Mancuso meets the fans. Michele Thonney catching up with Screech at Oshkosh. Michele learning all there is to know about flying the jets.

Thonney, #3, is the sole female on the team. She has flown in more than 170 air shows, and logged over 3600 hours total time. But even so, the stresses and strains of constantly being on the road are hard. While she says that the latest team gets along much better than just a season ago, she looks forward to shows where she can get away even for a little while to spend time with her surrogate family members on the U.S. Navy's Leapfrogs parachute team.

Despite the grueling travel schedule and the growing pains such as high personnel turnover, the team appears to be hitting its stride. Ever the visionary, Lortie is constantly expanding the enterprise. The team is now met at each air show by their own custom-built 53-foot tractor-trailer to serve as support wagon and on-site billboard. This first class mobile Northern Lights headquarters is equipped with an air conditioned pilot's lounge, a maintenance workshop and a cool observation deck to host VIPs from their devoted corporate sponsors. With such a highly visible and fully integrated marketing profile, the team is not just popular with the fans; companies like Lycoming, Unison and Aeroshell are realizing the tremendous value that the Northern Lights offer as an advertising medium.

With so much momentum and support, Lortie has just launched his boldest move yet. He is presently organizing the creation of the world's first civilian jet team. This year at Oshkosh, the team unveiled the first of seven Soviet-Bloc L-39 Albatross jet trainers from the Czech Republic. With fresh maintenance and a new coat of trademark Northern Lights paint, each jet will cost close to $400,000. Already the team is training regularly in jet number one in preparation for delivery of the other planes.

Lortie's plan is not to substitute the jets for the existing planes but to expand into a double-billed performance where the Extra pilots will perform opposite six new ex-Snowbird pilots on the same day.

With seven jets and five Extras, he hopes to get two trucks eventually and even the team's own sound system for shows. He along with the rest of the industry is preparing for more television coverage, more team-related products and a whole new approach to marketing.

In the view of pilots who have flown both, jets are much easier to fly in aerobatic performance than propeller-driven aircraft. As heavier aircraft, they are less susceptible to choppy wind conditions and in formation, jets are easier to control since there is no engine torque to overcome as with propeller aircraft. "Many people perceive the jet to be something special. I think the Extra 300 does a more entertaining show. But people like watching the jet. It goes faster," says Lortie. "And for sponsors, it's a whole different kind of prestige, a totally different ball game."

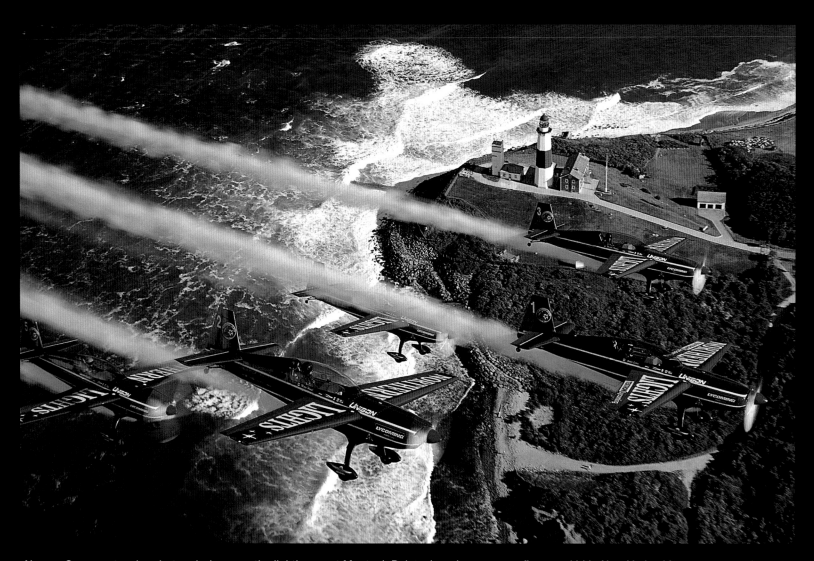

Above: One spectacular photo mission over the lighthouse at Montauk Point where I grew up surfing as a kid in New York. After years away from the ocean, I finally got the chance to use my lighthouse for the perfect background.

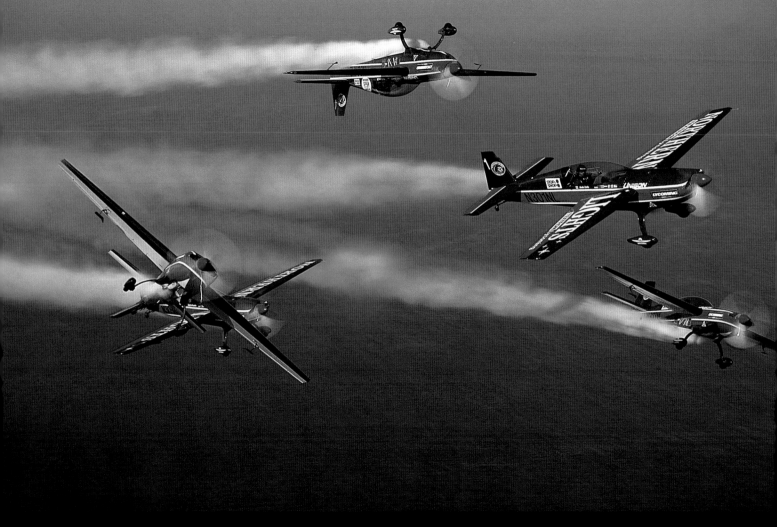

Above: A cool head-on view of the Crazy Diamond. We shot all of the air-to-air pictures from a DC-3 flown by Alan Henley and Gene McNeely.

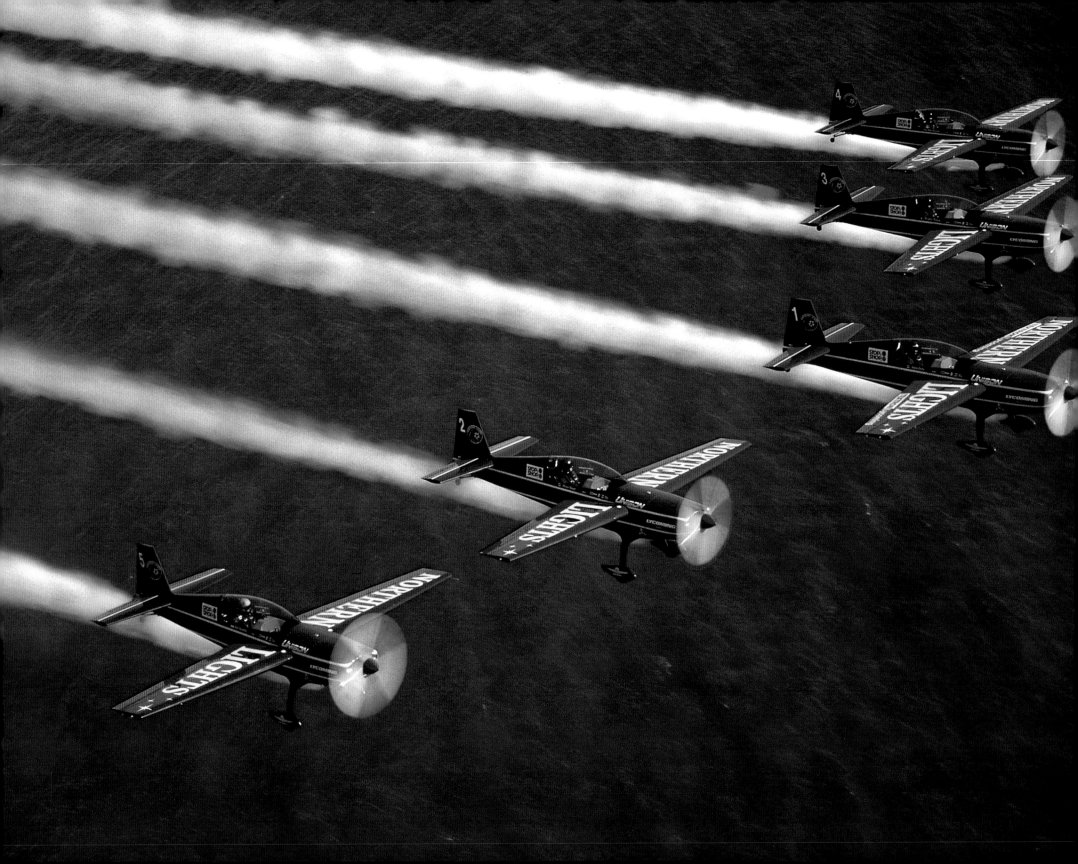

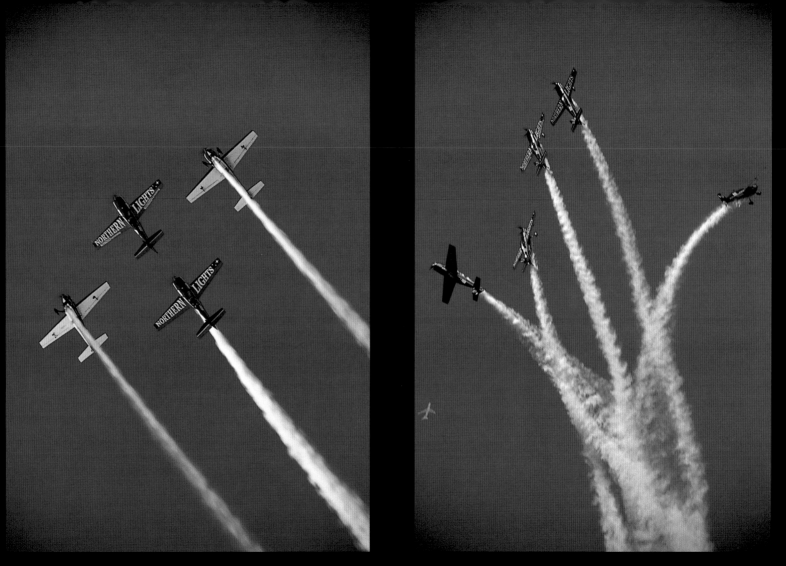

With timing and precision the Northern Lights execute flawless patterns of smoke and color for audiences all around North America. Right: An airline captain trying to get into the act. No doubt he was pointing out the Oshkosh Convention to the co-pilot when these were shot.

EAA'S
OSHKOSH

It is the battle cry of millions of aviation enthusiasts around the world: "See you at Oshkosh." More than stating simple fact, it's a virtual pledge of allegiance implying of the speaker a deeper understanding of all things airplane. It also serves as a sort of secret handshake to those who understand the power of seven days in wing-nut heaven.

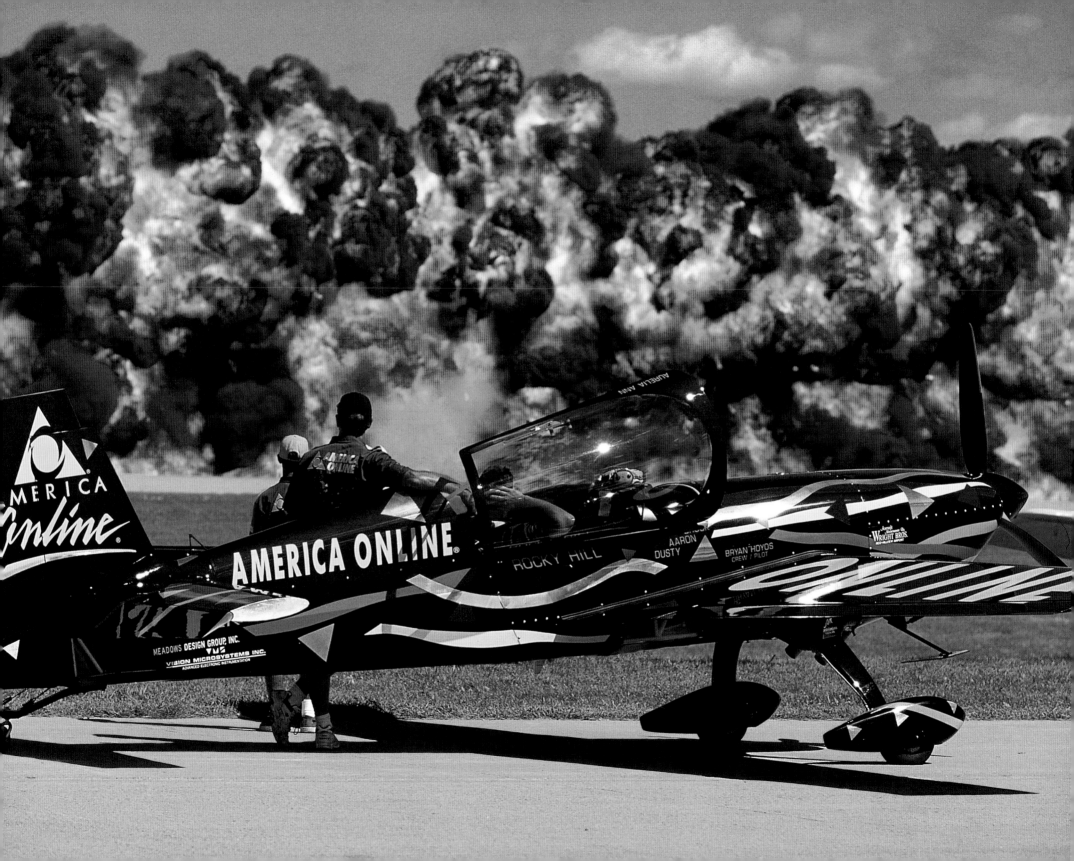

Like most who have been to the Experimental Aircraft Association Convention known simply for the Wisconsin town in where it is held, I had heard of Oshkosh long before ever making my first trip. It was right after we had moved to Minneapolis in 1992. I was scratching the airplane itch by flying a radio controlled model of a J-3 Cub I had built during that first Minnesota winter. In the spring, the RC flying club I had joined buzzed with one question: "Are you gonna go to Oshkosh this year?"

During one of the monthly Tuesday night meetings leading up to D-day, the club's full scale pilot-in-residence stood up if front of the geezers and geeks, myself obviously one of the latter, and began spinning his yarn. Like a revival tent of lost souls, we sat mesmerized in hard folding chairs absorbing this description of Mecca. He spoke of fields brimming with home-builts as far as the eye could see, and of pristine examples of the rarest of rare WWII warbirds. He passed around blurry snap shots and a dog-eared program from the year before; his ninth consecutive pilgrimage. Towards the end of his rant, he leveled the coup de gras and played for us the voice from above.

It was a cassette recording of the radio transmissions on the Oshkosh control tower frequency. The whole room fell silent. In rapid-fire staccato, the air traffic controller barked out directions as if he were auctioning off all of Wittman field: "Low wing Beech, you are cleared to land, hit the numbers and make the first taxiway. Red high wing in downwind, rock your wings, you are number three behind the Mustang. North American, you are number two to land, report short-final, you need to land mid-field, expect the last taxiway." I, along with a dozen or so other RC model pilots, was now a true believer.

The next thing I remember is driving my car packed to the gills with camping gear, taking up the rear of a six-vehicle formation. We were a misfit band of micro aviators hell bent on seeing the light. We circled the wagons out in the back forty of the well-organized campground and spent almost the full week doing the Oshkosh shuffle up and down the three mile flight line. Each night we would meet back at camp and sit around a fire drinking beer and resting the tired dogs. It was special to me, sitting around with a bunch of guys with a common interest. The image stays with me to this day of the flames dancing over the wild-eyed, sun-burned faces of that first group.

While the EAA Convention is far and away one of the most successful commercial aviation events with millions of dollars both spent and earned, it's success is still rooted in what it's founder Paul Poberezny has always provided for EAA members: practical support and a sense of belonging. Founded and organized during what some have described as the "underground years of aviation," the EAA was a grassroots response to a crippled and dying general aviation industry in America during the latter half of this century.

In the 1960's, manufacturers of private aircraft like Cessna, Piper and Beechcraft were being battered by staggering financial judgements leveled against them in civil product liability lawsuits. Under the law at that time, survivors and heirs of a private plane crash victim could sue a manufacturer for product liability and punitive damages. The seemingly endless cycle of losses facing the private general aviation industry caused many small companies to simply shut down completely and the larger manufactures to abandon light aircraft altogether. With a finite reserve of small airplanes worldwide, prices skyrocketed leaving private ownership accessible to only a privileged few.

It was under this atmosphere of aviation elitism that the movement towards home building your own airplane came into vogue. All across America as well as in many other industrial nations, basements and garages clamored with the sounds of wood-working and steel tube welding. What emerged over the next twenty years has forever changed the universe of the private pilot. Everything from the ultralight to Burt Rutan's composite marvel Proteus owes their humble beginnings to the tinkering homebuilder. These inventive Americans turned industrial adversity into private opportunity and eventually into the technological triumph that we experience here at Oshkosh every July.

It's about a five hour drive from the Twin Cities to Oshkosh, a drive I know by heart after this year's seventh trip. I still camp, albeit with a different group of friends, but in my opinion, it's the only true way to experience the Convention. Camping makes it a total immersion experience that allows you to feel what a lot of folks would argue Oshkosh is really about: community. The daytime is for hoofing up and down the flightline, in and out of the exhibition hangers; basically soaking in the commercial side that is today's rebounding aviation industry. But it is in sitting with your airport buds back at the campsite that the memories you take home are created.

The dramatic opening shot shows Rocky Hill appearing to be nearly blown up. Actually, it is just the wall of fire detonation during the afternoon warbirds show on Saturday. Right: Tom Gregory flies the Lone Star Jug just a few feet from the B-25 cameraship.

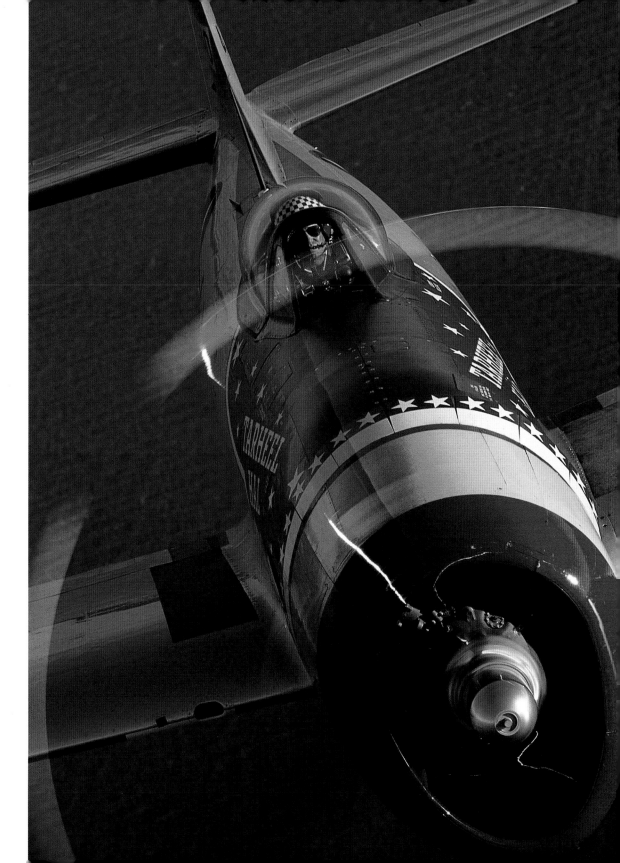

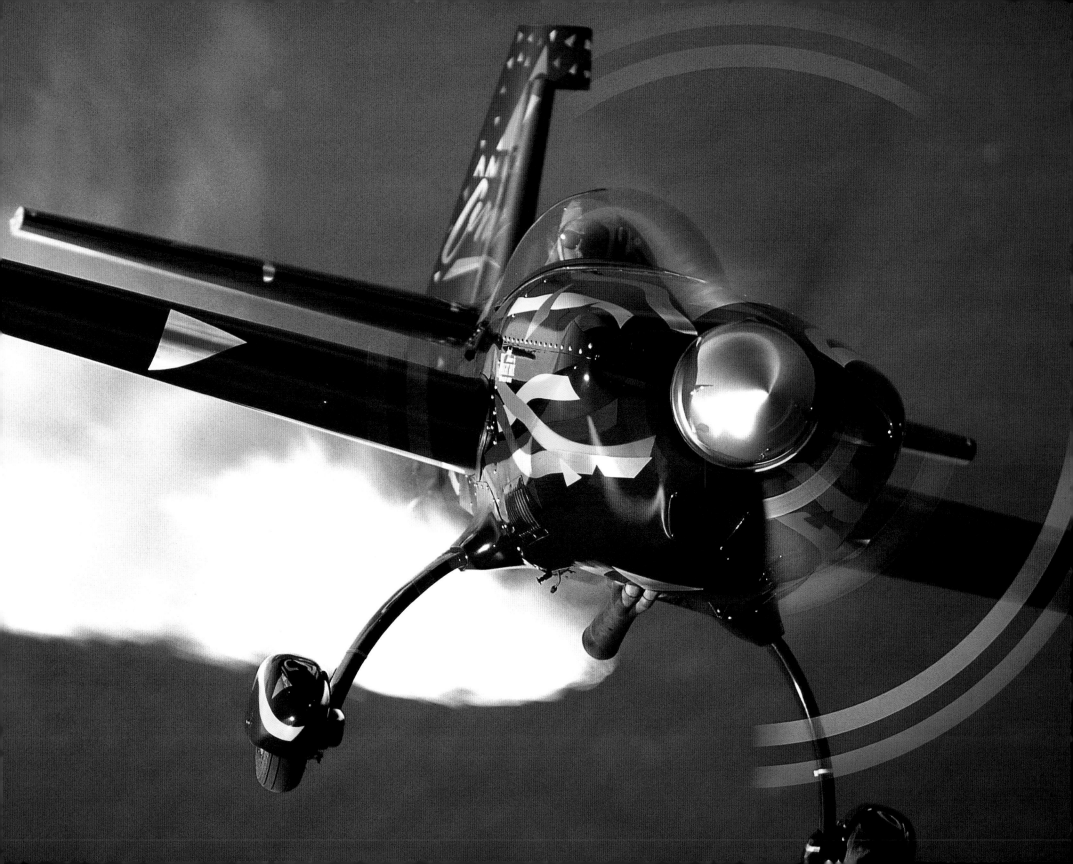

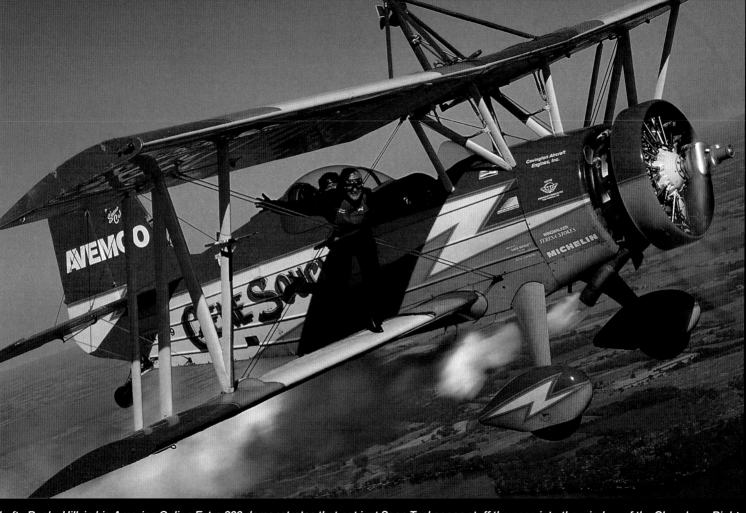

Left: Rocky Hill in his America Online Extra 300 demonstrates that not just Sean Tucker can stuff the nose into the window of the Cherokee. Right: Theresa Stokes and Gene Soucy taxiing off to fly their wingwalking show.

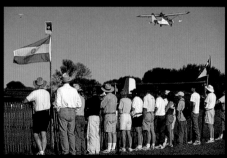

Top Left: The largest American flag ever to be jumped by parachute. Morning finds the breakfast table full of kids camping out of a classic Cessna 195 with their folks. Blue skies and fair winds. Kermit Weeks taxis by in his better than original P-51. Two of kind, Bob Hoover and Sean D. Painted horses. Family values. Cruising the grounds. Boy, those things can fly; ultralight heaven. Opposite: Gene Soucy in his familiar Extra dancing on the rudder peddles out of the lake.

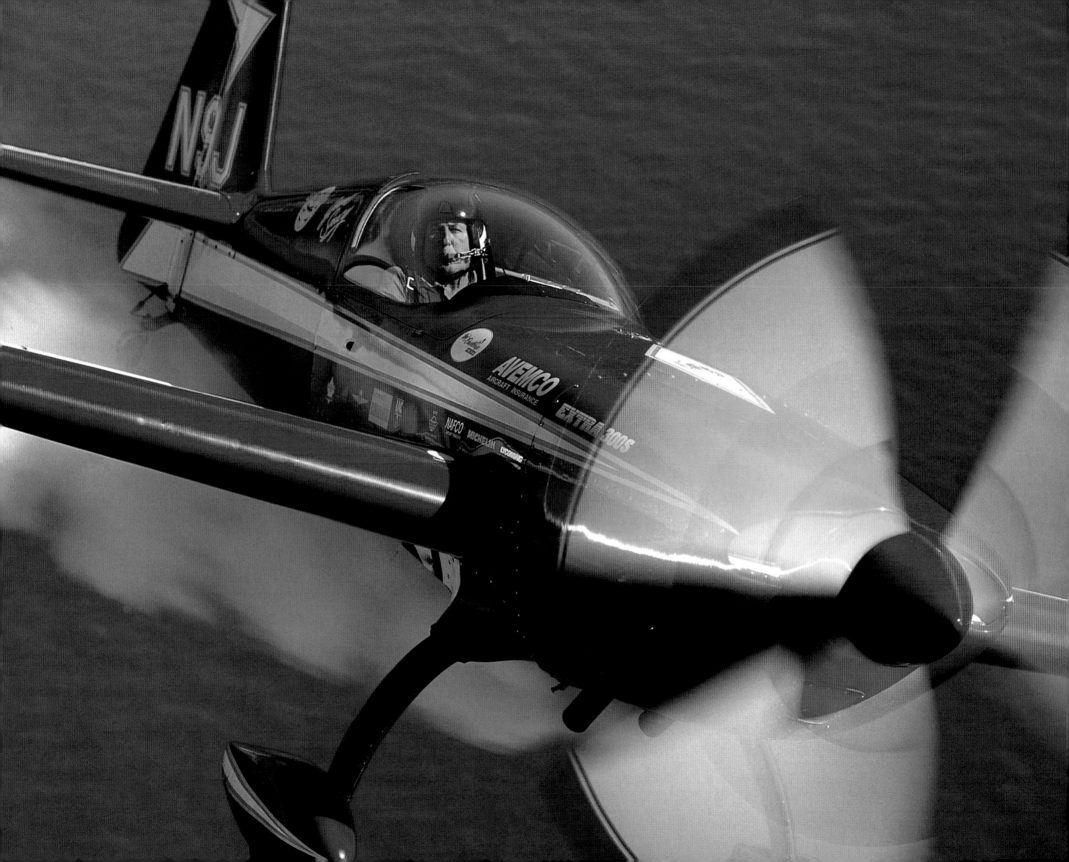

Top Left: Paints a painter painting a Corsair. A Coast Guard crew perches for a better video vantage. The ultralight you ride, not fly. Scaled Composites HALO marvel. Matt Chapman puts on the CAP . Same food, different place. Greg Herrick polishes up the Kreutzer Trimotor for judging. Gene Soucy makes it look easy. The walk of fame. Opposite: Tom Gregory just a few feet from the lens with the Lone Star's Thunderbolt. Tom Wood takes the lead in the elegantly plain Bearcat with his Mustang close behind flown by Frank Strickler.

HERITAGE
FLIGHT

At the turn of the century, two American brothers named Wright invented a machine that forever changed the course of civilization. Unfortunately, the significance of that invention was appreciated more fully in Europe than it was in America for the next thirty years. With the advent of Hitler's and Japan's military might, this country began a belated effort to change our lack of interest in aviation matters. — Frank Borman, Col. USAF Ret.

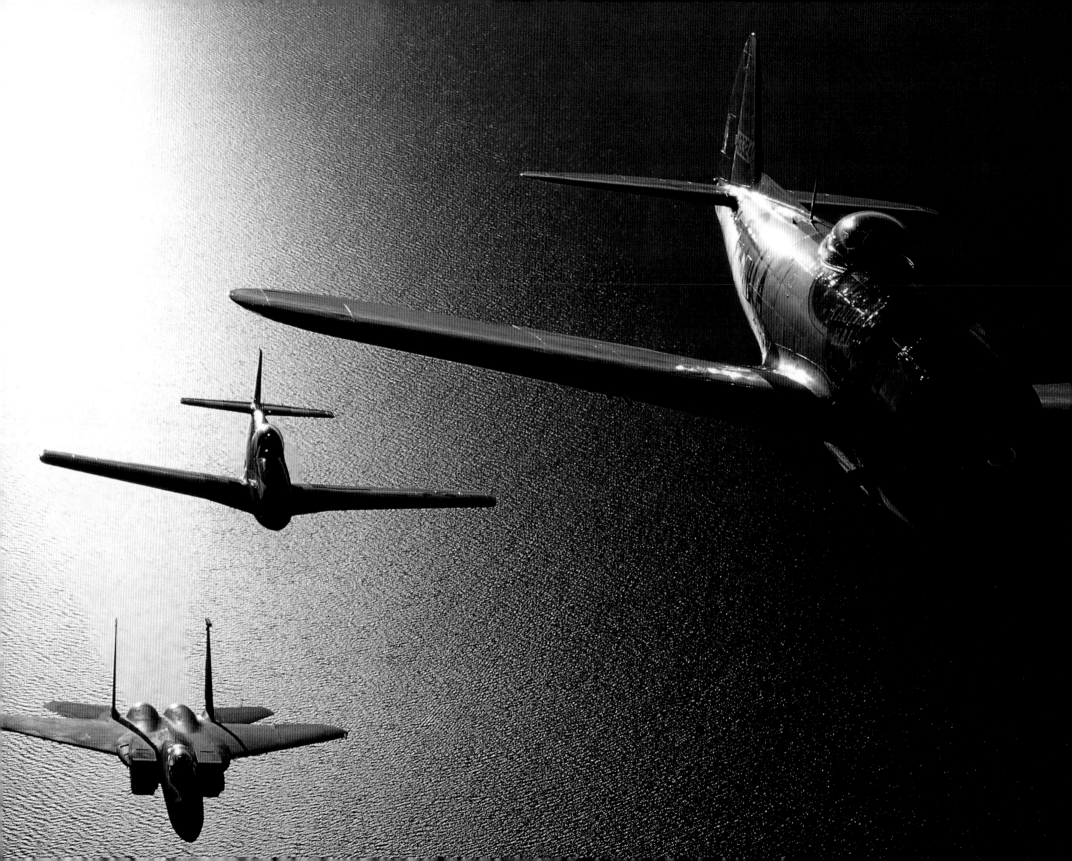

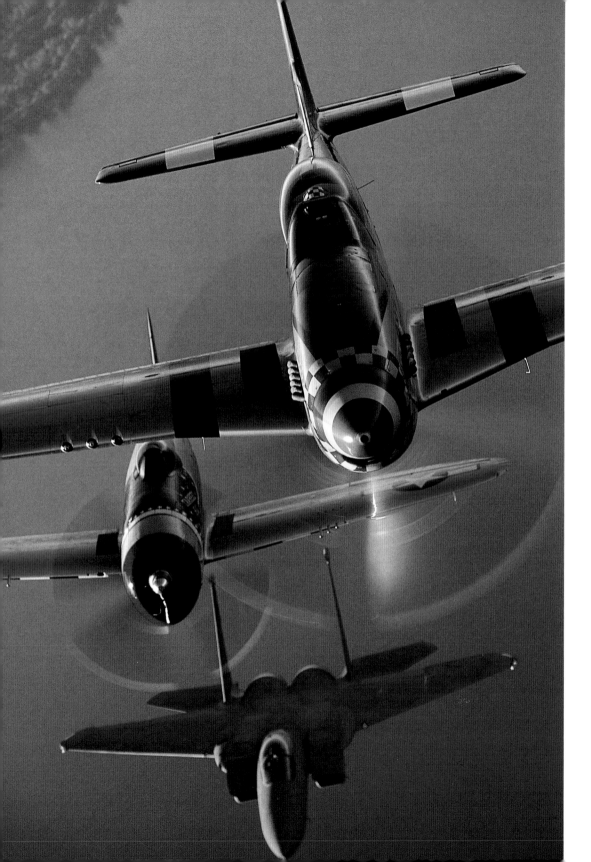

The effort was monumental. In the period between 1939 to 1945, the U.S. produced 300,000 airplanes and 16 million souls were involved either in building or flying this air armada against the axis powers. The U.S. emerged from WWII as the leading air power of the world and has maintained that position to this day. It has not been easy. With the end of every battle in the cold war, the U.S. Air Force was downsized while its commitments in many ways have been increased. The result has produced a difficult time in attracting and maintaining the kind of people required to deal with the sophisticated machines today.

In an effort to confront this problem, the U.S. Air Force initiated a program to focus the public's attention to its glorious past and its remarkable present. The program known as the Heritage Flight involves pairing old fighters with modern jets in formation at air shows across the country. Several individuals with WWII fighters were asked to participate in the program. I was one of the fortunate few. I am impressed with the direct professional manner in which the program is administered. All the participants are required to attend an annual briefing and seminar touting the significance of the program and the manner in which the flights are to be conducted. A Briefing Guide and a program manual covering all of the actions expected of the participants is presented. On an annual basis actual formation training is conducted. Each civilian participant is qualified and required to maintain proficiency.

Flying a P-51 in formation with an F-15, F-16 or an A-10 is a dream in itself. The job is difficult because of the dissimilarities of the aircraft. An F-15 pilot for instance, needs only to think of advancing the throttle before he has exceeded the capabilities of the old airplane flying next to him. Formation references are different for each of the airplanes. Fortunately, the active Air Force pilots are all

Opener: A sweet-light formation of Tom Gregory in the Lone Star P-47 flying a loose lead to Reg Urschler's P-51 Gunfighter and the Eagle flown Capt. John York, know to all as Screech. Left: A slight variation of the same three aircraft bringing it all in a little tighter.

designated demonstration pilots whose primary mission is to perform at air shows so that the public may understand the ultimate capabilities of these airplanes.

The experience in participating in the Heritage Flights has been very rewarding, especially interfacing with pilots and their dedicated maintenance crews. It has renewed my faith in the capabilities of the modern Air Force and its fine young members. It is a very different Air Force than the one that I retired from in 1970. Candidly, I believe that the leadership challenges today are far greater than we experienced in the past. There are no perceived major threats to our country's national security today. In the cold war we had a very active and aggressive opponent with nuclear capabilities.

The modern military is expected for perform super-human tasks in every corner of the globe. It is expected to prevail in a strange kind of war where the public expects some remote button be pushed and have only enemy buildings and bridges destroyed. Heaven forbid that any one of our foes be killed. This is a disturbing scenario to a cold war warrior who still understands that the pilots flying today over Iraq are performing a dangerous mission with little recognition or appreciation from our countrymen. Another unsettling aspect of today's environment is the fact that modern communication has made possible a centralization of command and control that was unheard of in WWII and in my mind is still undesirable.

I am happy to remind air show audiences of the sacrifices made by so many young men so many years ago in these old airplanes as they gave their lives to preserve our freedom. My association with the young members of the Air Force has given me the opportunity to see first-hand their dedication, competence and the sacrifices that are made on a daily basis. Sacrifices that are not often understood, acknowledged or appreciated by Americans from the President on down

–Col. Frank Borman, USAF Ret.

The Heritage Program: An Air Force Pilot's Perspective

What's it like to fly just off the wing of America's aviation legends for two years? Inspiring. Breathtaking. Humbling.

My name is Captain John York and I am one of two U.S. Air Force F-15 demonstration pilots. As an instructor pilot, I have over 1200 hours of F-15 time and more than 2800 hours in high performance jet aircraft. But nothing I have done in the Air Force prepared me for the two years I've recently spent flying in close formation with some of the world's finest vintage World War II fighter aircraft in front of millions of awe-struck air show spectators all over the world.

Nothing can describe the surge of adrenaline and pride for our nation that I feel each time a beautifully restored P-51 Mustang pulls to within three feet of my F-15's wing; or the roar of the Merlin engine's 1,800 horsepower that you can actually feel while inside the cockpit of the F-15 Eagle.

And I won't even try to describe what it's been like to spend time and fly with the incredible group of civilian pilots, test pilots, former Apollo astronauts, world-renowned air show pilots and aviation legends who provided the warbird portion of the Heritage Flights.

The Heritage program was initiated to help celebrate the Air Force's 50th anniversary celebration at Nellis Air Force Base in Nevada in 1997. Largely by coincidence, I was there to witness the first-ever formation flight of an F-15 Eagle with a P-38 Lightning, an F-16 Falcon with a P-51 Mustang, and an A-10 Thunderbolt with a P-40 Warhawk.

The Heritage Flights proved to be so popular that the Air Force expanded the concept and continues to support the program to this day. As a result, air show audiences throughout North America and Europe have been captivated by the inspiring sight of America's aviation history presented together with today's most sophisticated military technology. I will always look back on flying Heritage formations with my aviation heroes as the very best experiences that I ever had in the US Air Force.

What is it like to be a Heritage Flight F-15 pilot? Awesome. Simply Awesome.

–Capt. John York USAF

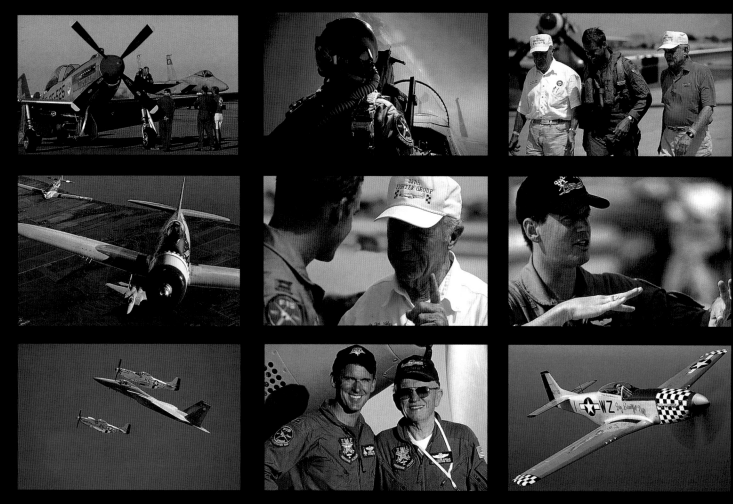

Above left shows Stockton where Snort Snodgrass, Frank Borman, Duck Duckworth all confer with Bill Anders to track down a prop issue. Screech dresses the part for the pre Heritage F-15 Demo. Capt. York walks with the legends; Bud Anderson and Chuck Yeager. Screech gets a few pointers from Chuck Yeager. Ed Shipley shooting at his watch again. Yeager, York and Anderson over Oshkosh. Frank Borman and John York take a moment at Stockton. Ed Shipley in Big Beautiful Doll over Cleveland where he flew with Duck in the Viper. Opposite come from that same flight over Lake Winnebago. Here, Tom Gregory and Screech compare sizes.

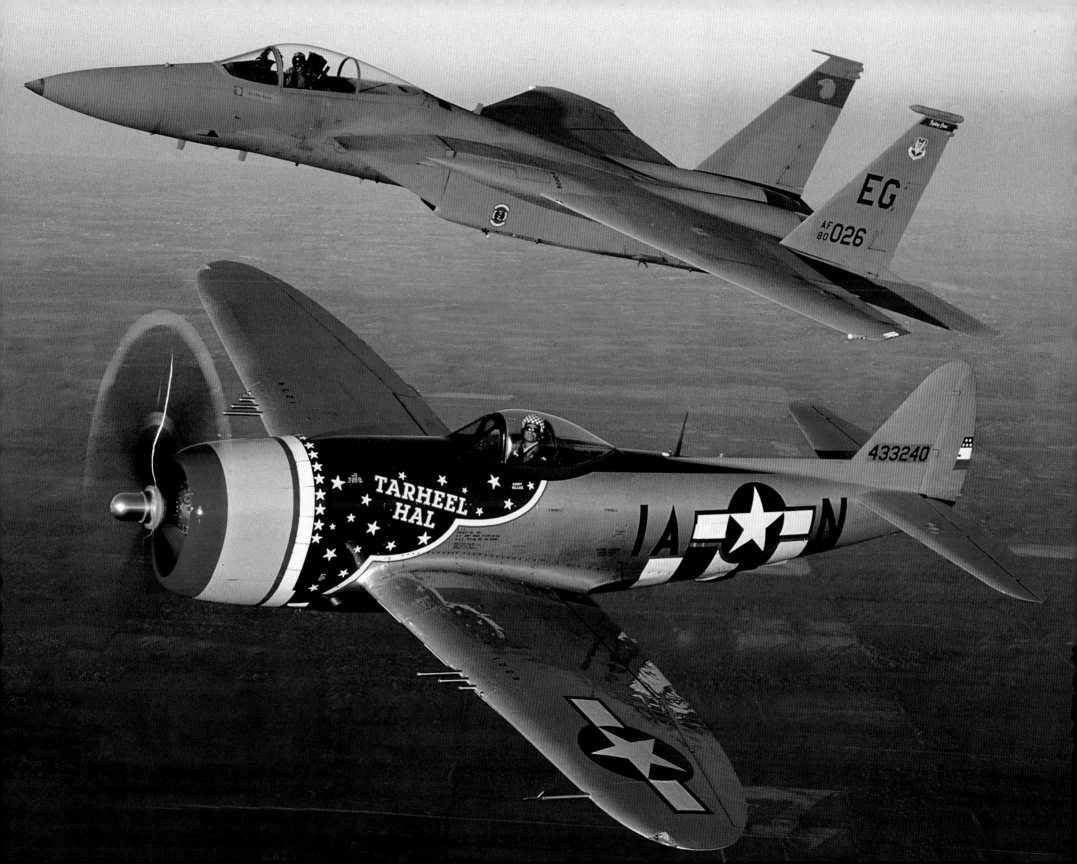

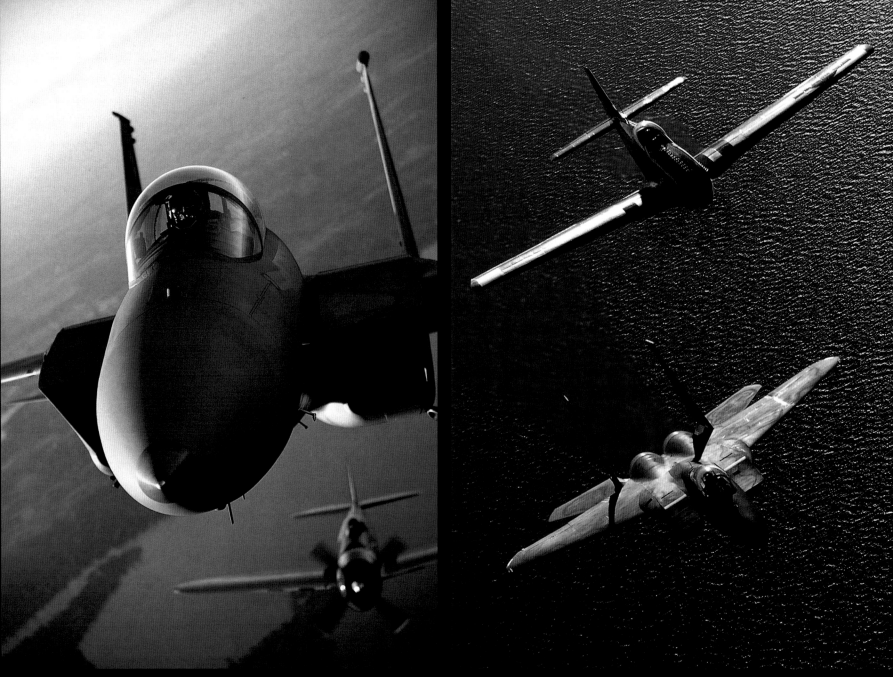

Above: Staring down the throat of the Eagle. Tom Gregory puts the coals to the Jug to catch up with Screech. Right side shows Reg and Screech turning fuel into flames as the heat signature from each airplane bends the light behind them. Opposite: A nice study in the form of the F-15.

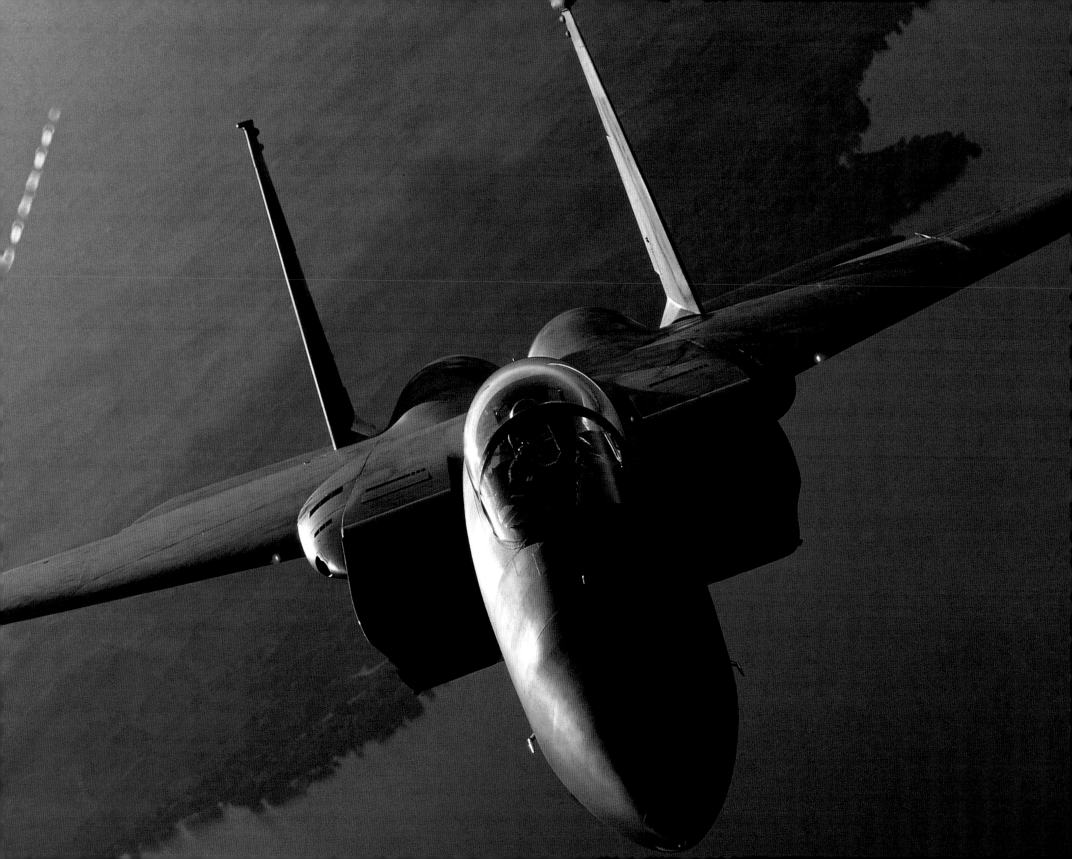

CANADIAN
SNOWBIRDS

The Canadian Snowbirds fly their grand formations with such majesty and grace that American audiences are reminded that military jet demonstrations are not only about brute thrust and noise, they are also about precision and splendor.

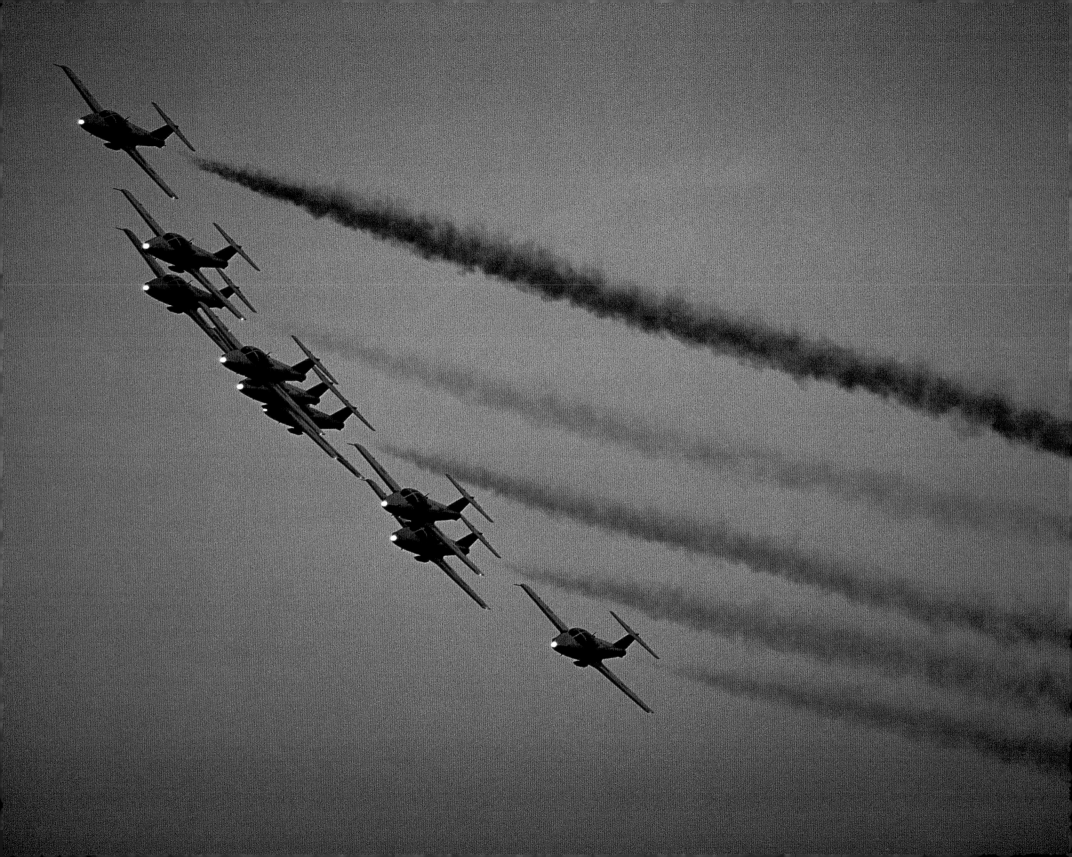

Like the flocks of Canadian geese that migrate though North America every year, so too do the Snowbirds arrive each summer, charming air show crowds from coast to coast.

It is by virtue of the aircraft they fly that the team has developed into the gentle giant of the circuit with a lullaby rhythm. The Canadair CT-114 TUTOR has been the mainstay of the Canadian Forces since 1963 and has been used extensively for everything from primary flight training to advanced maneuvering. Weighing in at about 7000 pounds, the TUTOR is powered by a single Orenda Z-85 jet engine that generates a seemly 2700 pounds of thrust. This modest thrust-to-weight ratio means the CT-114 has a much narrower performance envelope than a jet with larger after-burning engines. Flying the TUTOR in large aerobatic formations is therefore extremely difficult since lesser performance requires more skill and concentration on the part of the pilot.

Whereas the Blue Angels have a full complement of support personnel and their own Marine C-130 with which to ferry parts and people, the Snowbirds travel with only what they can carry onboard. This means that each demo pilot transports his own aircraft crewchief along with both men's personal effects as well as their share of the team's most common replacement parts. On arrival day at show, it is almost like watching a clown car at the circus as shoes, spare parts and clothing are pulled out from every nook and cranny. When you look at the huge pile of gear that they manage to cram into each jet, you realize that flying isn't the only talent they have. They could almost be called the Canadian Packrats.

All kidding aside, these nine pilots are truly expert formation technicians. Regularly executing the only nine-plane formation takeoffs and landings in the world, the team more than compensates for their diminutive jets. At Wings Over Stockton, I was invited to fly along on a media flight where I was afforded the chance to fly in the #7 position out on the left side of the formation. During the flight I was amazed by just how visually confusing it was to be flying amidst so many aircraft. The takeoff was one of the most unnatural maneuvers I have ever experienced with the noise, jet wash and overlapping wings all contributing to a near chaotic opening sequence.

Once airborne however, the flight seemed quite routine for Maj. Ian McLean who chatted effortlessly with me about the different formations he was demonstrating. Our intention was to fly from Stockton out to the Golden Gate Bridge for some pictures, but as we approached, it was clear that the notorious San Francisco weather was not going to cooperate. The bridge was totally obscured by the marine layer of clouds, so #1, Snowbird Boss Maj. Bob Painchaud took the flight to the north. We did a series of slow wing-overs and steep turns and then we were allowed a few minutes where each of the team members actually let their media passengers fly the jet. Seeing the formation from inside the airplane gave me an even greater appreciation for the discipline and skill required to fly within a massive aerial arrangement.

Sadly, the Snowbirds have recently been threatened by the likely disestablisment of the squadron as the Canadian government is moving to retire their entire Tudor fleet as a cost saving measure. While the next generation of aircraft slated to replace the aging CT-144 has yet to be announced, one thing is for certain, the extinction of the Snowbirds would forever alter the character of Canada's influence on the Great American air show.

Opener: A late day performance at Wings Over Stockton. The Snowbirds have long been famous for their unique brand of gentle aerobatic maneuvers. Right: On the ramp at Oceana, the team is poised to begin the march down to their TUTOR jets.

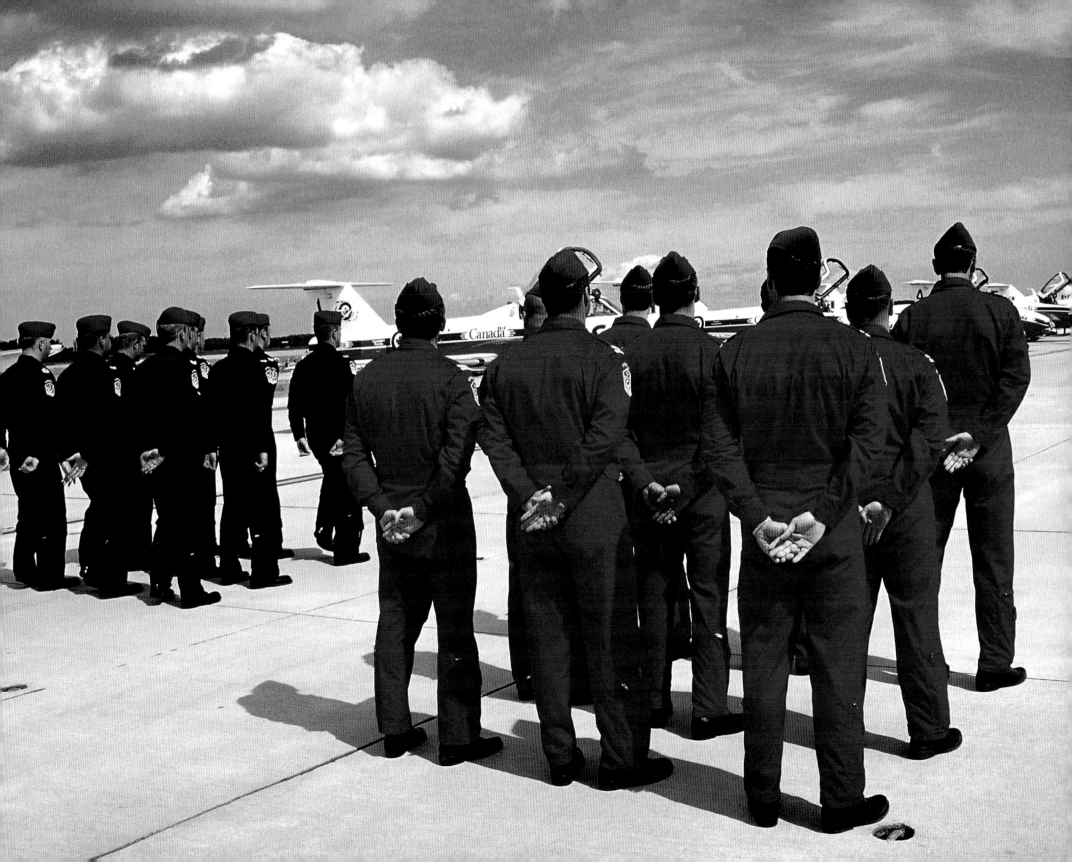

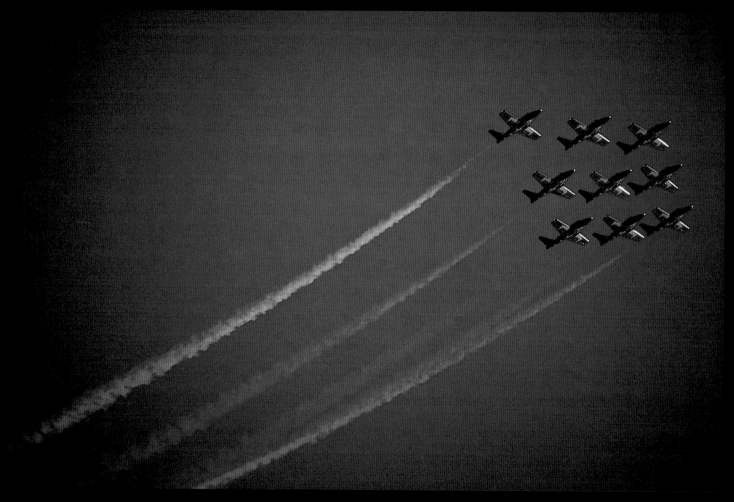

Unlike the Blues, the Snowbirds have just a single crew chief for each airplane. The opposite page is an inside view the #7 jet with Maj. Ian McLean during a media FAM ride over the back country of Marin county in Northern California.

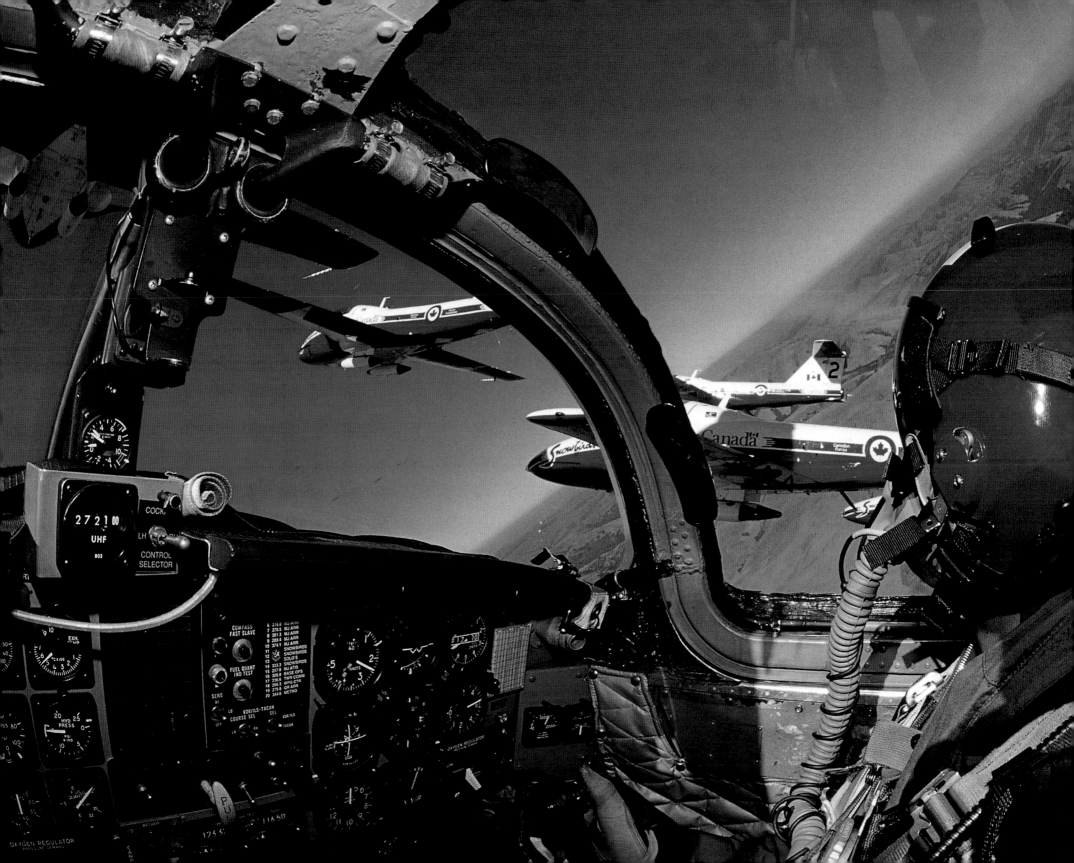

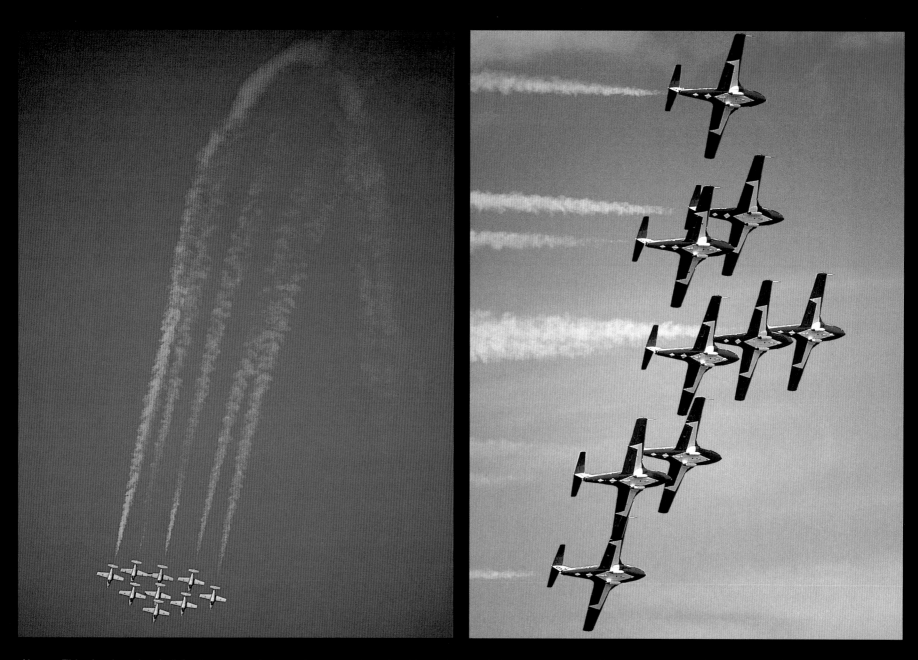

Above: This shot is a visual cliche that every photographer has to take, but it's pretty nonetheless. There are no filters on that frame, just the liquid light a few short minutes before sunset. Opposite Left: It is a rare site to see both the Snowbirds and the Blues parked on the same ramp, but this year at Oceana, the crowd was treated to the performances of both legendary teams. Top Inset: The ramp at Oceana as the team taxis onto the active runway. Bottom Inset: A simple image of beauty with all nine TUTORS carving the same line.

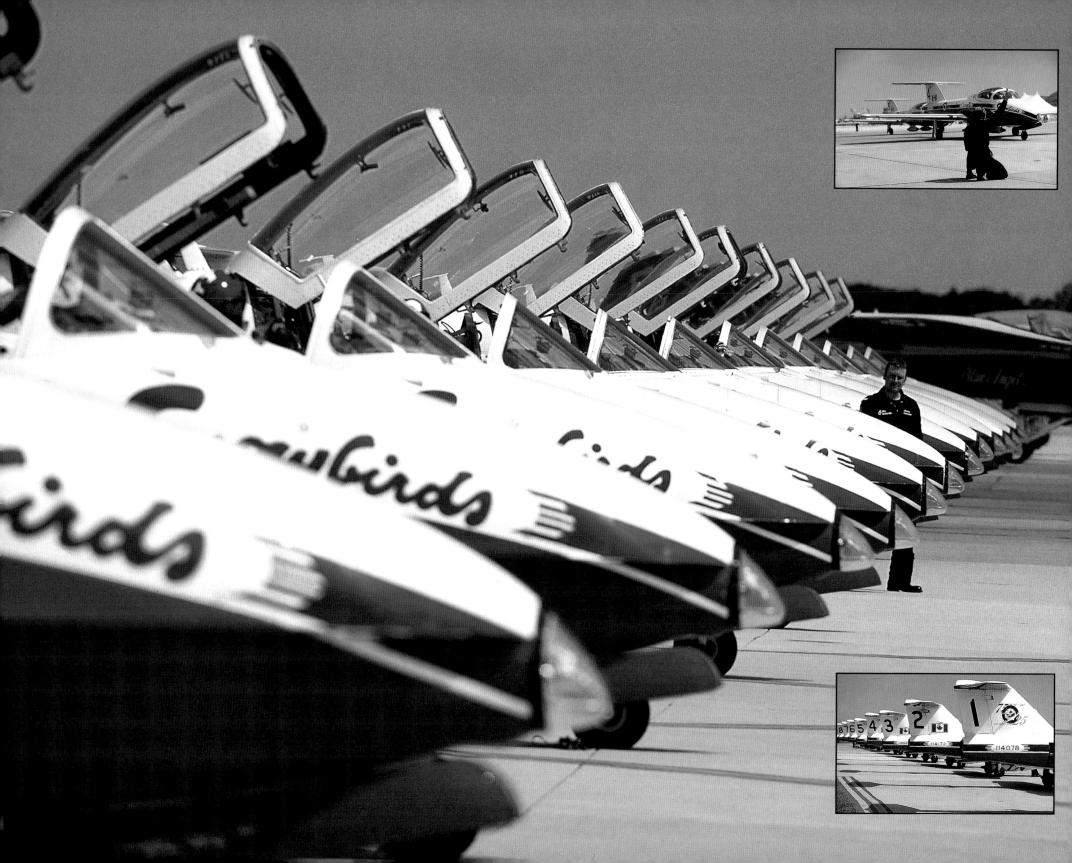

WAYNE
HANDLEY

In this competitive business built on talent, innovation and creativity, Wayne Handley has long been one of the pivotal forces influencing the course of the air show industry.

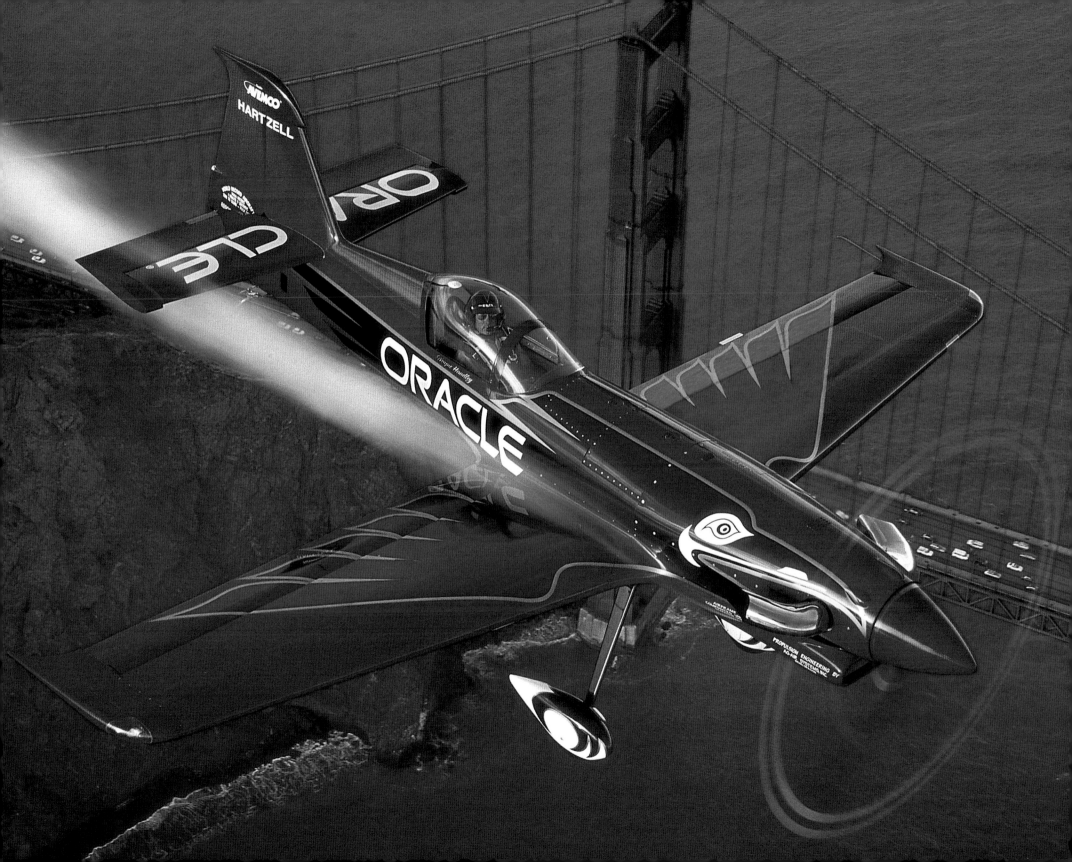

From his early years spent pushing the physical limits of the sport to his more recent spree of record setting accomplishments, Wayne is living proof that there is no substitute for experience.

In the world of aerobatics performers, Wayne Handley is a study in contrast. A soft-spoken ex-crop-duster with the rugged good looks of a cowboy, he is truly the last of a vanishing breed. Although very much a solitary man, he is pleased to play father figure to aspiring young performers in spite of an airplane tragedy that took his own son. Yet the noble and quiet persona he exudes on the ground is sometimes hard to connect with the aerial extremist he becomes in front of the crowd. Wayne Handley is clearly a man who lives to perform. Laughingly narrating the flights from the cockpit, he is the ultimate showman, bent on leaving the crowd begging for more. "I want to just grab 'em and entertain 'em," he says. "And get out."

Born in Carmel, California in 1939, Wayne came to show business late. A brief stint as a Navy utility squadron pilot led to a quarter century of crop-dusting over the rich farms of California's Salinas Valley. Yet part of Handley was not content with security. In 1983, he sold some spare aircraft parts and with the $19,000 bought a Pitts biplane. He flew off to his first aerobatics contest and placed 19th out of 21 contestants.

For a pilot with more flight time in the air than all of the people who beat him combined, it was humbling. For an aspiring performer who knew little about the world he was entering, it was eye opening. For all of the disappointment of that first contest, Wayne saw that while these other pilots were all fierce competitors in the air, they were a kind bunch on the ground. He was drawn to them and admired how they shared virtually everything from spare parts and tools to constructive criticism to help keep each other flying safely and staying alive.

His crop dusting business back in Salinas bloomed into a circle of performers. A young helicopter pilot named Sean Tucker and another named Rocky Hill both quickly surpassed Handley in aerobatic competitions. But Tucker and Hill were flirting with danger. "They were flying way past the limits of their abilities," Handley says. "Back then they were loose cannons."

The three have remained close friends and competitors over the twenty plus years since then. At the Wings Over Stockton show this year, Wayne outperformed both pilots to the quiet surprise of his wife Karen and won a $35,000 cash prize. It was a truly sweet moment that meant a great deal to Handley, and he took great pride in reminding each of them with light-hearted pokes.

Handley's airplane, like the man himself, is unique. Designed and built totally from scratch, the Oracle Turbo Raven was made with one goal in mind; to set records. Wayne currently holds several world records including the most consecutive inverted flat spins - 78. But the one he had set his sights on to conquer in the Turbo Raven was the time-to-climb speed record. To achieve this, he constructed almost the entire plane out of carbon fiber and other super lightweight materials. Next he chose a powerplant that would not only provide the greatest thrust-to-weight ratio, but at the same time allow Handley to hold on to his record for a long time. The 750 horsepower Pratt&Whitney PT6 turbo-prop engine had both the power Wayne needed, and a price tag to put it out of reach of his competitors. "No one can afford to follow me." he says. Successfully clinching the record at Oshkosh this year means that Wayne Handley will be holding on to the record well into the next century.

Opener: One of my all time favorite images that was shot over the Golden Gate when we flew a late day photo flight out of Moffett with Tucker over downtown San Francisco. Right: Wayne during the Moffett air show getting ready to go circle the jumpers.

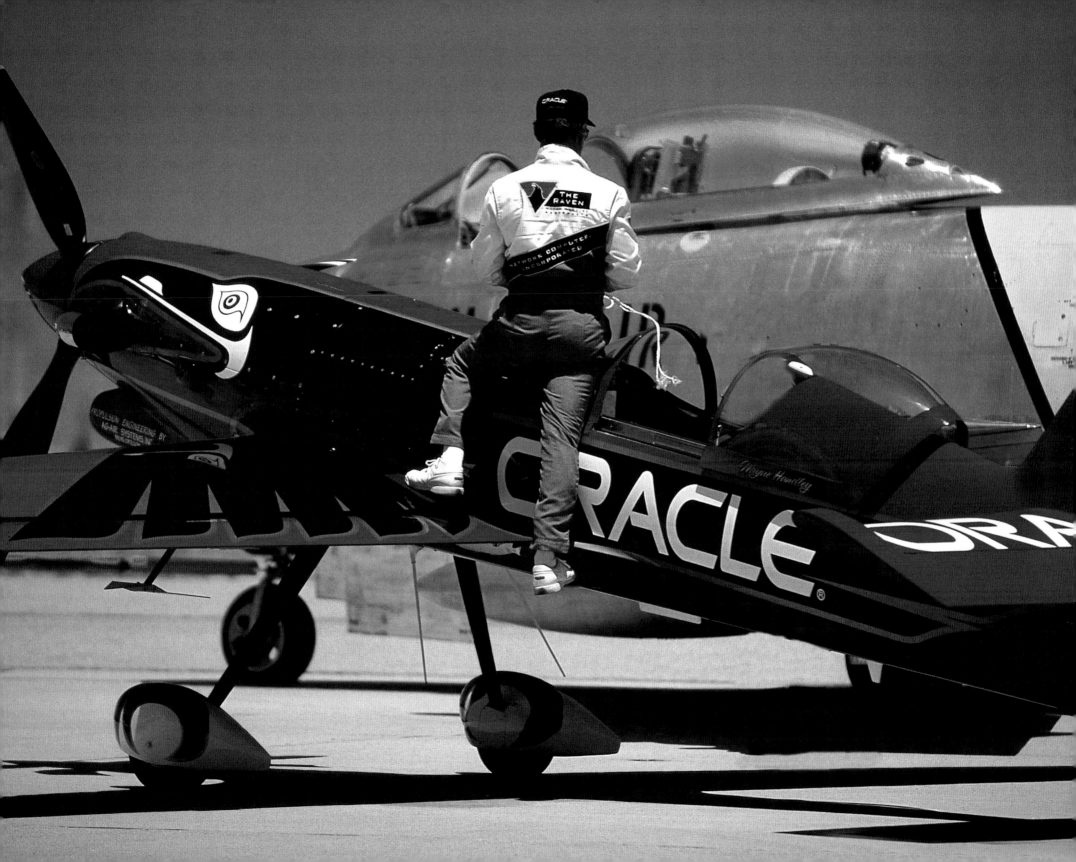

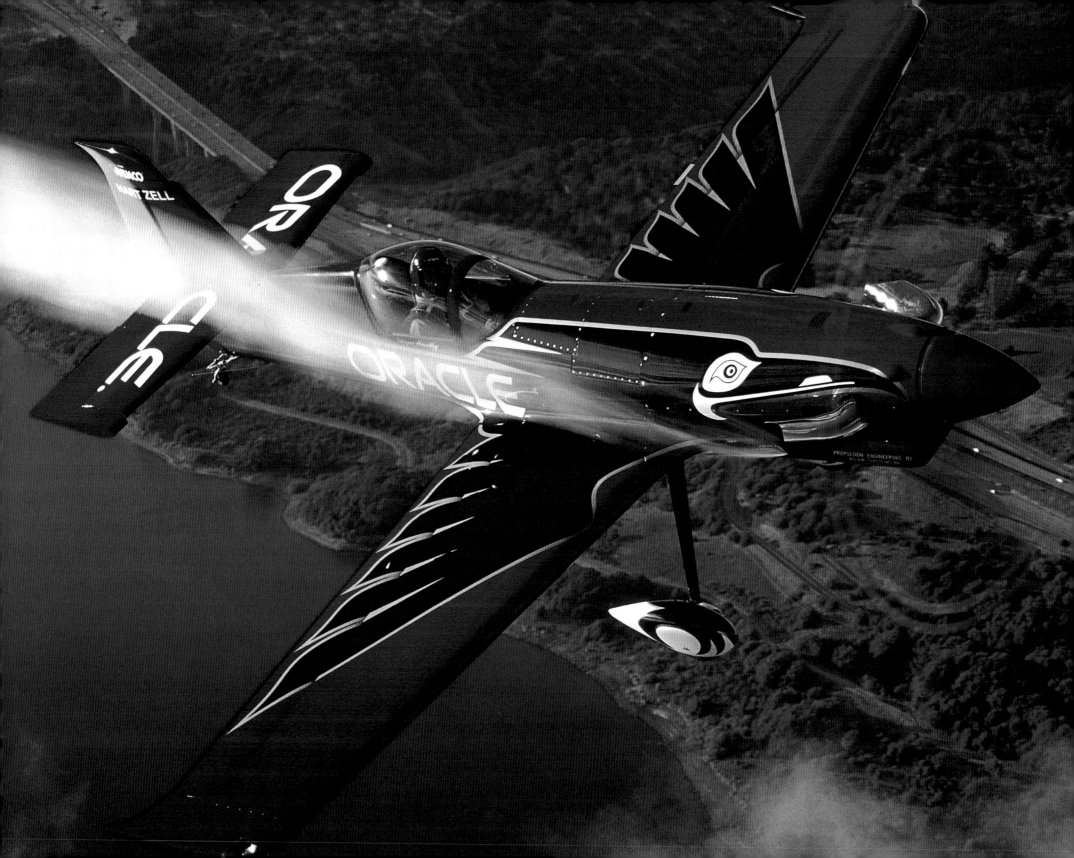

Opposite: The graceful lines of Wayne's hand built wonderbird. Above: The span of the huge prop that Handley swings with the PT-6. Right: A few pictures that help capture Wayne's world: his wife Karen, working on the Raven and playing jokes on the kids. He is a true one-of-a-kind and we are all grateful he's going to be around for a long time.

The Oracle Turbo Raven has captured not only the attention of the air show crowd, it has also helped Wayne to secure a place in aviation history with a new World Record time-to-climb altitude speed run. The shots above capture the beauty and brawn of this radical design. The left-hand picture shows longtime comrade Sean D. Tucker tucked in close behind the air show statesman. On the right, Wayne prepares to redefine fixed wing flight. Opposite: The Raven climbing aloft from the runway at Moffett field south of San Francisco.

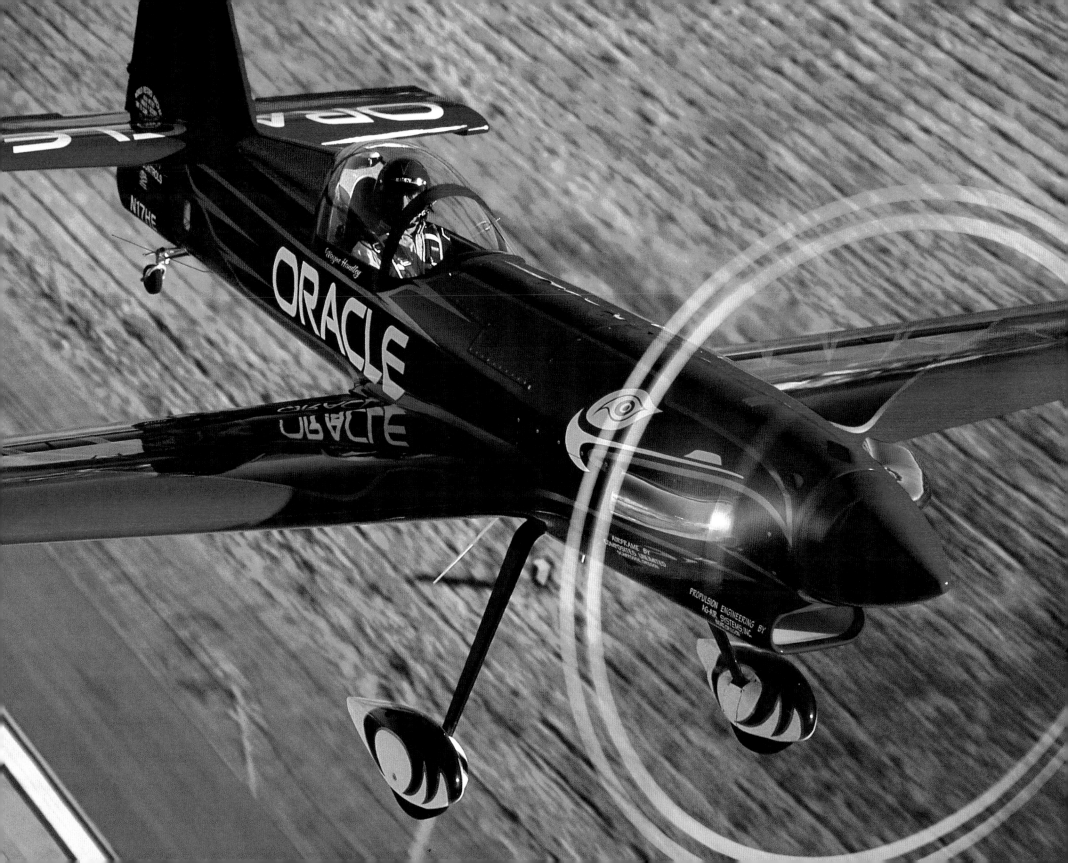

N.A.S. OCEANA/NEPTUNE
FESTIVAL

Bad weather is a fatal menace to the success of any air show. But this past September in Virginia Beach, show organizers narrowly escaped a disaster when Hurricane Floyd invited himself to the show.

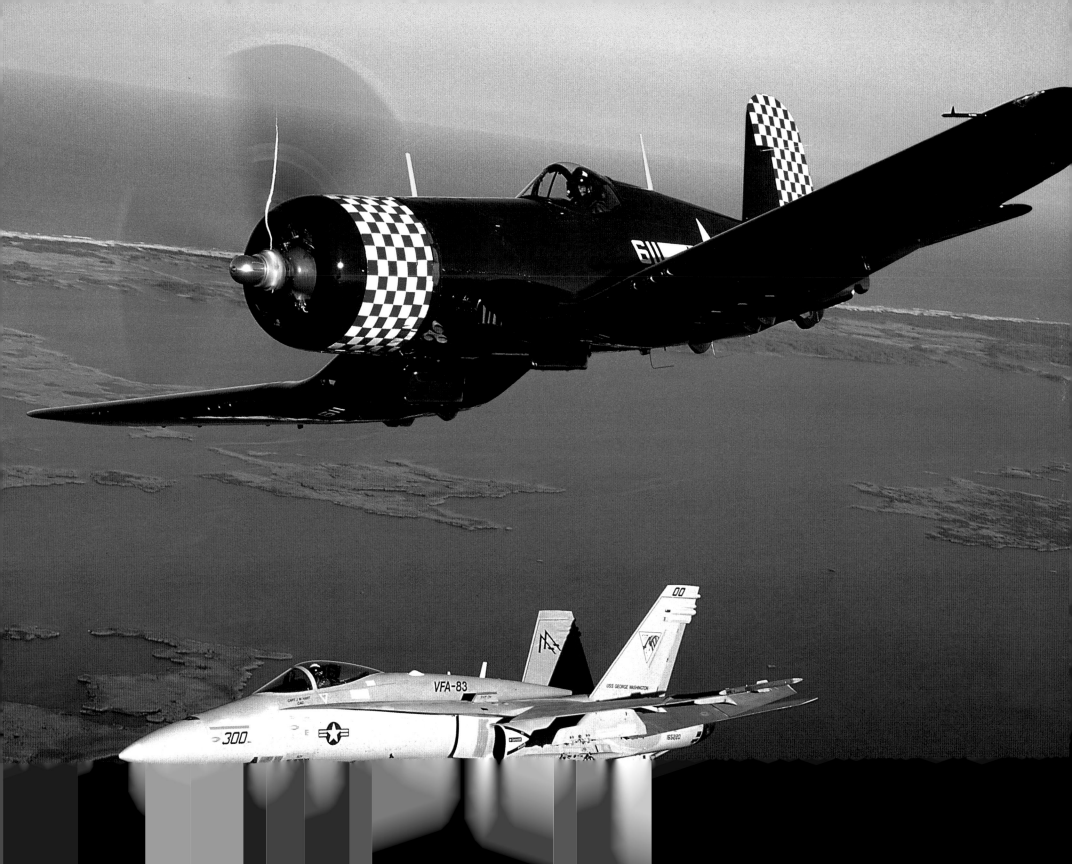

When I arrived on Tuesday to prepare for the Friday night spectacular that was scheduled to kick off the three week Neptune Festival, there was already a buzz in the air over an approaching hurricane. "Floyd," as the storm had been dubbed, was bearing down on the Mid-Atlantic States with virtually all of the forecast models predicting it would pass directly over the top of NAS Oceana just in time for the weekend.

For those who have never had the chance to attend, Oceana combines the punch and power you'd expect at a military open house with the excitement of a world-class aerobatics show. But all of that was now in jeopardy of being blown away as Floyd drew ever closer to show center. At first, the hope was that the storm would stall off shore and at least spare organizers the Friday practice and evening air show, but it soon became clear there was no stopping the storm's advance and everyone began pulling for a rapid arrival and departure.

As the U.S. Navy's Master Jet base on the East Coast, NAS Oceana already had both the Hornet and Tomcat demonstration teams on site. However, all of the performers, vendors and static aircraft that would normally arrive on Thursday were now forced to steer clear of the area. By Wednesday afternoon, authorities were calling for the evacuation of all low lying areas as well as the beachfront communities. With no choice but to improvise a plan to fit the constantly changing scenario, air show director

Debbie Mitchell and her Navy administrative team pressed forward to try and salvage what little they could of the weekend.

After evacuating the ocean front residence where I was staying and moving inland, I woke up on Thursday to the brunt of a Category One hurricane with little hope of seeing the sun for several days. I couldn't help but feel tremendous disappointment knowing how hard everyone had been working to pull together the epic lineup showcasing both the Blue Angels and the Snowbirds. But, by Thursday evening, the ferocious winds had died down and on the horizon, scattered clouds could be seen brushed with the bright orange glow of the setting sun.

At first light Friday morning, the base was already hustling with activity. The air boss' radio was alive with inbound aircraft and the static ramp area from one end of the runway to the other was swarming with vendors. The sky had the brilliance seen only after you experience nature's fury and except for a few downed trees and some pond size puddles covering sections of the roads on base, Floyd left few signs of his visit.

The Snowbirds arrived first and made a couple of site familiarization passes before landing. The Red Baron Squadron circled and landed next followed by paired members of the Blue Angels. By Friday evening, with the Blues on

the ground and lined up on the ramp next to their Canadian cousins, it was clear to everyone present that the show would indeed go on.

Saturday and Sunday were both mirror images of perfect Indian summer conditions. Right away at 9:00 a.m. the flying schedule kicked off with a local flight of the F-117 Stealth fighter. This provided the crowd with a rare glimpse of the start-up, taxi and take-off procedures of this aviation oddity. The Army's Golden Knights parachute team officially opened the show by jumping both the Canadian and American flags as the anthems of each country played. Circling the jumpers for their lengthy descent were the four members of the Red Baron Squadron in their red and white Stearman biplanes. The smoke and noise of this patriotic arrangement together with the cheers from the crowd set a truly emotional tone for the performances still to come.

On both days there was an eight-plane formation of Hornets and Tomcats scheduled as the Fleet Flyby to represent the squadrons stationed at NAS Oceana. On Saturday, I flew in the slot position in the back of one of the VFA-106 Gladiators two-seat Hornets. With Wing Commander Capt. John Leenhouts flying lead, this wedge of US Naval frontline tactical aircraft roared overhead casting a mighty shadow over the crowd as it passed. Shortly after the formation departed the area, a division

Opener: A portrait of naval heritage. In the Corsair is Dale "Snort" Snodgrass, a retired US Navy Captain who commanded all US domestic Tomcat Squadrons from right there at NAS Oceana. In the Hornet, Commodore John Leenhouts, also a Navy Captain is currently commander of all East Coast F/A-18 squadrons. Cut from the same bolt of ancient sailcloth, these two are truly two-of-a-kind. Left: F-104 Starfighters taking off in full blower.

of F/A-18 Hornets rolled in on the centerpoint of the runway and proceeded to demonstrate the low-level strike capabilities of Boeing's premiere self-escorted fighter/bomber. The rumble of the air as these jets maneuvered in such close quarters literally sent shivers up my back.

Similar to the Air Force's Heritage Flight program, the Navy embraces its glorious 200 plus year history by presenting what they call the Legacy Flight. At Oceana this year, circumstances provided a rare and significant opportunity. Dale Snodgrass is a recently retired USN Captain who previously served as wing commander to all domestic F-14 Tomcat squadrons and was based at NAS Oceana. He flew the Tomcat air show demonstration on and off throughout his 20-plus year career. For this show, he returned at the controls of a WWII vintage F-4U Corsair owned by the Kalamazoo Air Zoo. In the spirit of the Legacy program, "Snort" as he is known by callsign, flew lead in the Corsair with Commodore Leenhouts on his left wing in a Hornet and LT. "Cobb" Alcorn on his right wing in a Tomcat. The sight of those three mighty warplanes in the air together is one that stays with you well beyond their final flyby.

With the crowd temporarily contented with the yank-and-bank performances, the Canadian Snowbirds commenced their unparalleled nine-ship formation takeoff. No other jet demonstration team regularly executes such an impressive and demanding maneuver. As the Blue Angels are renowned for their high energy,

rock-and-roll brand of flying, the Snowbirds are lauded for their elegance and grace. In part by virtue of the modestly powered Tudor jets they fly, the Snowbirds have nearly perfected the art of aerial ballet. Instead of gripping the crowd with flashy high-G turns or screaming afterburner climbs, the Snowbirds almost entrance their audience with soothing classical music and beautifully arching loops and rolls.

Taking advantage of the gentle pace of the show at it's midpoint, air boss Dirk Hebert, call-sign "Gumbo," launches the Red Baron Squadron for their time slide back to the days of barnstorming. Long-time announcer Jerry Van Kempen takes the crowd back in time with his raucous colorful descriptions of young trainee pilots learning the maneuvers being demonstrated overhead by the airborne Barons. While a formation of slow flying Stearmans may not seem all that thrilling, the roar of the four propellers and the howling of Jerry's commentary raises the level of excitement enough to rival a jet team. As the Red Barons taxi back to their parking area, the crowd is on their feet and hungry for more action…and maybe some pizza.

Gumbo has a handle on this crowd and he gives the people what they want: noise and speed. There are only two flying F-104 Starfighters in this country and both of them are rolling down the runway for takeoff in full afterburner. For a spindly little jet, the Starfighter packs a hell of a punch. When you stack two of them side by side, their volume multiplies and it doesn't take long before you're sticking your fingers in your ears to keep from

going deaf. Because they have such a tiny wing and were originally designed as an interceptor, their wide-turning radius allows for short moments of calm in between the scorching high speed passes. These Korean War era fighters demonstrate the quintessential fighter jet shriek as they enter the overhead break for landing.

Rounding out the civilian headliners is Patty Wagstaff. With her brand new red and white checkerboard Extra 300, she paints patterns across the cloudless afternoon sky. Few performers can captivate an audience like Patty. She strings together a dynamic blend of raw power tumbles with precise and intentional beauty maneuvers to grab the viewer's attention and then pull them through to the completion of her performance. Her inverted ribbon cut always leaves me wanting more.

Finally, the stage has been set. The flightline is still and the air even more still. Without warning, the PA system booms with the thunderous voice of Lt. Keith Hoskins as he starts the chant that is his narration of the Blue Angels. Just as it has done hundreds of times before, Fat Albert opens the demonstration. This hometown crowd can hardly contain their pride and by the time the rest of Team begins their march to the jets, it seems as if the place just might spontaneously combust with all of the energy. The flight goes off without a hitch and while the team doubts it will ever fly a perfect show, their fans at NAS OCEANA sure thought it was perfect.

Top Left: Judge and Iron narrating the hometown Hornet crowd. F-104s get ready to taxi. Airboss "Gumbo" Hebert works the airspace. Hank Avery's Sky Raider with "Doc" Sinden and Tommy Hennessee goes "feet-wet." Snowbird Boss Bob Painchaud meets the crowd. Hank Avery's TB-M with Lites in trail over the bay. Snowbirds return. Patty and Suzanne get ready to launch. Blue jets lined up with white jets.

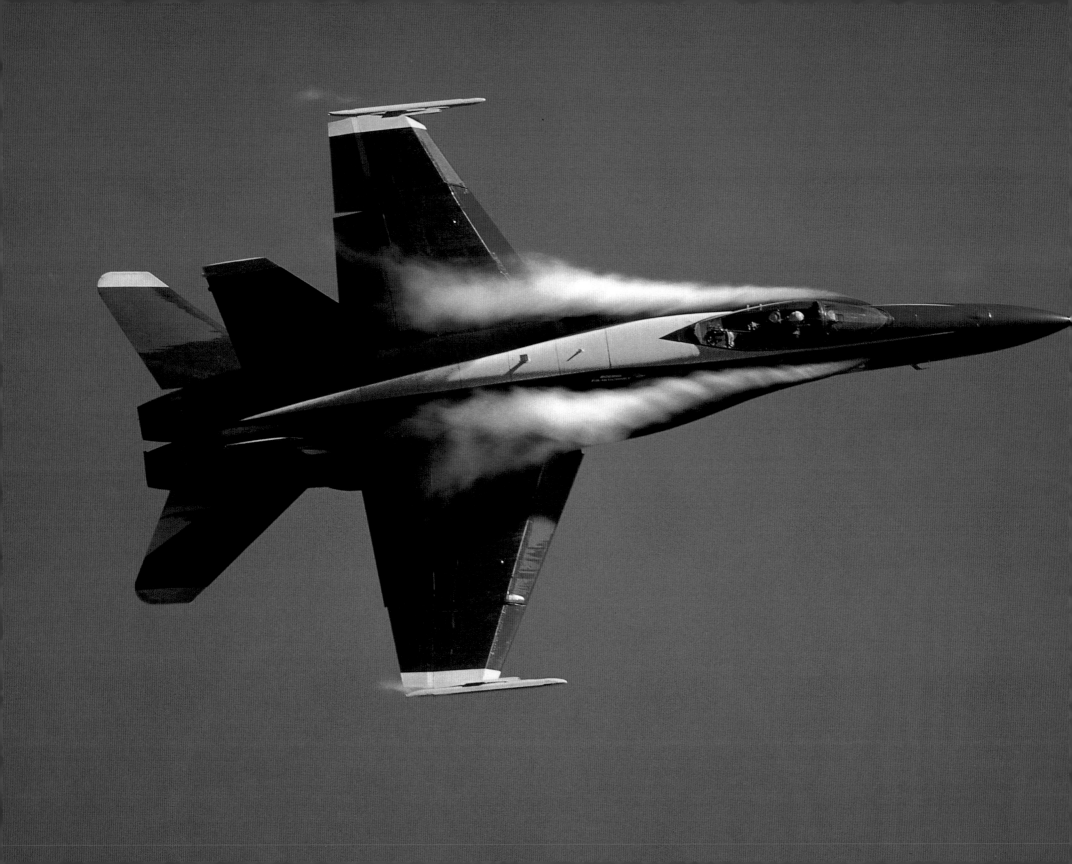

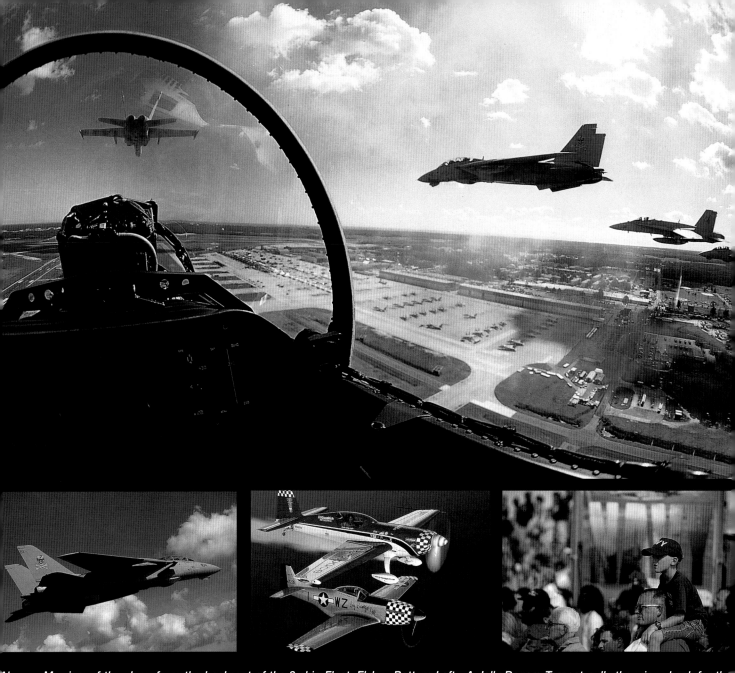

Above: My view of the show from the backseat of the 8-ship Fleet Flyby. Bottom Left: A Jolly Rogers Tomcat pulls the wings back for the
sharp looking pass. Bottom Center: Patty Wagstaff picked up a tag-a-long Mustang flown by Ed Shipley with Patty's crew-chic/ferry pilot
Suzanne Dodson in the back. Bottom Right: Passing on the fever, fathers and sons continue the tradition. Opposite: This image almost makes
me groan under the strain of the G oad. V8 pulls a solid 7.5 clearing the showline after the head-on 4-point roll.

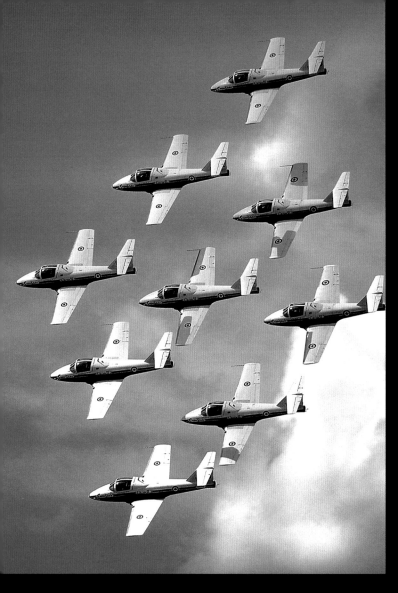
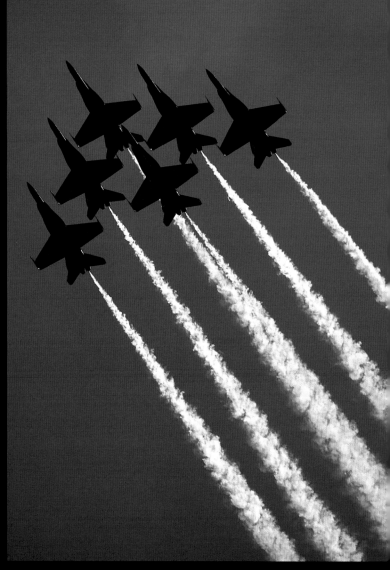

Above: Two very different shapes from two very differnt teams. Opposite: A Tomcat eclipses the sun during the holding pattern for the Fleet Flyby.

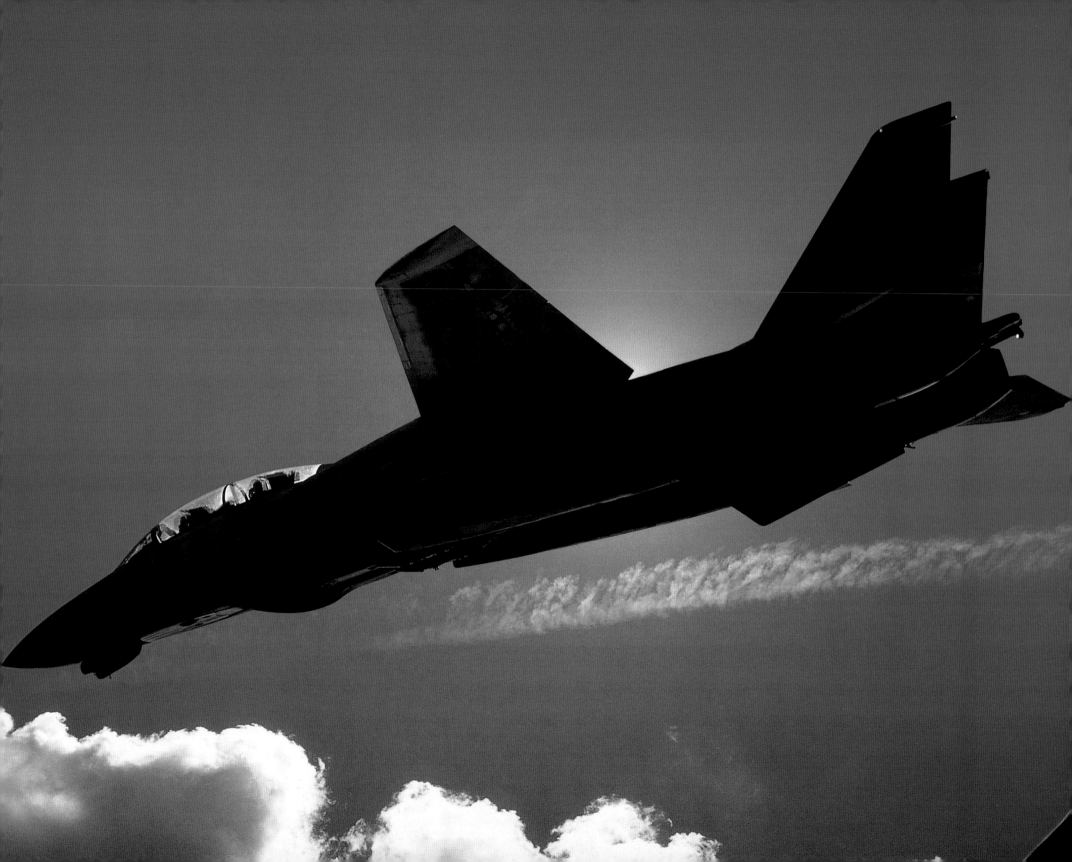

Above: The past, present and the future of the Great American air show. The Red Barons circle the Golden Knights for the opening flag ceremony. Opposite: A great head-on portrait of Snort Snodgrass at the controls of his very own T-6 in which he performs a dazzling routine.

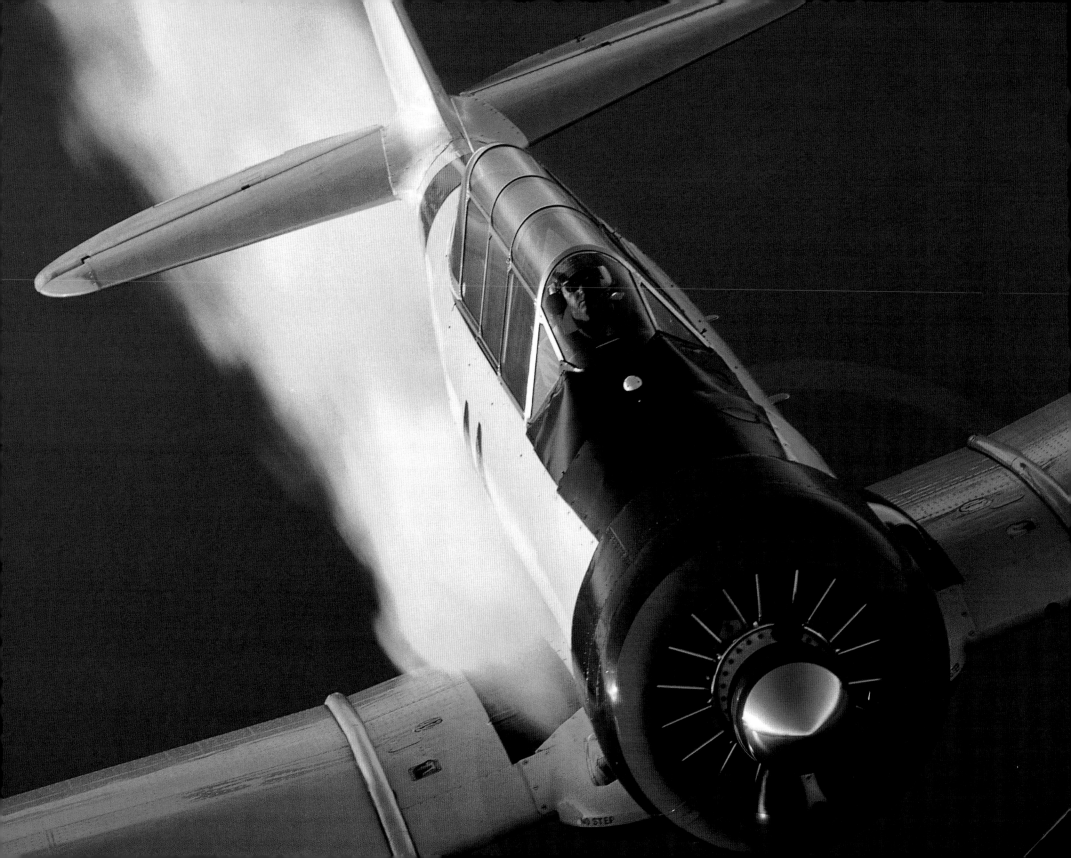

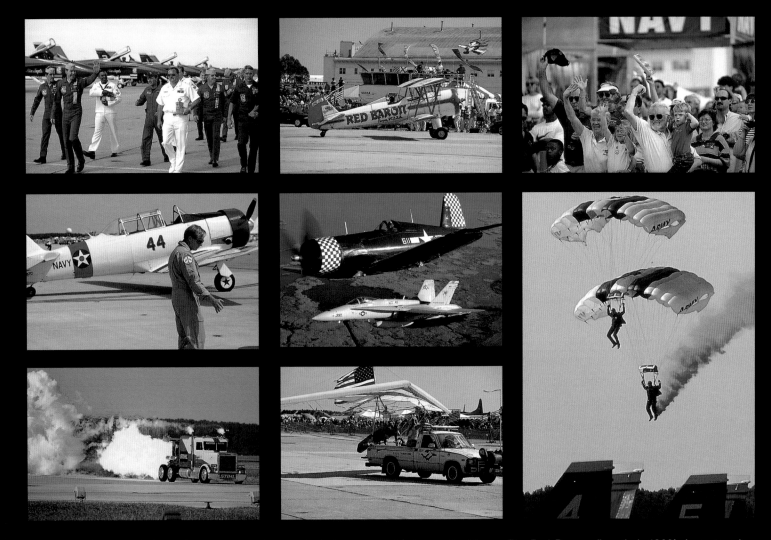

Top Left: The post flight audience meet-and-greet for both the Snowbirds and the Blues. The Red Barons flew their 1930's barnstorming show as a nice contrast to all of the heavy metal military demos. Nobody pumps up the crowd like the Blues do. At this mainstay installation of naval aviation, friends and families turn out en force. Snort walks through his performance maneuver visualization. Snort and Lites reeling in the years. Golden Knights prepare for touchdown. Not really an aerial air show attraction, Les Shockley has nevertheless made quite a popular spectacle of his jet-powered semi-tractor- ShockWave. Hang glider performer Dan Buchanan inspires crowds all across the country with his pyro shooting aerial rig. The disability of being confined to a wheel chair on the ground dissolves away as he carves slow powerful turns out in front of thousands of people.

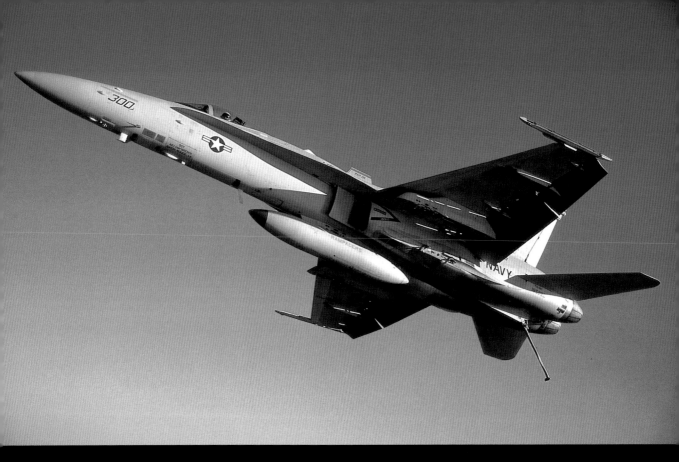

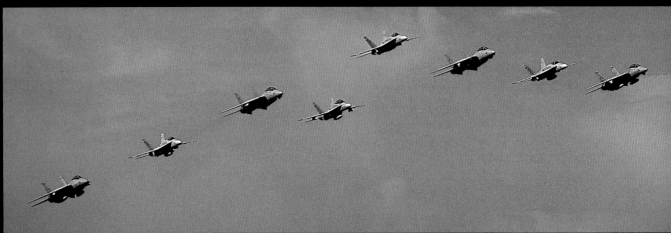

This page shows the Fleet Flyby as they roar past show center on day two of the Neptune Festival. This page top: Capt. John "Lites" Leenhouts with the tailhook down. Lites currently holds the world record for most carrier landings with over 1634 traps

PATTY
WAGSTAFF

She is the closest thing to perfect as she follows invisible, precise circles and sharp straight angles through the moist summer air. One of the greatest American aerobatic champions in history, Patty Wagstaff has retired from competition, yet she continues to fly as if winning is all that matters.

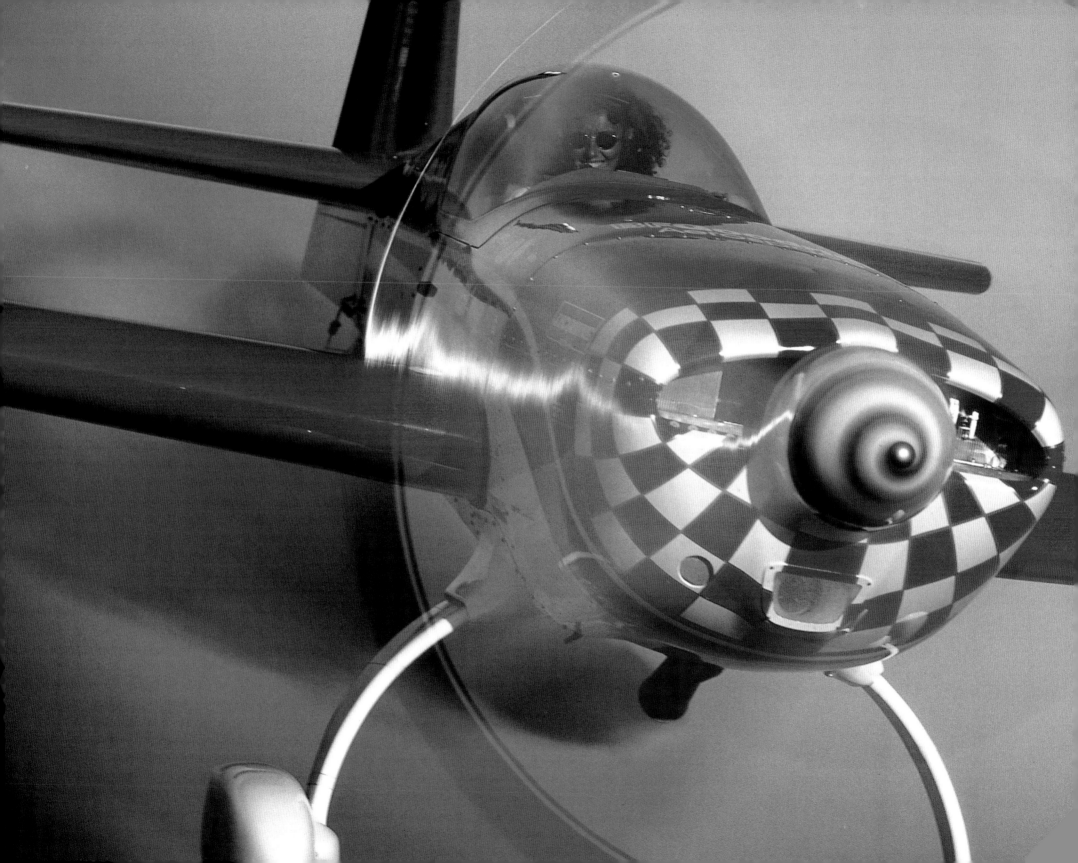

Twenty years after she first climbed into a cockpit, Patty's life seems in transition. She has achieved virtually every professional honor bestowed on an aerobatic pilot. Her familiar competition airplane, an Extra 260, now sits proudly on display in Washington, D.C. And while Patty is trying to enjoy life on the road, travelling from air show to air show, she admits she is thinking about doing something else; perhaps launching her own business. She recently settled into a house near the beach in Florida with a little green bird that she calls Buddha. The quiet pace and easy living of the Atlantic coast seems harder and harder to leave each weekend for the "been there, done that" world of air shows.

After two decades as one of the few top women in the sport, she is grooming at least one successor, troubled that women still occupy so small a place both in sport flying and aviation in general. "It bothers me that after all this time I'm one of the few role models," she says. "It bothers me that there aren't more doing it." Patty came to flying comparatively late, at nearly 30. The daughter of an Air Force father, she was a wanderer in the 1970s, studying and travelling across Japan, Europe and Alaska. In 1979 she took her first flying lesson in a Cessna 185 float-plane. She flew her first air show when she was 33.

"It doesn't matter if you don't know what you want to do. When the time comes that you're ready to accomplish something, you know," she says. "It's important to be really good at one thing because it means that people will take you seriously for the rest of your life." By 1985, she was good enough to join the U.S. Aerobatic Team. She has since flown with the team six times, won the U.S. National Aerobatic

Championship three times being the first woman ever to win it. In 1996, she retired from competition. The aforementioned plane with which she captivated the sport is on display next to Amelia Earhart's Lockheed Vega at the National Air & Space Museum in Washington, DC.

Patty's change in direction was spurred by a visit to an astrologer in 1996, who told her that for the first time she would enter a reflective

period in her life. "I spent so many years in hotel rooms and dumps, it was depressing," she says. "She told me it would be the only period in my life that I would be here, gathering the tools for the next stage of my life. So, right now, I'm kind of just kicked back a little bit. I'm kind of in between."

During this in-between period, two figures have entered her life: Buddha, a baby Green Cheeked Conure parrot, and a kind of apprentice named Suzanne Dodson whom Patty hired to ferry her new Extra 300. Dodson has already established herself as a fierce aerobatics competitor who tells me, "I want to be like Patty."

The wife of an Air Force F-16 pilot living in Georgia, Suzanne helps Patty with much more than just flying the Extra around the country. Her job is not the most glamorous in the business, but for an aspiring champion, getting to fly Patty Wagstaff's Extra can only lead to good things. Suzanne is much more than a ferry pilot for Patty; she usually arrives to the show sites early and arranges almost everything including picking up the rental cars and checking into the hotel. She conducts the pre-flight check, checks the oil and fuels the Extra, then briefs and organizes the fans that get to hold the poles for Patty's ribbon cut. She calls it "the best summer job in the world."

Patty's right, women are still the exception rather than the rule in aerobatics, just as they are in general aviation. Just six percent of American private pilots are women, according to figures from the Aircraft Owners and Pilots Association. Women make up only three percent of airline pilots. "We're on the cusp of a new century in flying and women still haven't achieved gender parity," says Bev Sharp, president of the '99s, the oldest organization of women aviators, founded in part by Earhart. "Patty is an example of just downright persistence and hard work. She came to it late. But in order to achieve, she worked."

On a hot summer day at Oshkosh, the crowd assembles for the afternoon performance. Wagstaff climbs into her Extra and zooms off out of view. Diving in from the left she pulls up into a crisp vertical climb. One thing is for certain, no matter what path Patty Wagstaff decides to follow next, she will forever have the satisfaction of having been not only the best female aerobatic pilot, but the best aerobatic pilot in the world.

Opener: Taken from Patty's Beech Baron that she had modified for taking pictures. There are two removable side windows and a small hatch in the floor to shoot directly down. The almost head-on perspective is achieved by Patty cross controlling her Extra so that the nose points toward the camera, while the direction of flight is held away from the camera ship. Right: A virtual plan-form of the Extra. She flew inverted directly overhead of Snort and I in his T-6 out at Oceana. Pretty slick. Right Inset: Patty with Parker the juvenile Mocking bird she found and adopted this spring. She taught Parker to fly and to fend for himself, then released him into the woods behind her house in Florida. He still comes around for food every once in a while.

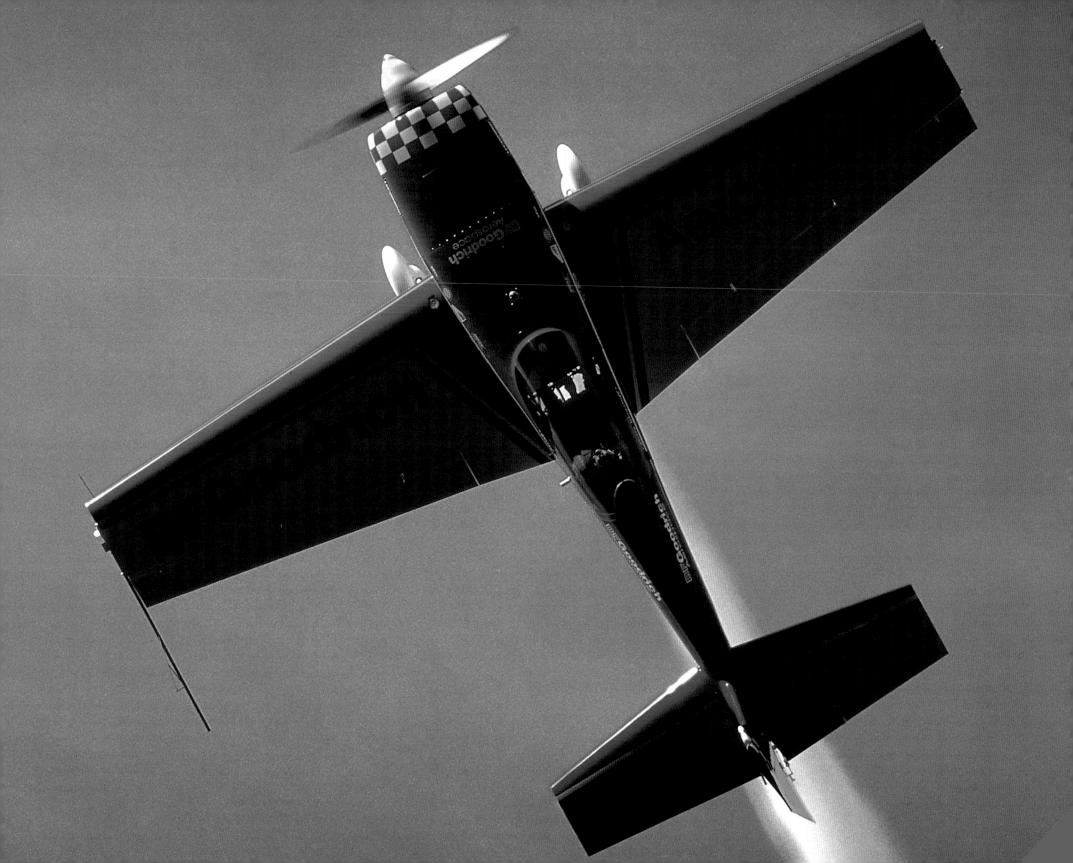

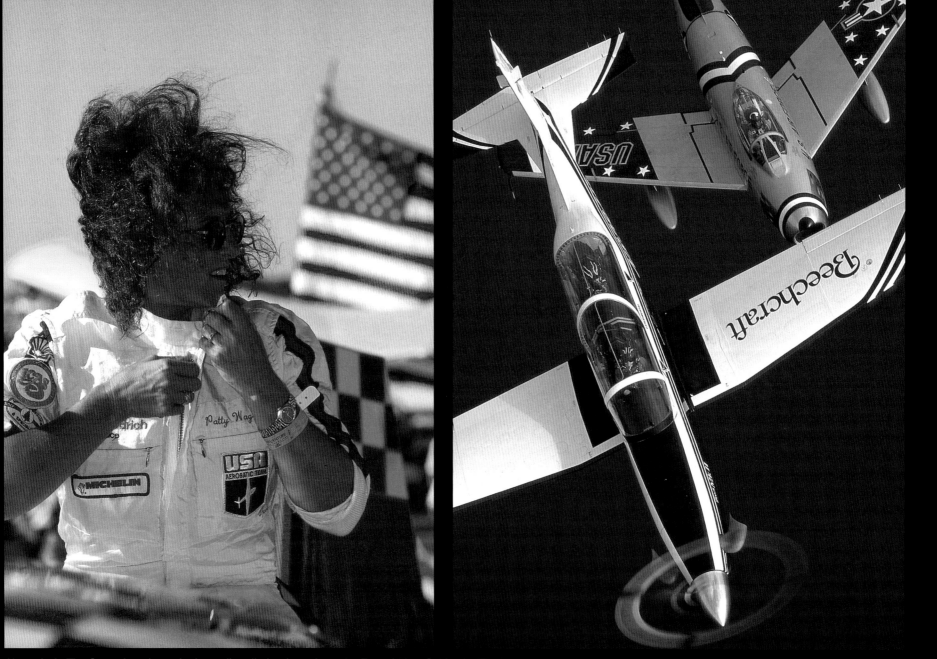

Above Left: The Great American air show pilot climbs down from the Extra 300 at Oshkosh. The image on the right is a very rare moment when Snort in the F-86 and Patty in the new Beechcraft JPATS trainer flew together out over the Chesapeake during the Andrews AFB show.

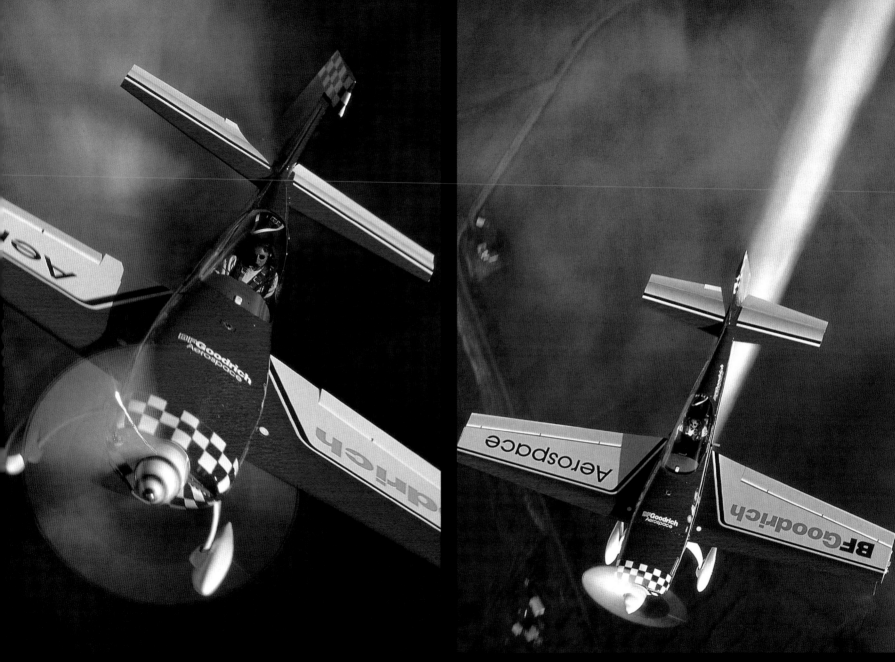

Above: Patty in the Extra as we zipped through the low clouds looking for breaks of sunshine.

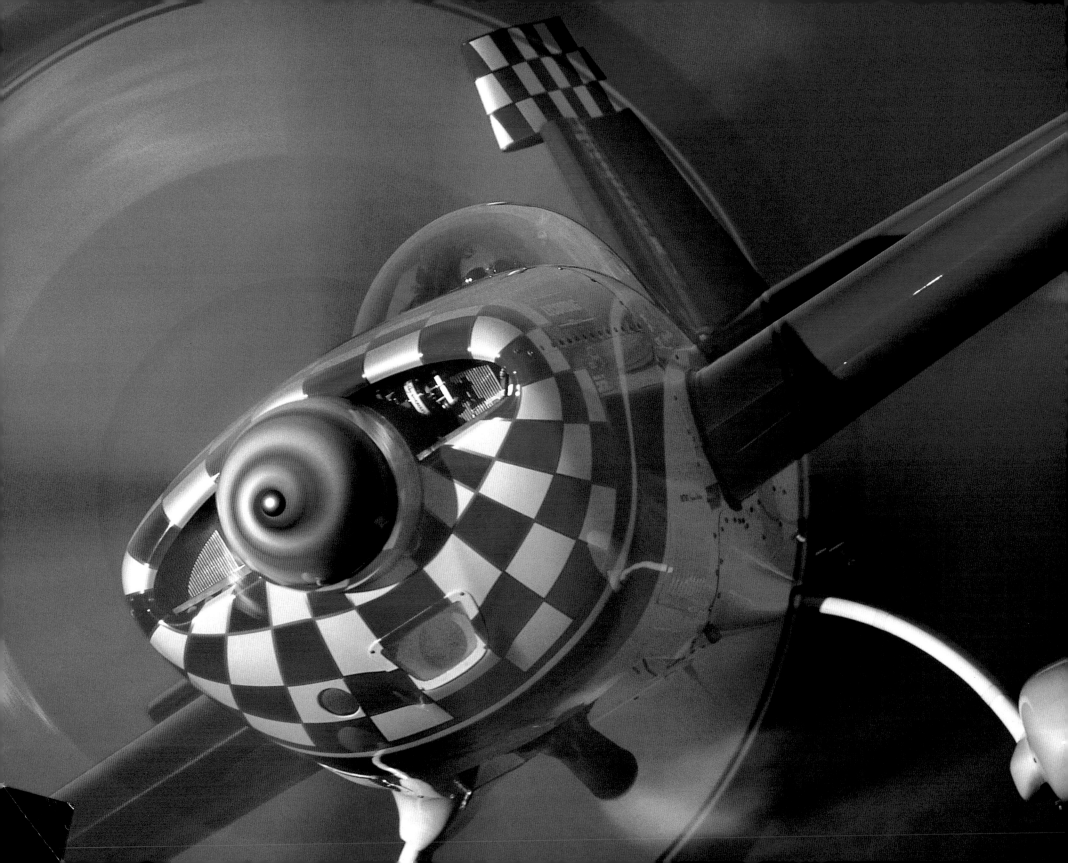

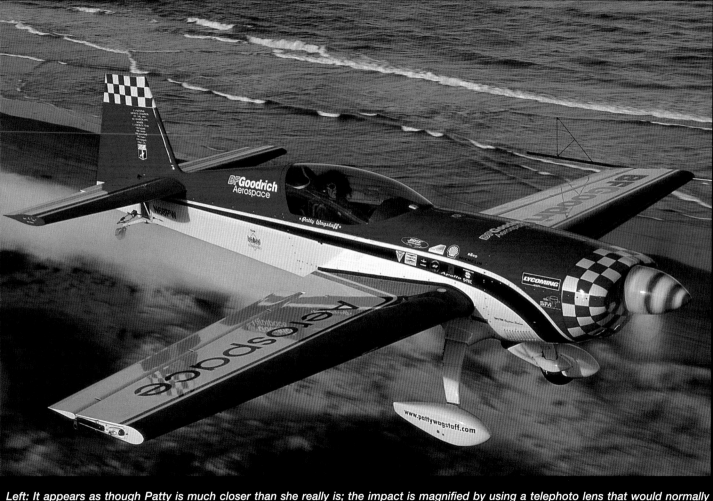

Left: It appears as though Patty is much closer than she really is; the impact is magnified by using a telephoto lens that would normally only be used on a tripod. The late afternoon sunshine was only occasionally peeking through the rain clouds, so the few moments when we did get sun we simply made turns around the hole in the clouds. Above: An image that Dale and I made from his T-6 as Patty buzzed the dunes over Sandbridge in Virginia Beach near Oceana.

MICHAEL
GOULIAN

Don't let the baby face fool you, Michael Goulian has more experience and raw talent than a lot of performers twice his age. He is a thirty-year-old powerhouse who has been around airplanes all of his life, competing professionally since he was only 18. Mike Goulian literally wrote the book on aerobatics. Well actually, he wrote an entire series called Basic and Advanced Aerobatics.

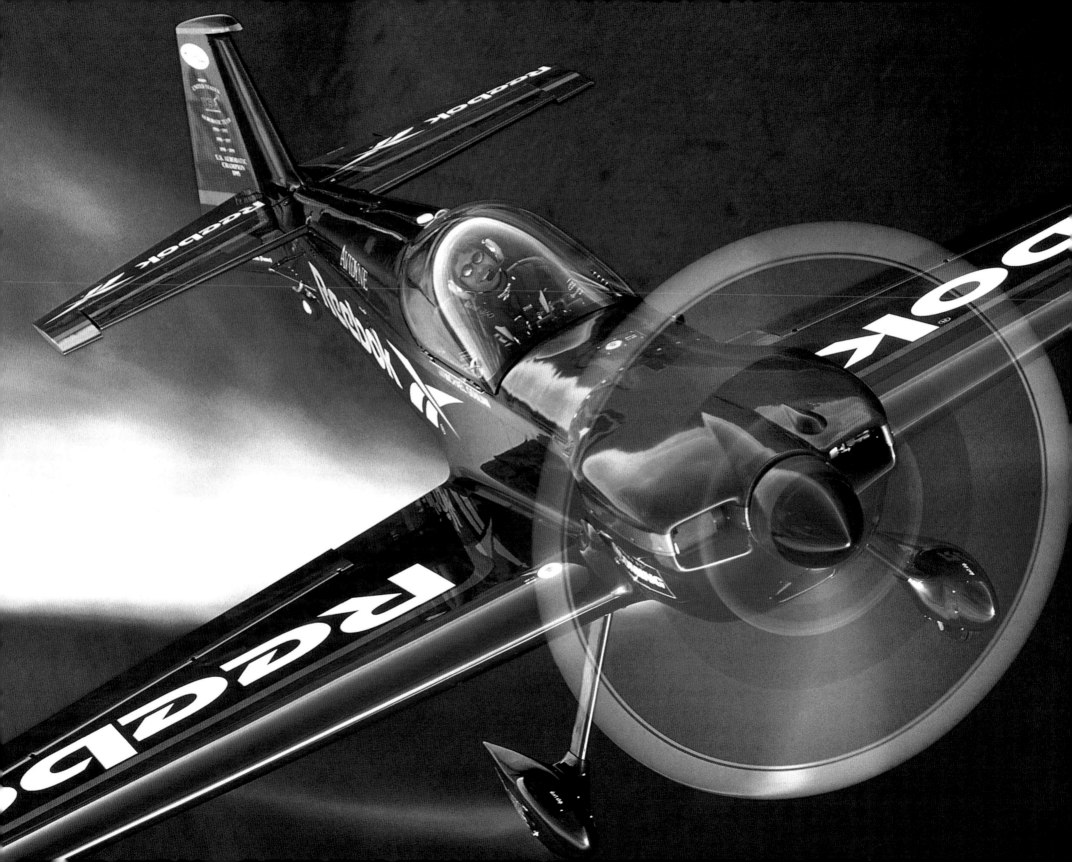

As one of the youngest pilots on the air show circuit, he has already achieved several of the most prestigious awards in the business including two U.S. National Championships as well as earning a slot on the U.S. Aerobatic Team in three different World competitions.

Most recently, Mike was one of six pilots invited to compete in the first annual Championship Airshow Pilots Association or CASPA series. His expert knowledge of the subject has lead to a long list of consulting positions for television programs including PBS's NOVA and ESPN's SPEEDVISION.

Born and raised in Arlington, Massachusetts, a quiet suburb of Boston, Mike grew up in a flying family. The Goulians own Executive Flyers Aviation, one of the oldest and largest flying schools in the Northeast. Mike works as an instructor there in the aerobatic school he founded within the large family business. When he's not out practicing and performing, the young Goulian supplements his income working as a corporate pilot, holding commercial type ratings in several variants of bizjets.

This summer, Mike took delivery of a brand new French-made CAP 232. With a dazzling paint scheme that highlights his recent alliance with Reebok, Goulian is now able to push the limits of his spectacular flying even further. The CAP is the world's most advanced production aerobatic aircraft and can achieve a roll rate of 420 degrees per second. That means in the time it takes you to say "one Mississippi," Mike Goulian can twist himself one and a half times around the centerline of this incredible plane.

But fast rolls are only a small part of what has made Goulian a world class performer. He is most famous for punishing gyroscopic maneuvers like the Pinwheel and the Suislide that hurdle both he and the plane through space in some of the most unnatural flight attitudes imaginable. Between the exit and entry points of these hardcore power moves, Mike Goulian flies by far the most precise and crisp tracking lines of any performer I have seen.

On the ground, crew chief Bryan Moore keeps the Reebok DMXtreme CAP 232 in top-notch condition. With the same impeccable style as his boss, Moore handles everything from the performance narration to making sure the plane is ready for each round of the rapid-fire CASPA heats. It is often the work of these behind-the-scenes assistants who make or break the daily successes of air show competitors, and Bryan Moore performs his job with all the seriousness of a truly dedicated professional.

Working together, Mike and Bryan have successfully positioned themselves as one of the highest profile air show acts in this ever-widening arena of big money sponsors. It has taken a long time, but it finally appears that the sport and spectacle of the Great American air show has hit the big time in large part due to the hard work and skill of pilots like Mike Goulian.

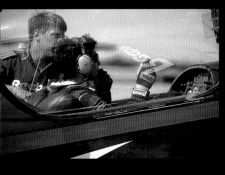 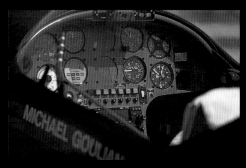 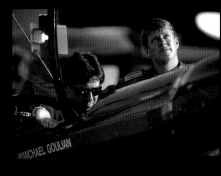

Mike Goulian is one of the freshest young fliers on the air show circuit today. From the brand new Reebok DMXtreme CAP 232 to the stylized look of the team's uniforms, Goulian is the model of a professional aerobatic effort. The top left image shows Mike as he skids the CAP into the sun over the waters off of Martha's Vineyard. Bryan Moore moves the airplane onto the taxiway during the CASPA Challenge at Oshkosh. Mike suits up and climbs to the state-of the-art cockpit of his wood and fabric machine. Bryan and Mike review the maneuvers before each hop. Like most performers, Mike Goulian visualizes the flight with both a mental and physical walk-through on the ground.

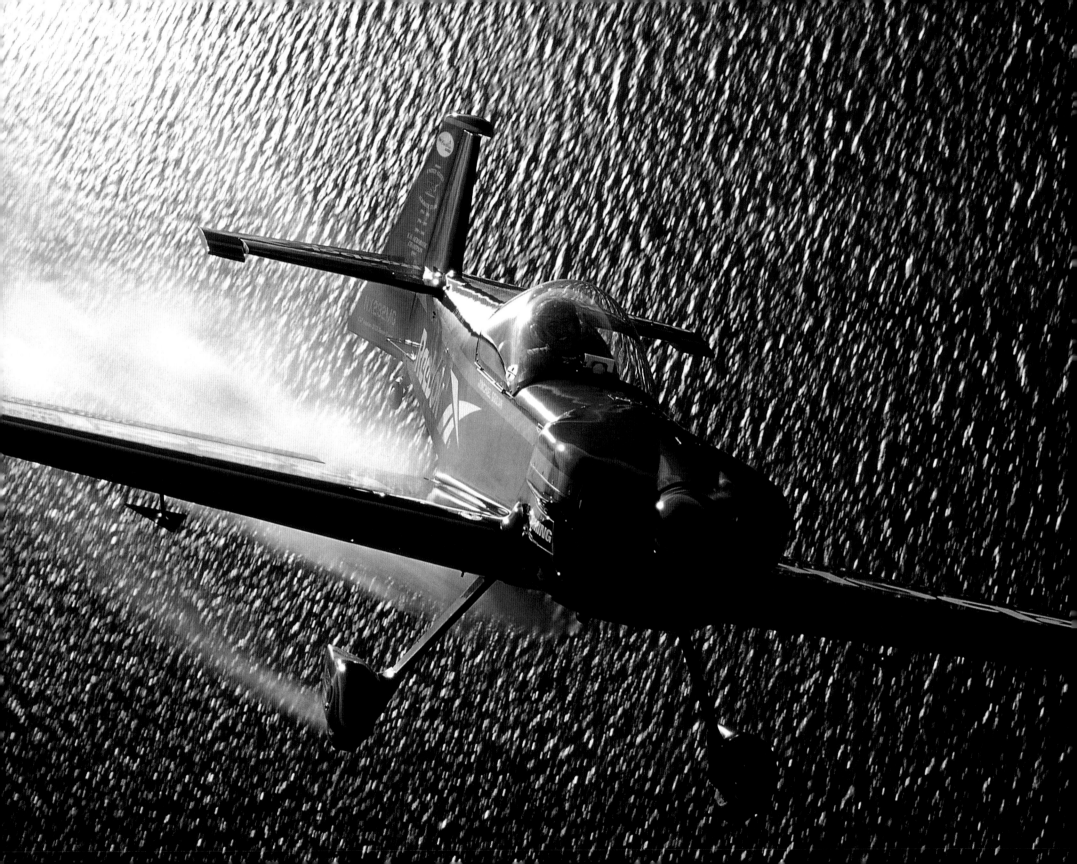

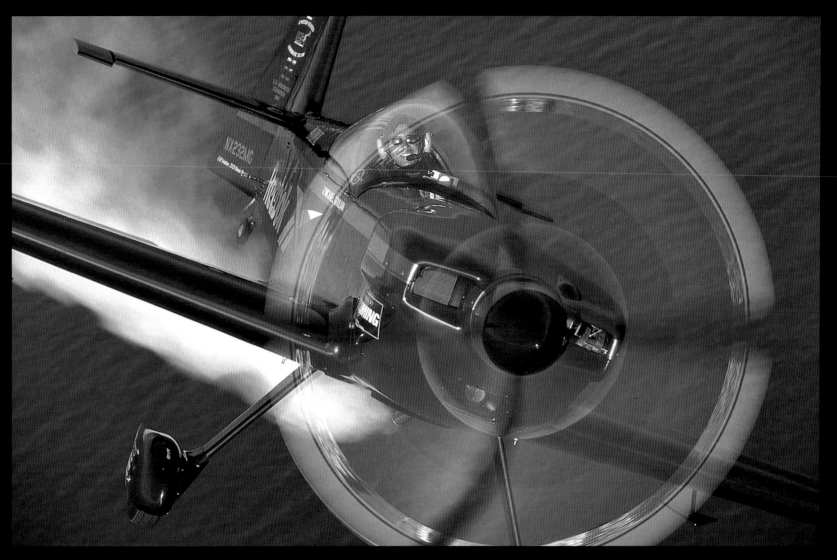

Above: The rainbow effect on the prop is created with pieces of a prism-like tape that started appearing on all of the CASPA planes this summer after Rocky Hill discovered it's aesthetic qualities and artfully applied it all over his AOL Extra. Left: Over the waters off of Wood's Hole, Massachusetts, Mike flies formation off of Brian Norris in the Tucker Cherokee.

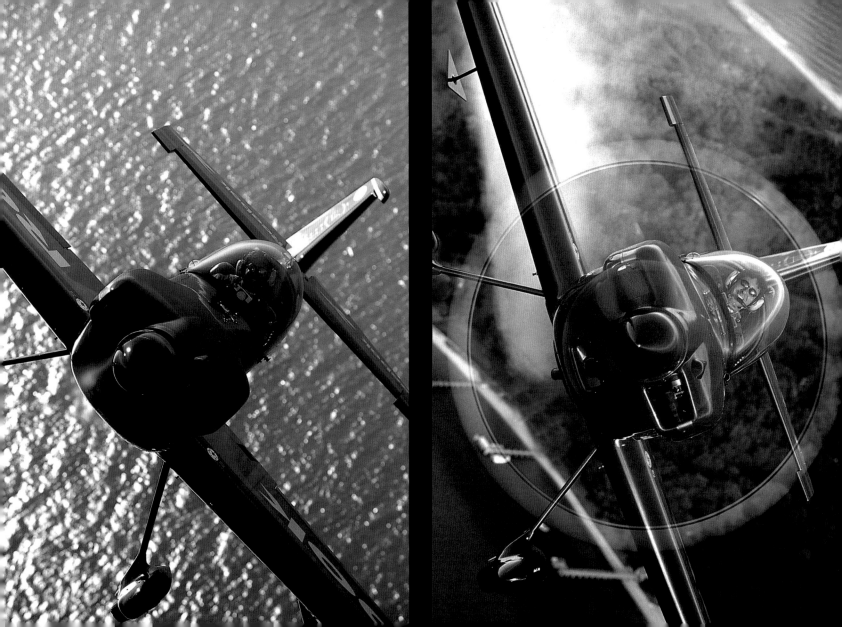

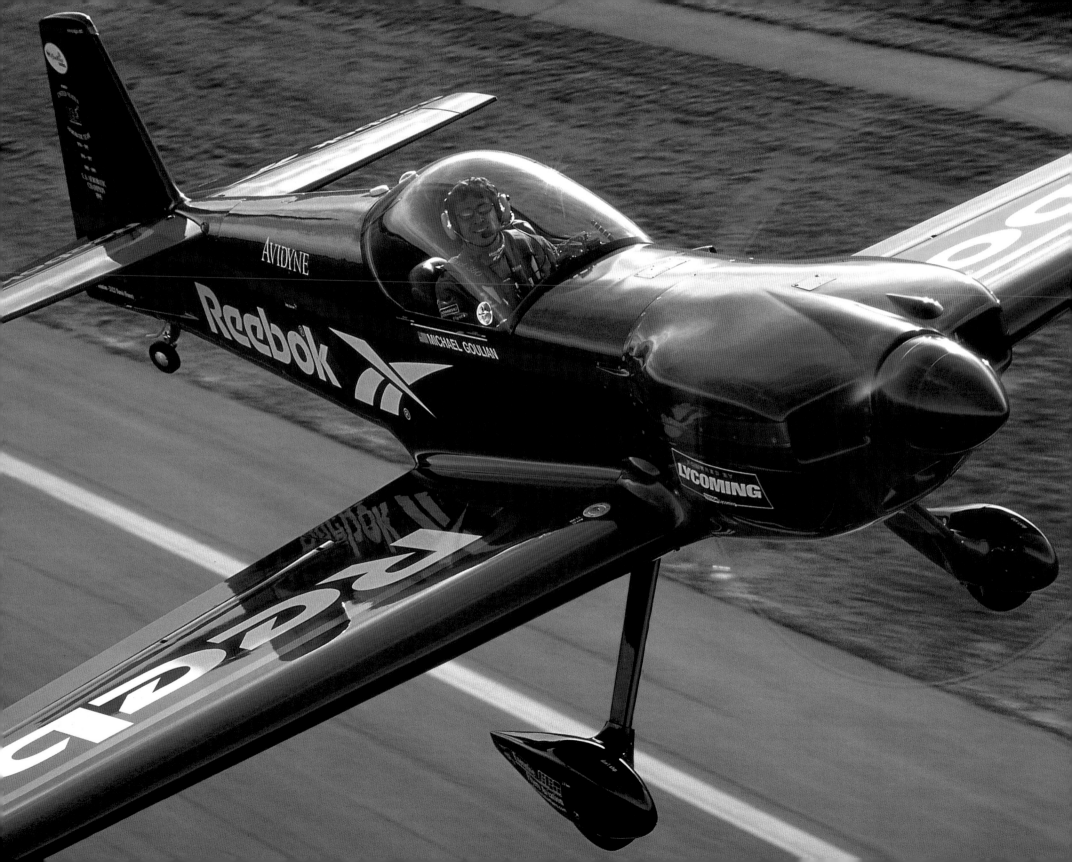

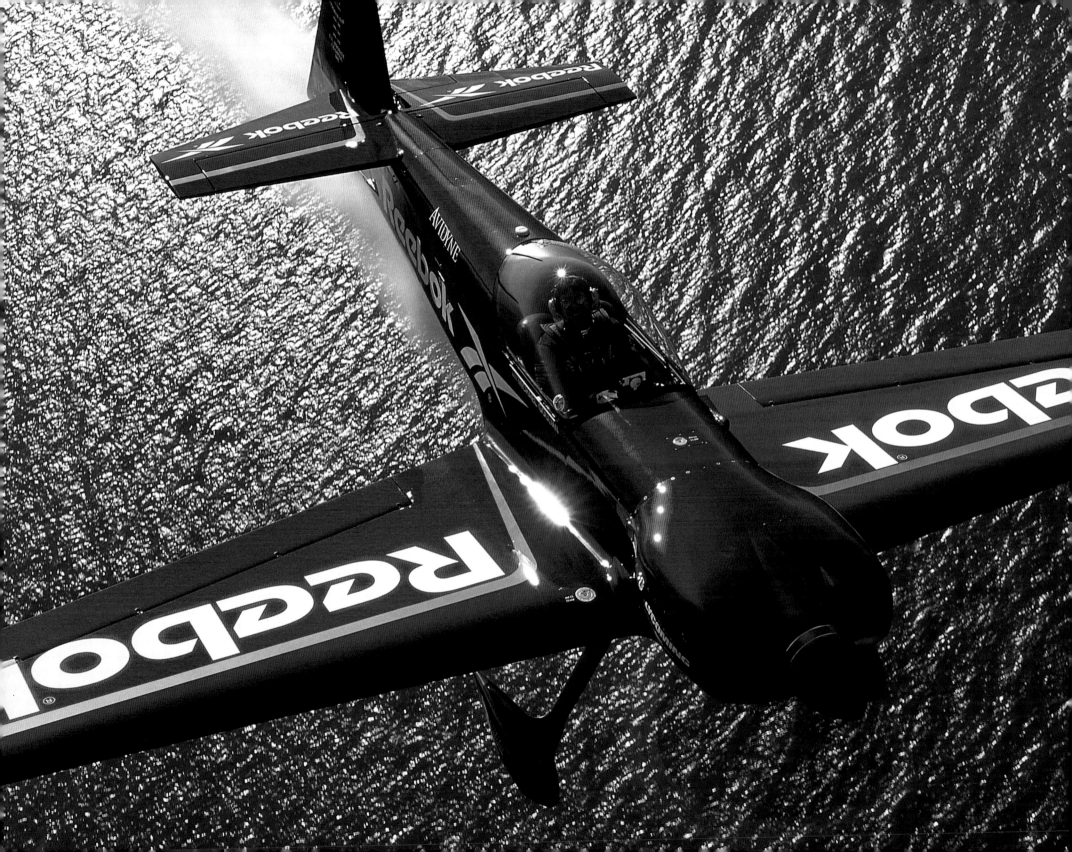

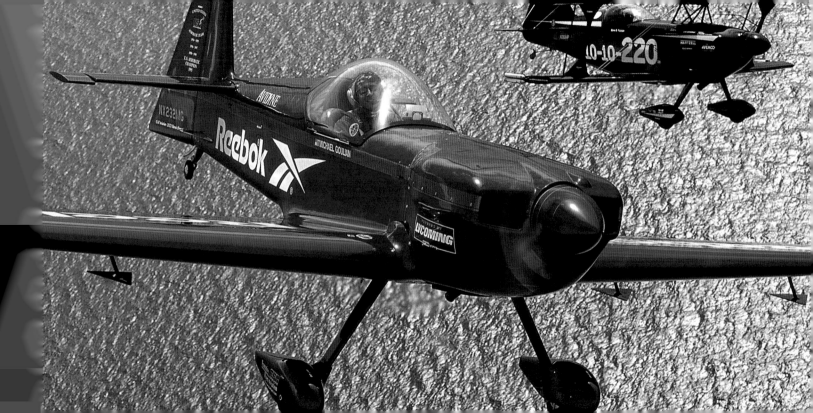

ADRENALIN AIRSPORTS
STEVE APPLETON

There are as many diverse ways to break into the air show business as there are pilots, yet there is one universal truth: you have to really know how to fly. The first time I saw Steve Appleton perform it was obvious that he is a truly great air show pilot.

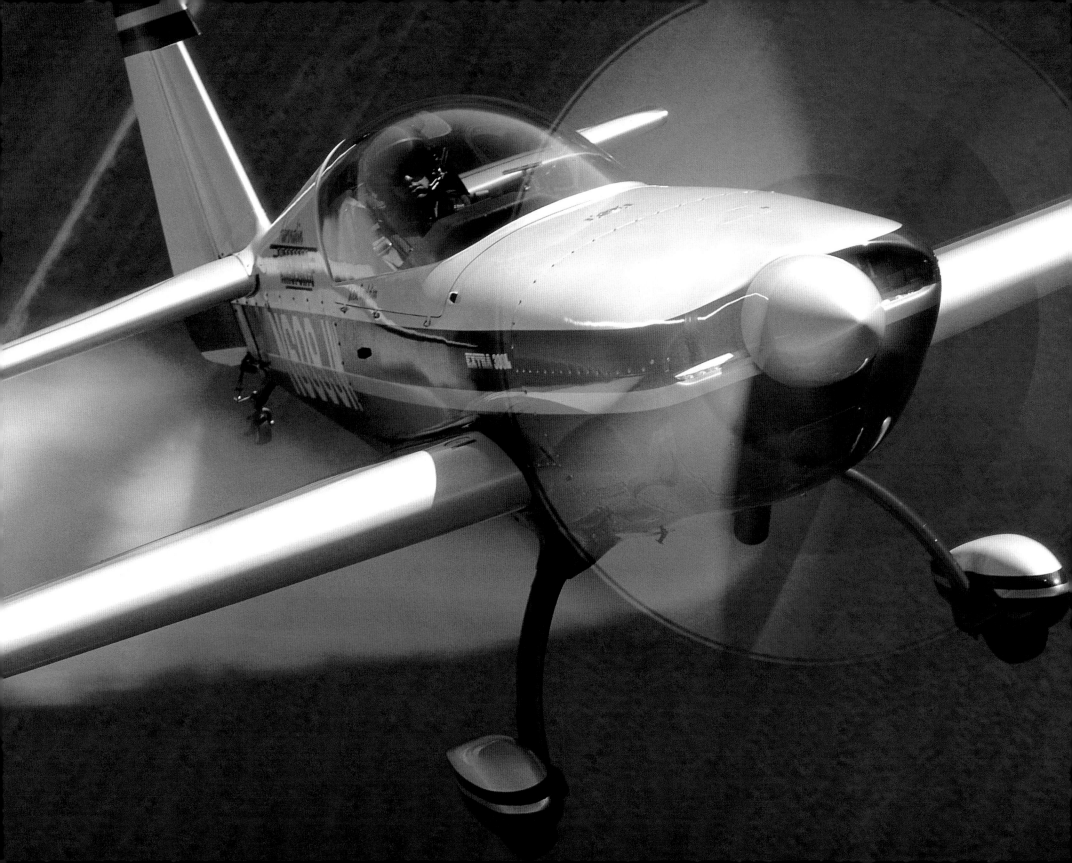

Steve's background in sport aviation is about as untraditional as any performer as I know. He is relatively new on the air show scene, performing only since 1997. But what he may lack in seasoning, he more than makes up for with skill and emotion.

Appleton is the only air show pilot I have encountered who performs demonstrations equally well in four vastly different aircraft: an Extra 300L, a T-6 Texan, an L-29 Russian jet and a British Hawker Hunter ex-military supersonic fighter. He regularly hops from one to the other on the same day to perform wildly different acts at a single air show. This year at Wings Over Stockton, Steve arrived with his brilliant red Hunter and had arranged for his Extra to be available as well. On both Saturday and Sunday, he first flew his full demonstration in the Extra, then later climbed into the Hunter and wowed the audience with one of the most dazzling jet acts around, tickling the speed of sound during his high speed passes.

As diversified as his choice of aircraft, Appleton dabbled in a variety of professional and amateur sports including tennis and motorcross racing before finding his true calling in air shows. His love of flying developed rather late in life after first learning to skydive in the early eighties. By the mid nineties, Steve was head-over-heels into his pilot training, achieving both private and commercial ratings until about the only thing left was to fly aerobatics.

Like most everything else in his life, Appleton committed his total attention to mastering this newfound passion. He had befriended the famous local air show pilot Greg Poe and the two of them flew hundreds of hours together in the Extra out over the Idaho foothills as Steve's talent rapidly developed. After a lengthy period of intense training, Poe was so confident in Appleton's burgeoning expertise that he made his official assessment as an FAA designated aerobatic competency examiner to grant Steve a surface competency card in all

four of the aircraft he owned. Since that time, Appleton has performed between ten and fifteen shows each season.

From his home base in Boise, Idaho, I had the privilege to fly along with Steve in the two place Hunter that he acquired after receiving dual instruction and his type certificate. This extremely British aircraft is unique and much larger than it first appears. Laid out similarly to the cockpit of an A-6 Intruder, the Hunter is not only a great show plane, it's also a wonderful training platform. The British rightfully believe that it is more effective to have the student sit side-by-side with the instructor where procedures and techniques can be demonstrated first hand.

The Hawker company designed the Hunter in the early 1950's flying the prototype on July 20th, 1951. It has since been employed by a wide variety of foreign governments including Malaysia and Switzerland who used it as both a fighter and as a close air support platform capable of launching air-to-ground AGM-65

As one of the most diversified air show pilots flying today, Steve Appleton performs three entirely different routines in four very different aircraft. Top left starts out in the L-29 Delphin, a Soviet Bloc MiG trainer made by Aero in the Czech Republic. The red jet in the middle is Steve's two-seat Hawker Hunter, a British supersonic fighter from the 50's that he flies in air shows around the country. Steve Appleton gets ready to fly at Wings Over Stockton in the Hunter as well as in his Extra 300, the third and most exciting plane he performs in. The lower left is a cockpit shot in the Hunter during the short one-hour flight from his base in Boise, ID to Stockton. The Hunter cuts a beautiful silhouette against the setting sun in Northern California. The image in the center shows Steve going over the top in the Extra. The camera ship for the Hunter and Extra photo flights was a Pilatus PC-7 piloted by the legendary Corsair performer Vaughn Olson.

TV-guided Maverick missiles. Hawker built almost 2000 Hunters making them the most commercially successful British military jet ever produced.

The exterior of the big jet belies few traces of the plane's former duties as an Imperial ground-attack fighter. The carnival red paint scheme lends the Hunter a certain degree of flash conducive to its livelier role as a showstopper. Large white letters reading crucial.com radiate down the wings and empenage in reference to the plane's corporate benefactor. Appleton serves as Chairman of the Board, Chief Executive Officer and President of Micron Technology, Inc. of which Crucial is their consumer products division.

In the air, the Hunter's sleek lines translate into some rather slippery handling characteristics. I had a tough time keeping the jet from "rocking" side to side on the swept wing but Steve's experienced hand quickly canceled out my sloppy profile and he smoothly carried the plane through a docile series of barrel rolls out over the Sawtooth

Mountains. The cockpit is very roomy for a tactical jet and despite the wacky British restraining harness/ejection seat set up, the systems are straightforward and easy to decipher.

Steve practices his routine almost daily within a locally wavered aerobatic box just a few miles outside of Boise. Despite his tireless work schedule, Appleton affords his air show flying as much time as most fulltime professional pilots. In fact, Steve is in the process of designing and constructing a custom eighteen-wheel travel rig so that he can spend time on the road next season without having to struggle with the Hunter's limited storage capacity.

Considering the performance specifications of the Hunter, it is clear why it requires a Fortune 500 CEO to operate. Able to carry a little over 1,000 gallons of fuel internally, Appleton's TMk-7 is powered by a Rolls Royce turbojet engine that develops 7,500 pounds of thrust and burns 600 gallons per hour. Currently Steve is in the midst of restoring a second two-seater that will resemble

the first in shape only. Already painted gloss black, Hunter #2 utilizes the largest engine ever developed for the type capable of generating 12,000 pounds of thrust.

To help streamline cockpit tasking and systems management in the new black Hunter, Appleton has custom engineered a totally glass cockpit for his air show masterpiece. Every single "steam gauge" instrument has been replaced by an onboard computer sensor that will display all system and flight data on an array of MFDs or multi-function displays. Basically, the instrument panel will consist of several touch-screen computer monitors.

Together with the red Hunter, Appleton's next generation jet demonstrations promise to ring in the millennium with state-of-the-art technology never before bestowed on the air show circuit. And who better to bring air shows into the 21st century than this master of silicon and speed? Expect Steve Appleton to forever change the look and feel of the Great American air show.

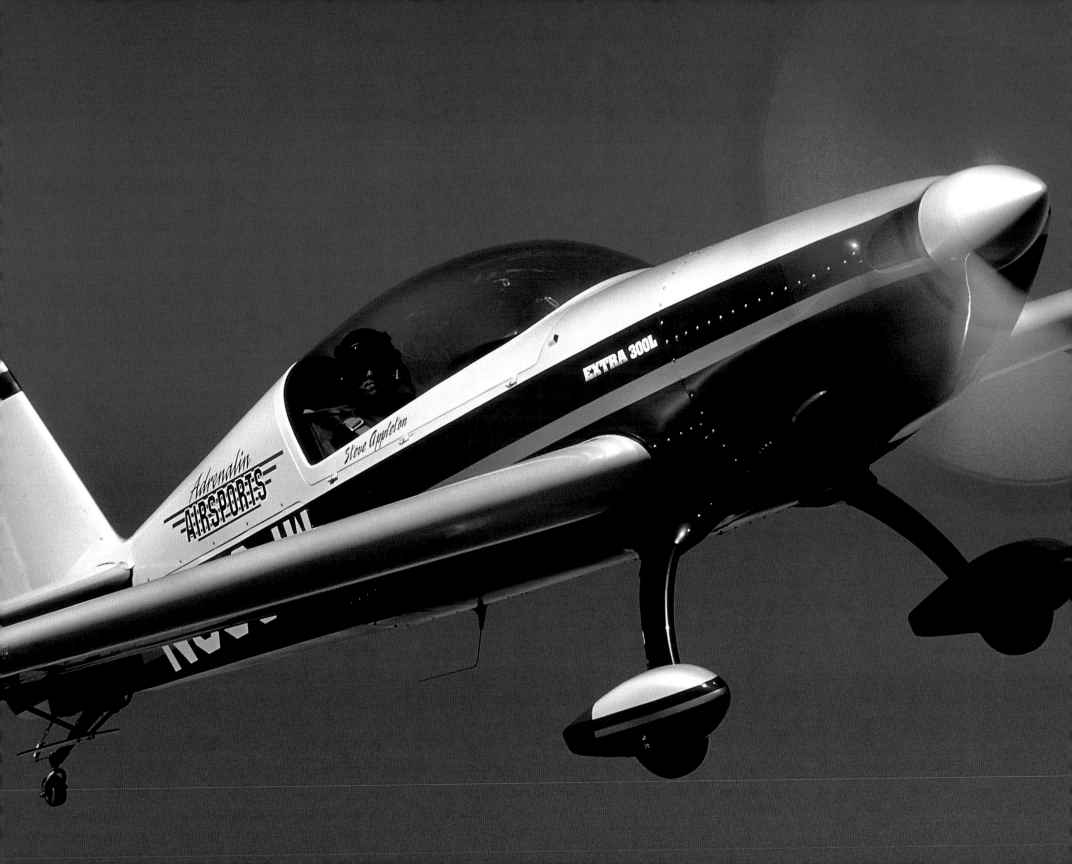

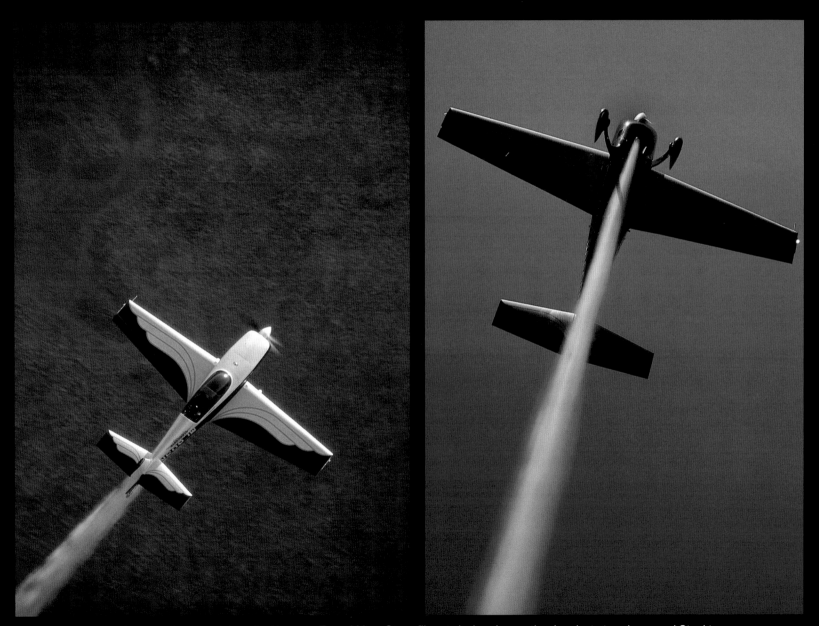

Above: A beautiful photo study of the Adrenalin Airsports Extra 300 as Steve flies at daybreak over the dry, dusty terrain around Stockton.
Opposite: Steve flying photo orbits with Brian Norris in the Tucker Cherokee.

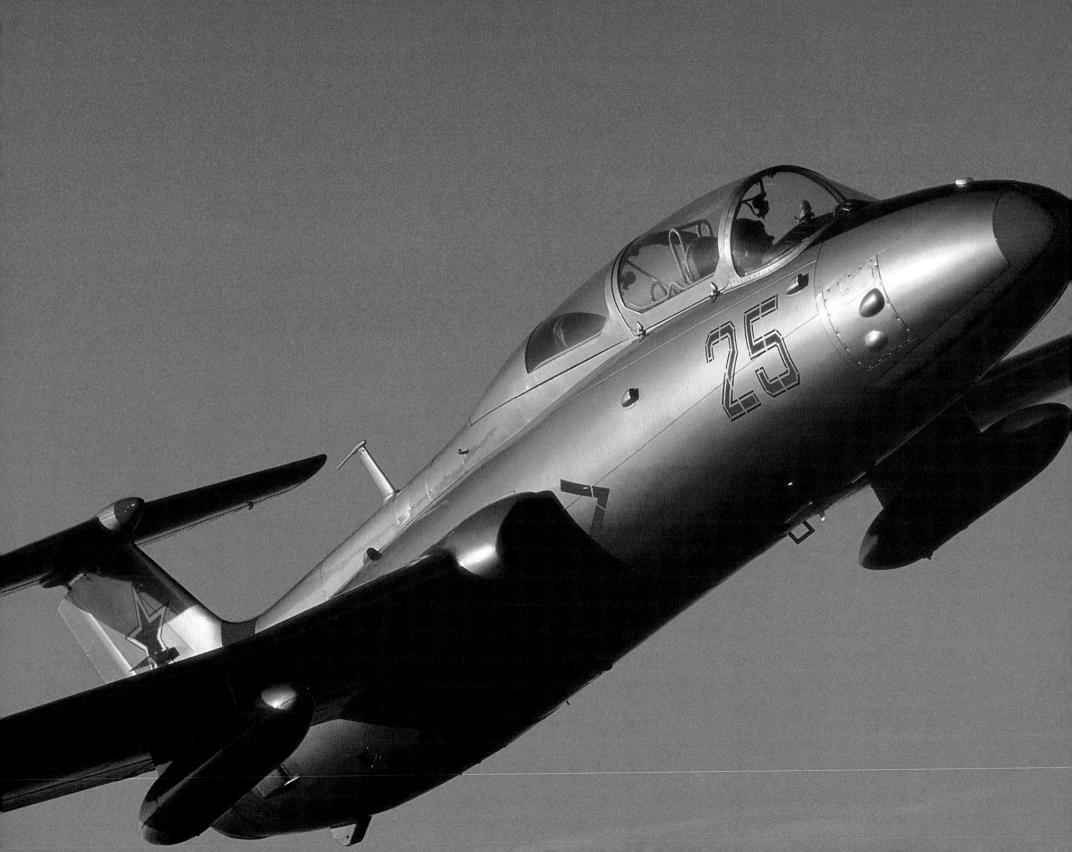

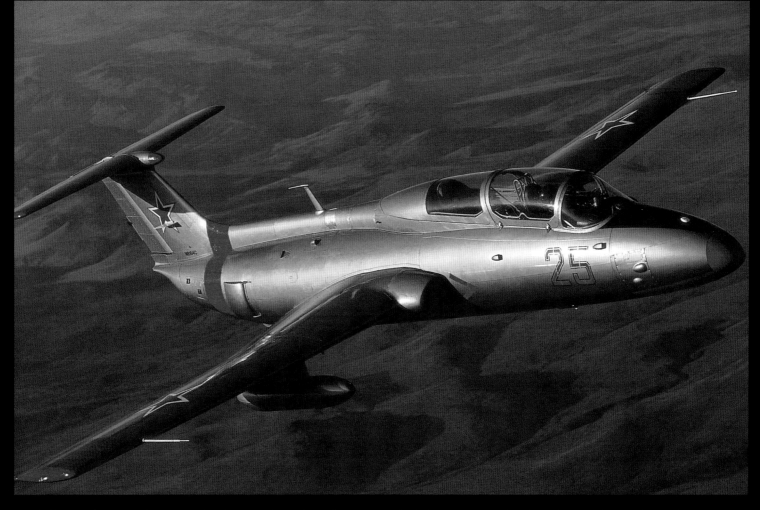

The L-29 was shot on a dawn-patrol sortie over the rolling hills south west of Boise. Designed and used as a fighter-trainer by Warsaw Pact nations, the Delphin afforded Steve the military jet experience he needed to transition smoothly into the higher performing and much more complex Hawker Hunter.

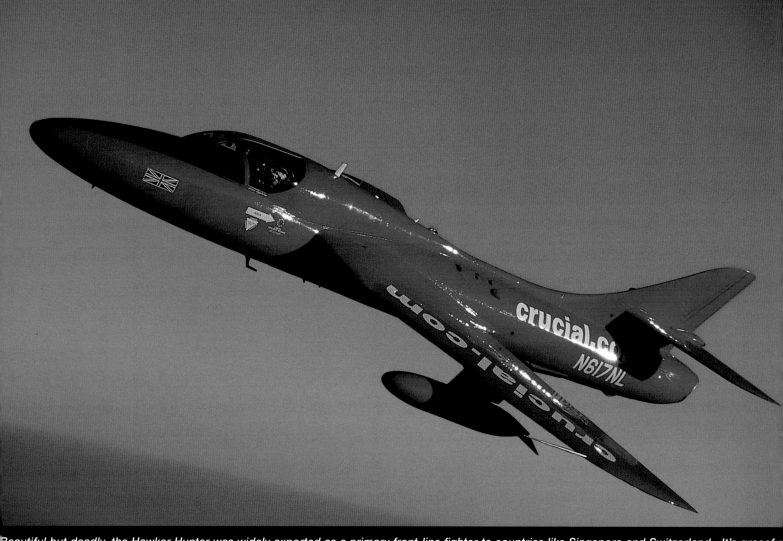

Beautiful but deadly, the Hawker Hunter was widely exported as a primary front-line fighter to countries like Singapore and Switzerland. It's graceful lines and ample speed provide Steve Appleton with one of the best looking ex-military air show platforms in the world. Capable of breaking the sound barrier, the Hunter truly is as fast as it looks. Both images were made during a late day photo mission during Wings Over Stockton.

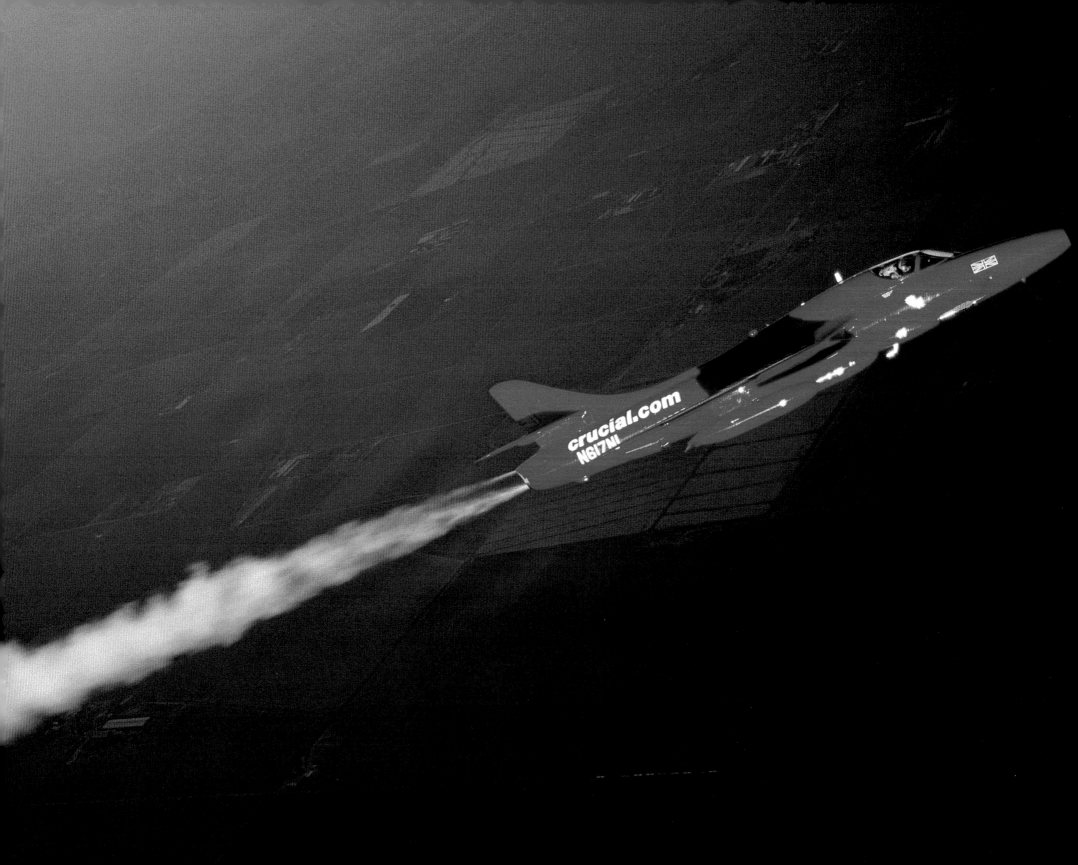

CALIFORNIA INTERNATIONAL
AIR SHOW

In spite of its cosmopolitan moniker, the California International air show in Salinas is better described as a great big homespun community airport party.

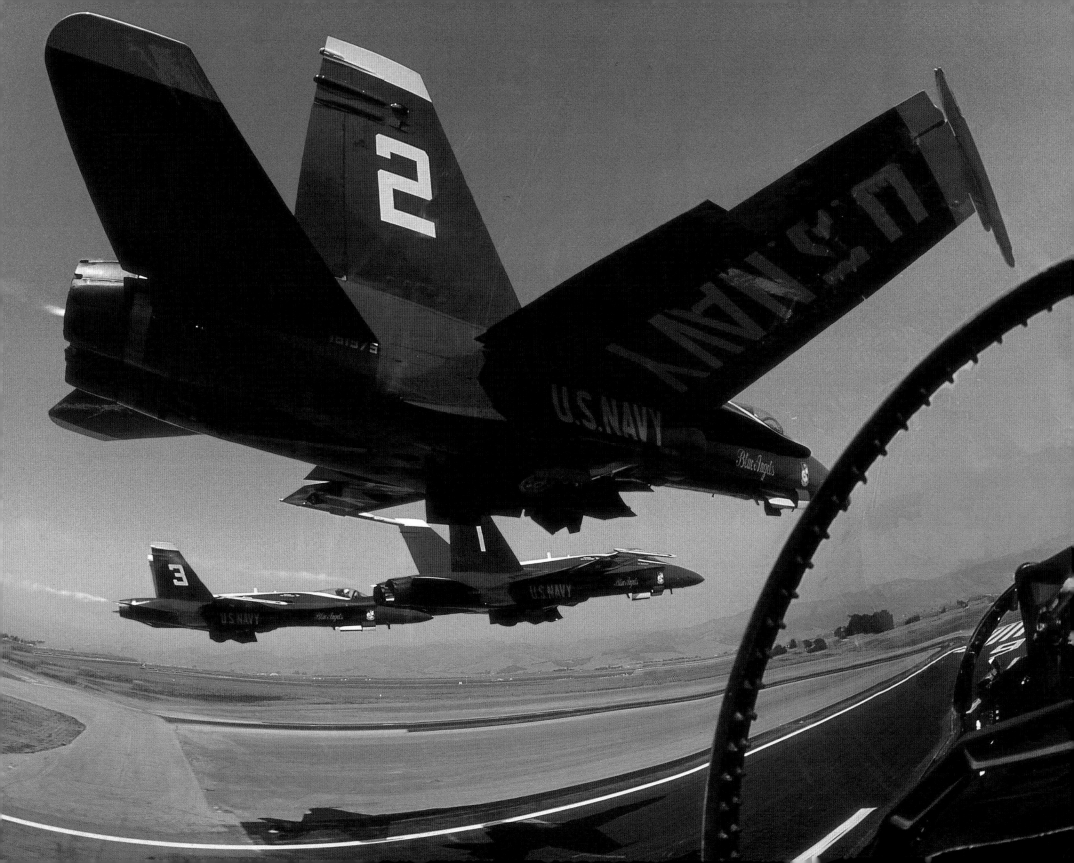

Centered on a lively regional hub airport that services the area's primarily agricultural air operations, the Salinas show pulls together the local population like no other. Partly because of their remarkable nineteen year commitment as a charity-based organization that has raised over five million dollars for local charities and partly because of the draw of their hometown talent, the California International air show has crystallized the spirit of why people come together to watch airplanes fly.

Long regarded as a big league player and widely respected for securing at least one major military demonstration team to anchor their annual lineup, Salinas has in the past always had to settle on the lesser victory of remotely staging demo teams due to restrictively short runways. This year however, local paving company PAVEX donated 2,000 cubic yards of asphalt to extend the rollout and ramp sections of the airport. This expansion of the facilities allowed air show Executive Director Harry Wardwell to host the Blue Angels on the home field for the first time since 1985 when they were still flying the much smaller A-4 Skyhawks.

Right up until the last possible moment, pavers and steamrollers worked furiously to finish the huge job they had started only

weeks earlier. As Blue Angel #7 taxied to a stop on Wednesday for the final site inspection, the finishing touches were being put in place that would allow for the historic arrival of the rest of the team the following day. On Thursday as the pilots climbed down from their jets, the significance of the occasion was increased even further. Along with the customary media representatives and air show officials, local resident and original Blue Angel Boss #1, Roy "Butch" Voris was on hand to welcome the team to Salinas.

Having the Blues on site contributed to a near frenzy of media attention throughout the community. Every local TV station ran stories on their evening news broadcasts highlighting the practice show on Friday. It was during that flight that I got to ride along with LCDR. Dave Silkey in the #4 slot position to take photos. All week, there had been a thick haze of smoke and humidity blanketing the area from a series of wildfires down south near the Big Sur wilderness, but once airborne, the air was relatively clear.

As the sun went down on Friday night, the show grounds were packed with energized fans eager to witness the magical combination of fire and flight. Pyro devices provide for a beautiful extension of daytime aerobatics and Gene Soucy utilizes their

dazzle better than anyone else I know. The Grumman AgCat he normally flies with wing-walker Theresa Stokes works beautifully as a mechanical firefly that literally showers the sky with curtains of sparks. Contrasting the elegant style of Gene's slow turns was Fat Albert, the Marine C-130 flown by Dwight Neeley and Andy Hall who blew the crowd away with their nighttime JATO takeoff. Talk about thunder and lightning, that maneuver is truly grace under fire.

To induce fear and panic among the waist-high members of the audience, the overgrown fire-breathing erector set called Robosaurus roared down the crowd line laying waste to three tired old automobiles by chewing them to pieces and then setting them ablaze with its propane panting. I guess for the same reasons professional wrestling is so popular, Robosaurus has become one of the biggest draws on the air show circuit in recent times.

With the chalet village filled to capacity and the President's Tent rocking with VIP's, the grand finale erupted with near seismic proportions. Designed and executed by World famous Rich's Incredible Pyro, three massive Walls of Fire were detonated in sequence. After the last two explosions on the ground, a twenty minute fireworks display played out in front of the huge crowd who thought they had only come to see a few

Opener: Shot from the backseat of the Blue Angel slot position on takeoff as Dave Silkey starts to slide into centerline. Right: A perfect wide shot capturing the entire show site as the Blues go to town for the Salinas crowd.

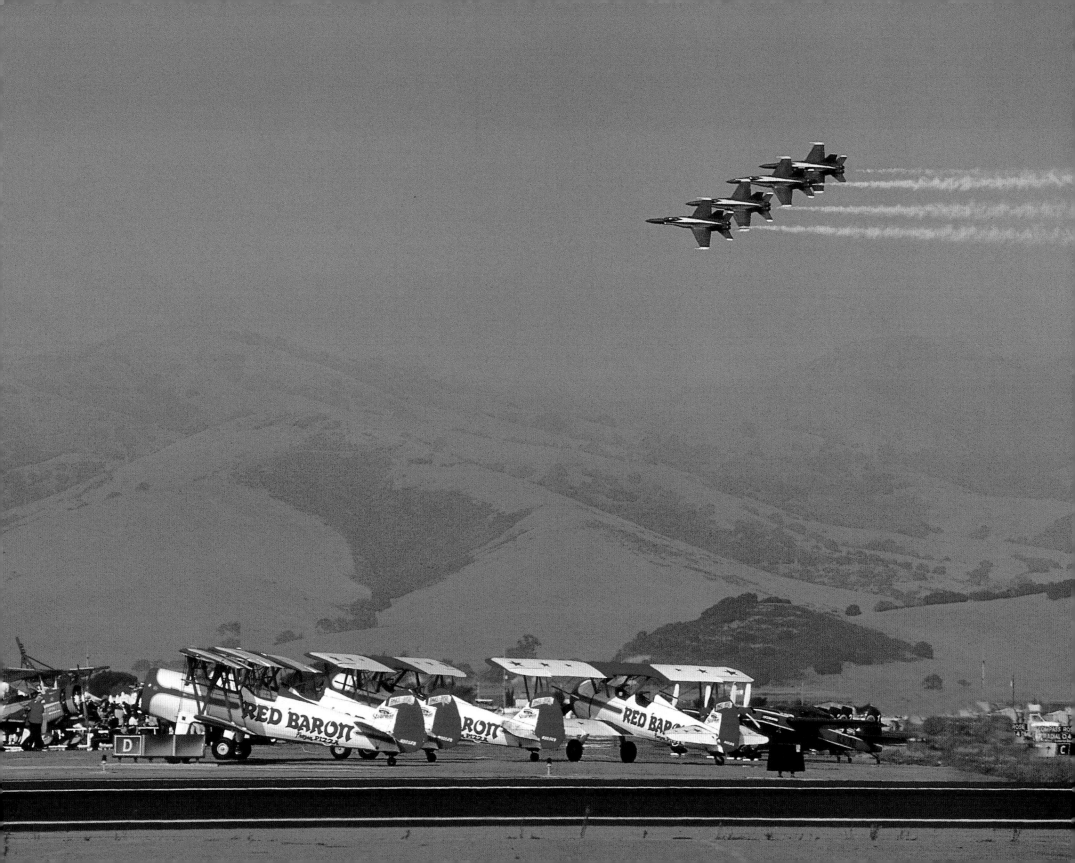

Top left: A junior Marine getting the camo treatment from his commanding officer. Robosaurus adds to the already smokey air this year caused by nearby wildfires. Sean "Rocky" Tucker knows how to please the hometown fans. Wayne Handley taxies out the incredible Turbo Raven for his near heart-stopping performance. The multi-talented Brian Norris belts out the narration for Sean D. Tucker's "Sky Dance." The US Navy SEAL skydiving team, the LEAPFROGS jumped the American flag each day for the show opener. Rich's Incredible Pyro ignites a massive wall of fire as the CF-18 strafes the infield.

airplanes perform. As the smoke cleared and the parking lots emptied, both the public and the show's organizers knew that they were in for an epic air show over the next two days.

Both Saturday and Sunday opened with a whirlwind of activity as the US Navy SEAL skydiving team, the Leap Frogs, jumped the opening flag ceremony with The Northern Lights circling overhead. Next came Ed "Hamster" Hammil, a full time F-16 driver who had recently completed his training at the Sean D. Tucker School of Aerobatics in his new Pitts S2-C. This was Hamster's first official air show and the crowd welcomed him open arms. Gene Soucy strapped on his Extra 300 and carved up the sky with all of the energy and precision that has made him so celebrated over the past thirty years. Gene flew a second time each day with Theresa Stokes for their awe-inspiring wing-walking act. Over the entire show, the lineup read like the dream-team of air show performers.

This was apparently the unofficial year of the formation team in Salinas with virtually every other act flying a multi-ship formation program. The Red Baron Squadron flew their vintage style show executing one of their trademark maneuvers. The calm morning air allowed their perfect smoke shaped heart to linger unfettered for all to appreciate. The

Canadian Tudors were on hand to demonstrate the casual beauty of their six-plane formation. They fly the active duty version of the Candair CL-41 just like the Snowbirds except for the paint scheme. The Northern Lights performed their glorious five-plane act in the brightly colored Extra 300s. And of course the Blue Angels were there with the most widely observed aerial demonstration team in history.

Strategically positioned between this amazing gathering of world class formation acts were the two performers that helped put Salinas California on the air show map: Wayne Handley and Sean D. Tucker. Both of these living legends began their flying careers as crop dusters from the very runways over which they were now performing air shows. The California International Air Show serves as the annual homecoming for Wayne and Sean who while on the road are both huge celebrities, but when back here are just a couple of regular guys, albeit very well known and well liked guys.

Sean's home base is actually right there on the field, occupying two hangers where he operates the aerobatic school and his Aviat/Pitts dealership. The inside of the hangars are like time capsules recording his many years in the business. Past generations of retired fabric wing coverings hang from the rafters and

record his commercial ascent with old sponsorship logos. On Saturday night, Tucker's hanger becomes the traditional "in" party spot where VIPs and performers all mix it up for a late night of telling lies and hand flying.

Wayne and Karen Handley live on a ranch about thirty miles away, toward the opposite end of the fertile Salinas Valley where they have a grass strip and hanger. Both versions of the Raven live inside. The first plane that Wayne flew for Oracle is an Extra 300 painted red with the streamlined black bird on the underside. His latest version, the hand made carbon fiber Turbo Raven sits along side with the updated paint design echoing Native American carvings of the Pacific Northwest.

This year, both pilots delivered their hallmark performances that have lead each to the tops of their field. Tucker, known for his aggressive and almost violent domination of the sky, cranked out yet another stunning victory over gravity, while Handley seemed to have a more amicable arrangement with the wind. Together, these two homegrown heroes are the heart and soul of this small town air show with the big time reputation. The California International Air Show is the perfect fusion of charity, charm and aerial excitement. Hats off to this inspirational example of the Great American Air Show!

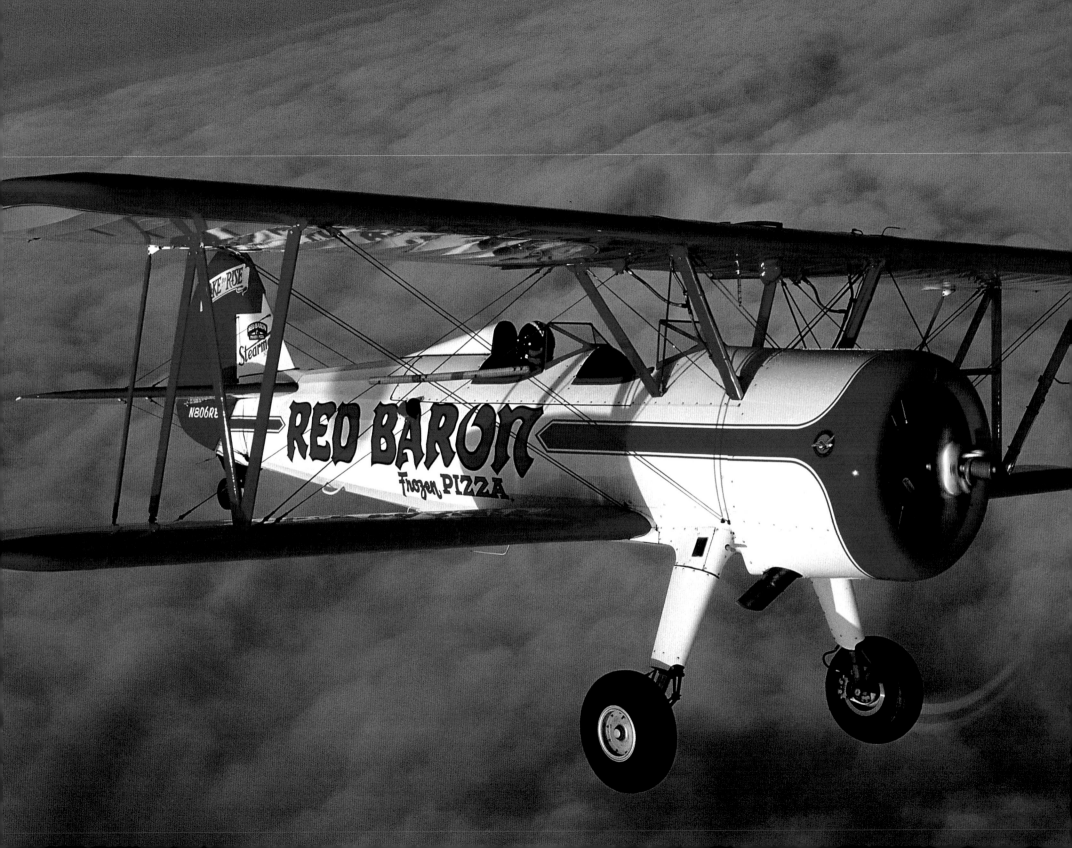

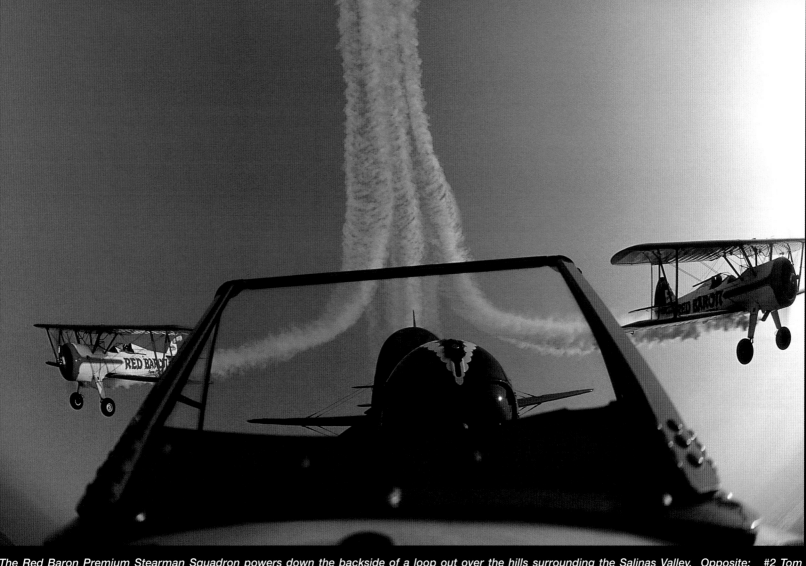

The Red Baron Premium Stearman Squadron powers down the backside of a loop out over the hills surrounding the Salinas Valley. Opposite: #2 Tom Womack tucked in tight to the left wing position during some slow turns over the thick and hazy marine layer.

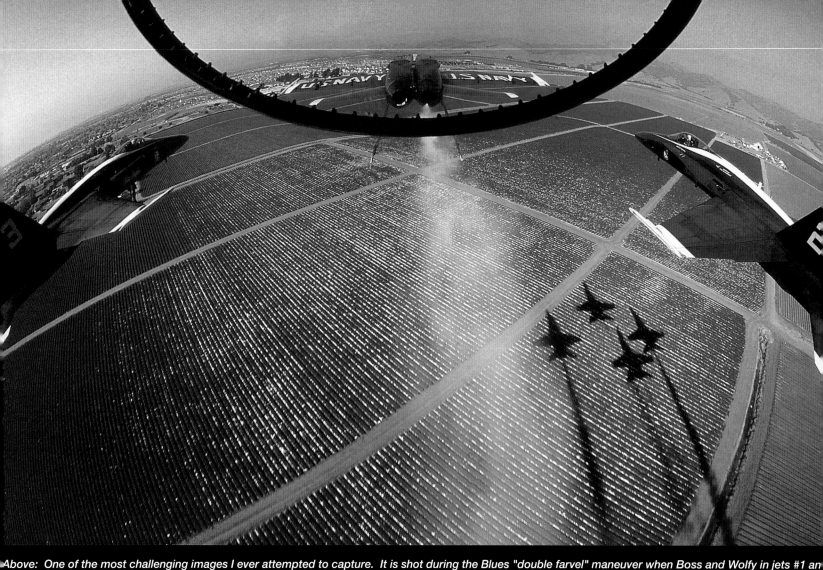

Above: One of the most challenging images I ever attempted to capture. It is shot during the Blues "double farvel" maneuver when Boss and Wolfy in jets #1 and #4 roll inverted for a flat pass of the crowd in the diamond formation. Hanging upside down in the harness isn't all that difficult, but safely maintaining positive control of the equipment I bring into the cockpit while keeping my hands free to shoot requires creativity. As you can see, Boss is inverted ahead of us and the shadow in the lettuce patch below depicts our position in between all three jets... also inverted. Right: Shows the apex of the diamond dirty loop.

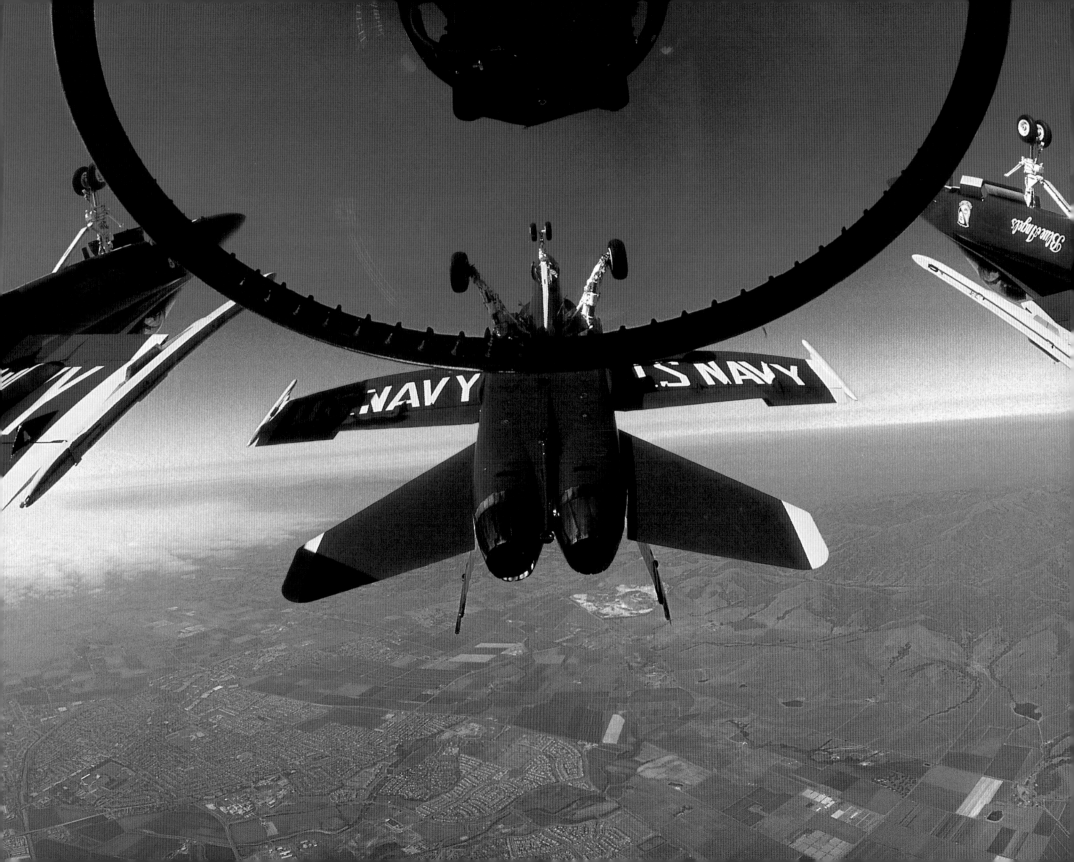

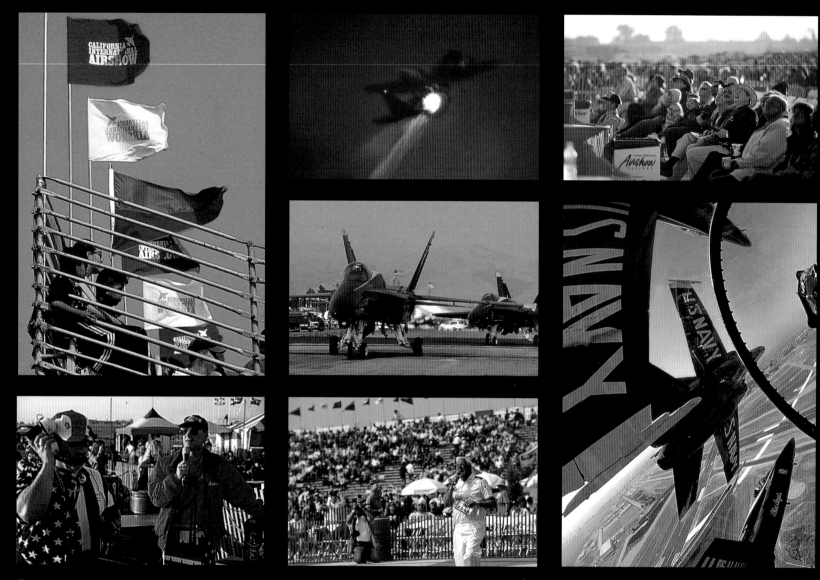

Top Left: A scene that helps make The California International air show so special, the grandstand. Few other venues provide this effective and intimate way of providing a quality vantage point for the crowd. Top Center: Fat Albert doing a nighttime JATO takeoff. The evening seats start filling up for the Friday night fireworks. Center shows the solos V8 and Banker getting into position to start their show. The nerve center of air operations, AIRBOSS Jim Vanderzwaan on the right and patriotic narrator Larry Shapiro. Jerry Van Kempen delivers pizza. Bottom Right: Blue Angel diamond pass. Opposite: The LEAPFROGS hitting the DZ and a still life of the coolest jet in town.

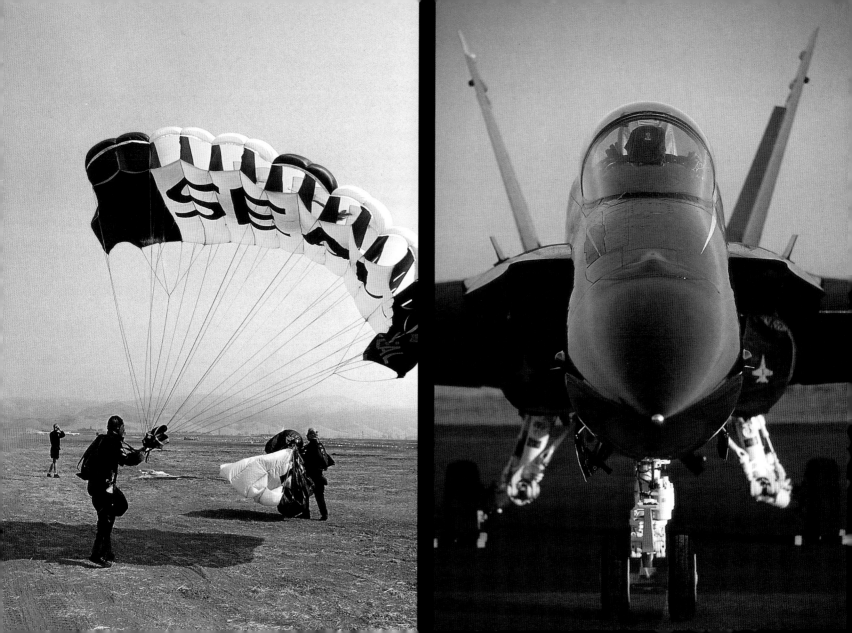

BLUE
ANGELS

Having performed in front of more than 322 million spectators since 1946, the United States Navy Flight Demonstration Squadron is the most recognizable public symbol of the military today. They are also the most frequently requested demo team whose top billing at any air show can virtually guarantee record attendance.

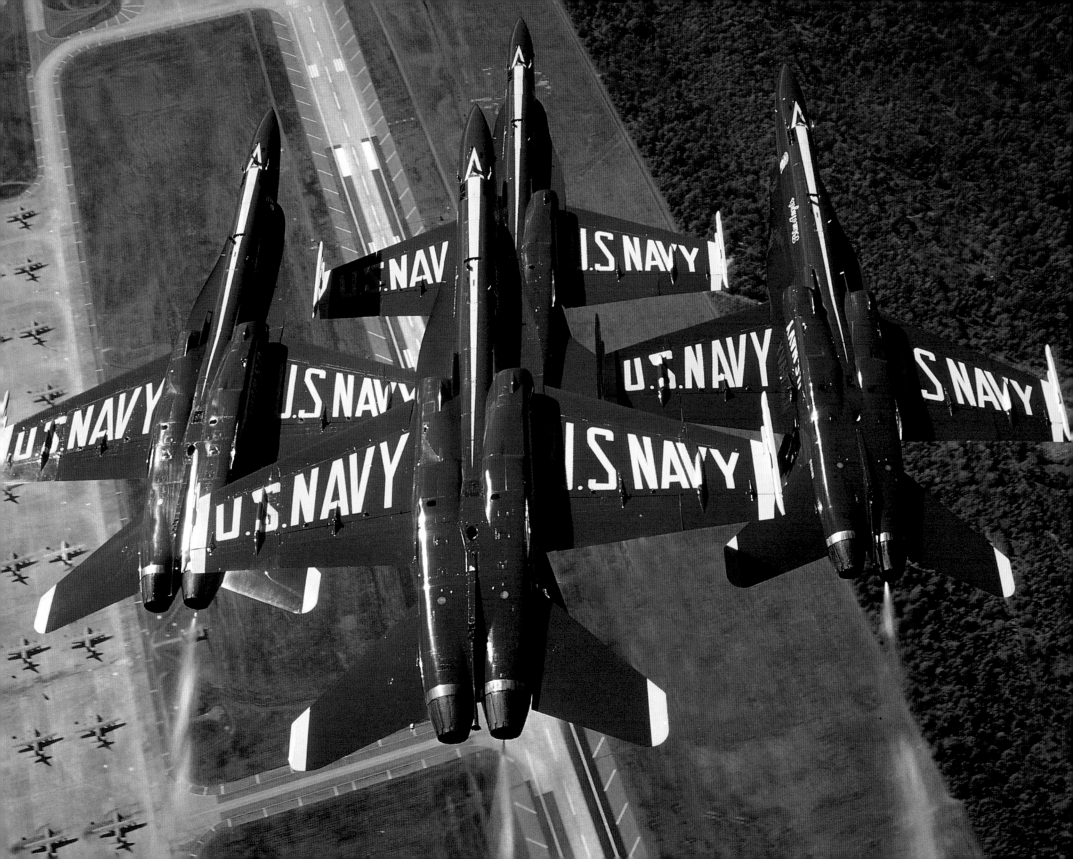

The near mythical presence that the team commands at a show these days is the result of over fifty years of tireless hard work by thousands of individuals. And while the squadron is renowned for their flight demonstrations, it should be recognized that they are not simply a team of great pilots. Those six jets are merely the focal point of a complete team of one hundred and twenty-six Blue Angels.

Achieving Blue Angel status is as much an accomplishment for a petty officer as it is a flight lieutenant and the selection process is just as tough for the enlisted as it is for the officers; you have to be asked to join. Each year, interested candidates out in the fleet "rush" the team, sort of like someone rushing a fraternity or sorority. Of the personnel qualified to become a Blue Angel, members already on the team select replacements for those Blue Angels rotating back to the fleet. These lucky few are called "newbies" and they must all learn an intricate system of cultural traditions that only the Blue Angels practice. There is literally a separate

vocabulary and a ritual treatment for even the most mundane duties of the repetitive daily activities of the show season.

For "newbie" pilots, life begins in September when they officially check into the squadron. There are typically two jet demo pilots who rotate in each year to begin the process of learning how to fly with the team. In this final stretch of scheduled appearances, new pilots are familiarized with each of the formation positions. They fly along in the backseat of the #7 B-model Hornet swapped into the normal formation during practice flights to give them their first look at what it will be like once they start training. During the season, the T-bird is used by Blue Angel #7, to give three media "fam" rides that happen at each show site.

In order to capture the images for this chapter, BOSS Driscoll and the rest of the team gave me the opportunity to experience the thrill of flying along with them during an actual warm-up demonstration at the California International

Air Show in Salinas. Short of getting selected to photograph a Space Shuttle mission, this is the best hop a civilian geek like me could ever hope for.

A slot ride is hands down one of the most powerful experiences in aviation. The feeling I got flying in a Hornet through all of the maneuvers of the Blue Angel demonstration while underneath, three other jets flew only inches away was simply indefinable. The visual experience alone is spectacular as the constantly changing formation evolves from one shape to another. But what is most surprising, is the volume of sound that hits you when you're tucked in tight for the vertical elements.

Not only are you flying directly behind the Boss's jet, but you also have two pairs of engines on either side of your head. In total there are eight howling after-burning jets within thirty feet of you, and the noise is something you feel as much as your hear. And, yes, if you're one of those people who have ever dreamed of getting this ride-of-a-lifetime the way I did, it is every

Opener: One of the rarest perspectives you will ever see of the Diamond, this image was made with solo Doug "V8" Verissimo flying #7 as a "floater." V8 was able to chase the Team though a select number of the demo maneuvers during the Friday practice show at Little Rock AFB.

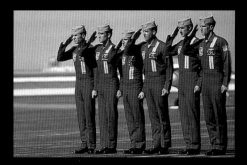

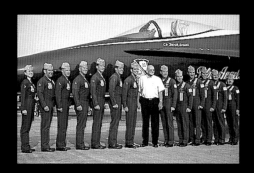

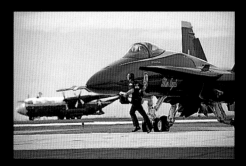

Top Left: The Team in the march back after the show in Cleveland. Center has #2 Mark Dunleavy who returned mid-season for an encore performance flanked by life support specialist John Beach on the left and crew chief Christian Cruz. Top right: looking sharp. Middle left is BOSS Driscoll getting to know the kids from the Cleveland Make-a-Wish Foundation. Middle right is a rare shot of the Team with Salinas's local hero Blue Angel Boss #1, Roy "Butch" Voris. Lower left shows Dave Silkey, callsign Wolfy climbing into #7 for the Friday practice in Salinas. BOSS Driscoll and Gucci catch up with BOSS Voris on the ramp. Fat Albert taxis back as the Team gets ready to fly Cleveland.

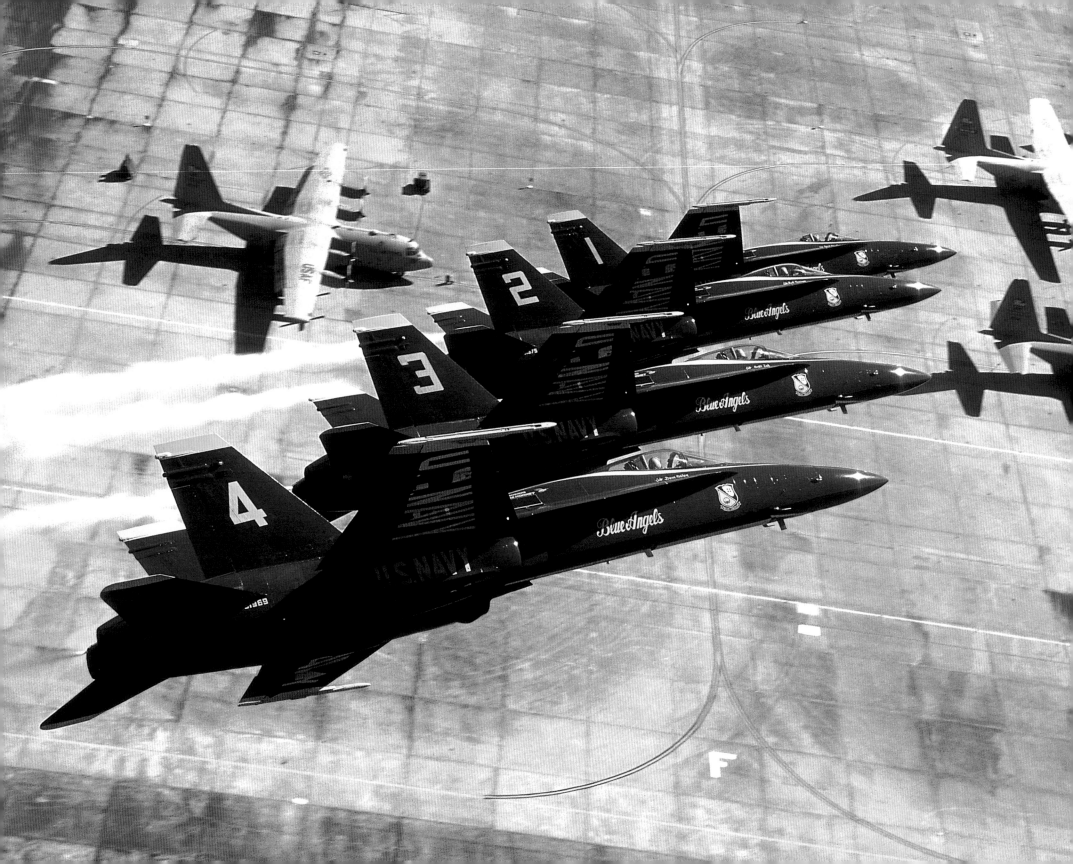

bit as wild, electrifying and fun as you could possibly imagine.

Now keep in mind that the guy in the back is just along for the ride, but the physical demands of this kind of flight are a little more than the average photo hop. Positive G-forces during the performance top out around 7.6 or so and are achieved during the recovery from a separating maneuver when each pilot hustles to rejoin the formation. Luckily there is not much to take pictures of during the rendezvous, otherwise it might get pretty difficult to handhold a six-pound camera to your eye that under a 7 G pull feels more like forty. It's effort enough making pictures during the typical 4-G maneuvering, but of all the ways to get in some weightlifting, this is by far the coolest.

Ever since I was a kid, I thought that being one of the Blue Angels would be the best job in the world. I mean, you get to fly almost everyday, you travel to every corner of the country, you get treated like royalty and all the while you're getting paid to do it. Working all summer on this book has taught me a few things, and one of most enlightening was learning just how incredibly hard it is being a Blue Angel. It is a non-stop, 24/7 high profile freight train that all but consumes your life.

Imagine packing up in January, and moving to the middle of nowhere California to fly two or three times a day, six days a week. After ten weeks of the most rigorous, never-ending formation flying you've ever dreamed of, you launch into a monotonous travel cycle of Thursday departures and Sunday returns that will last for the next nine months. While away from home, your time is almost totally occupied with show site familiarization, physical training, social commitments and oh yeah, three flight demonstrations. I have only observed it from afar and I can't even fathom the level of commitment needed to fulfill those requirements.

Yet each and every Blue Angel not only fulfills the requirements, they continually push the definition of what it means to be "committed." This rock-and-roll road show of military aviation is famous not just because they can fly impossible maneuvers at weekend air shows, it's because when the Blue Angels are in town, you are touched by their historic greatness. You see it in the faces of dedicated young enlisted corps who put the privilege to serve before everything else. You see it in the pilots who repeatedly rise up to the professional challenge to be their absolute best. And you see it in the air show crowds who well up with immense patriotism just watching their Navy's six blue and gold jets fly for them.

Left: Shot during the solo ride with V8 in Little Rock as the Team clears the echelon pass out over the Hercs stationed at the country's premier C-130 training installation.

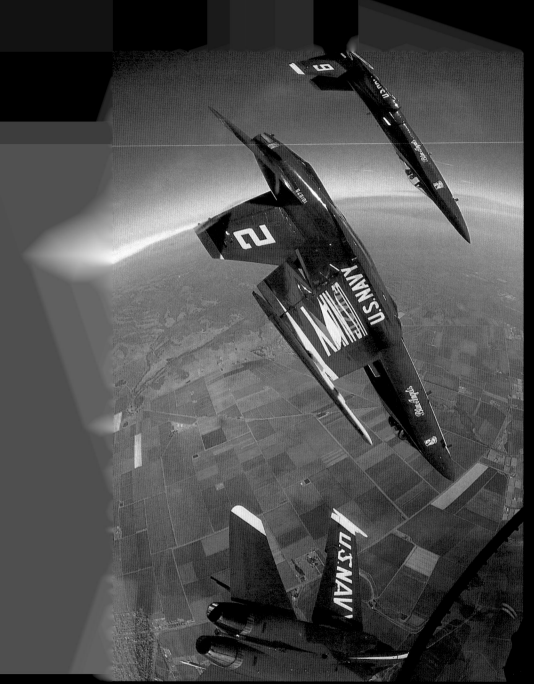

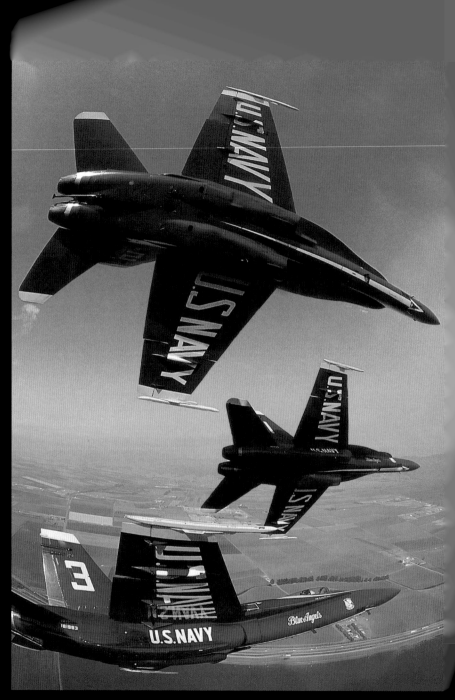

Above: Two images from the Salinas slot-ride with the one on the left showing the backside of the delta loop. Above Right: Tater, Gucci and Boss driving back towards

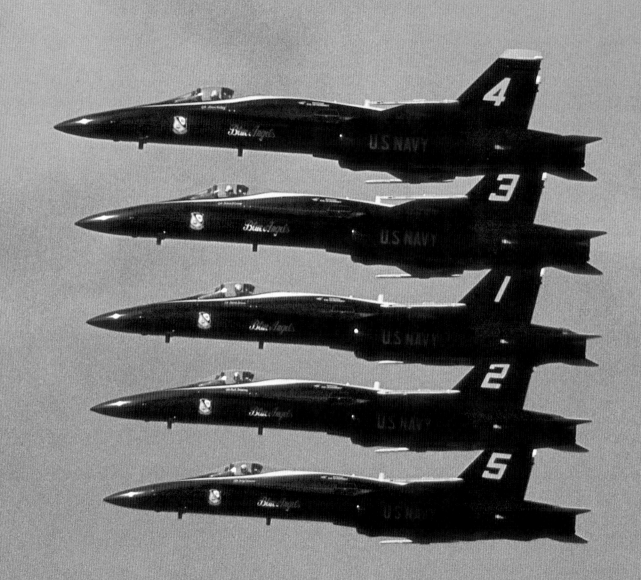

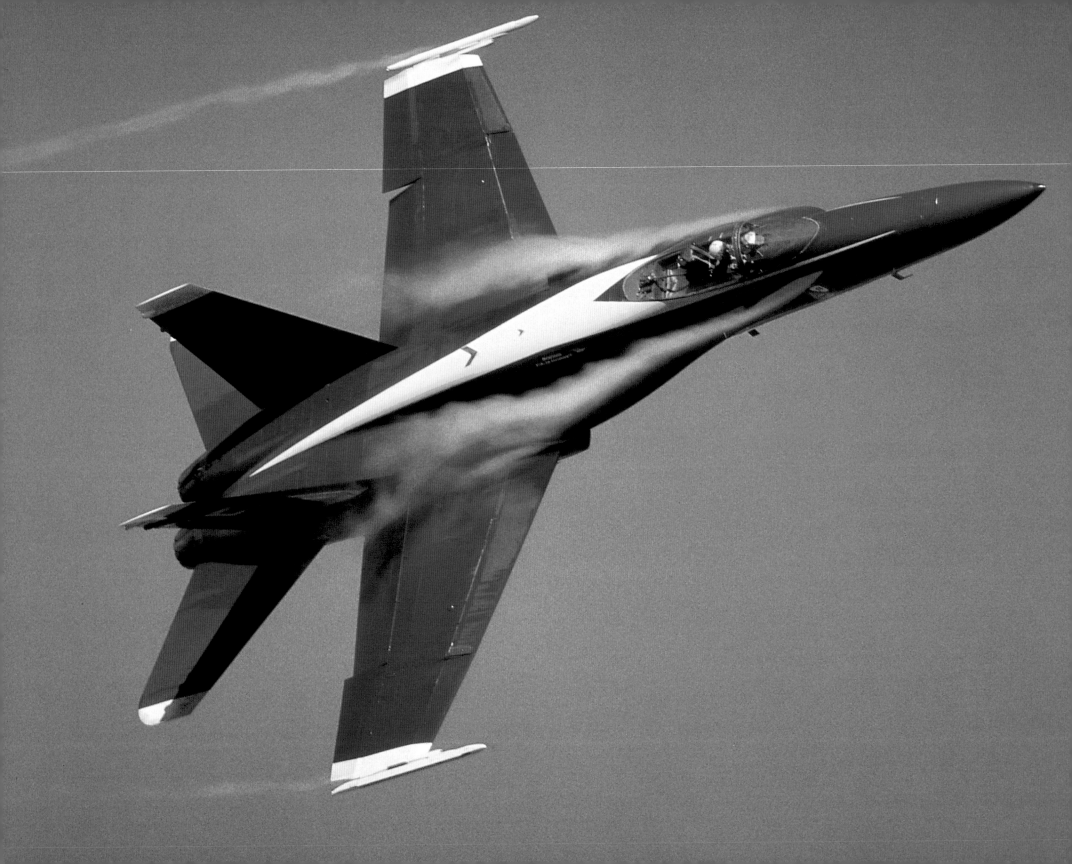

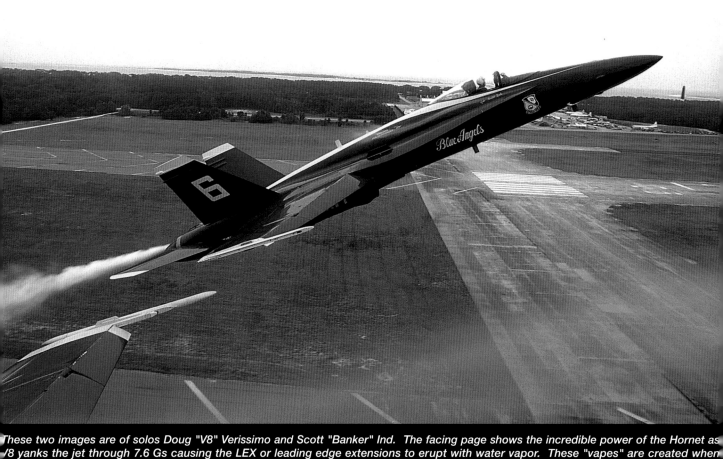

These two images are of solos Doug "V8" Verissimo and Scott "Banker" Ind. The facing page shows the incredible power of the Hornet as V8 yanks the jet through 7.6 Gs causing the LEX or leading edge extensions to erupt with water vapor. These "vapes" are created when moisture in the air condenses in the low-pressure areas that develop lift as the jet carves through a turn. The bright blue sky is an indication of low humidity, meaning V8 was really pulling hard to get plumes like that out of such dry air. The shot above on the other hand was done in the thick moist air on a cloudy day down in Pensacola. The maneuver is the solo's high alpha pass and you an see that even though the jets are hardly moving, the low pressure area above our LEX is causing vapor to pour into the lower right of the frame.

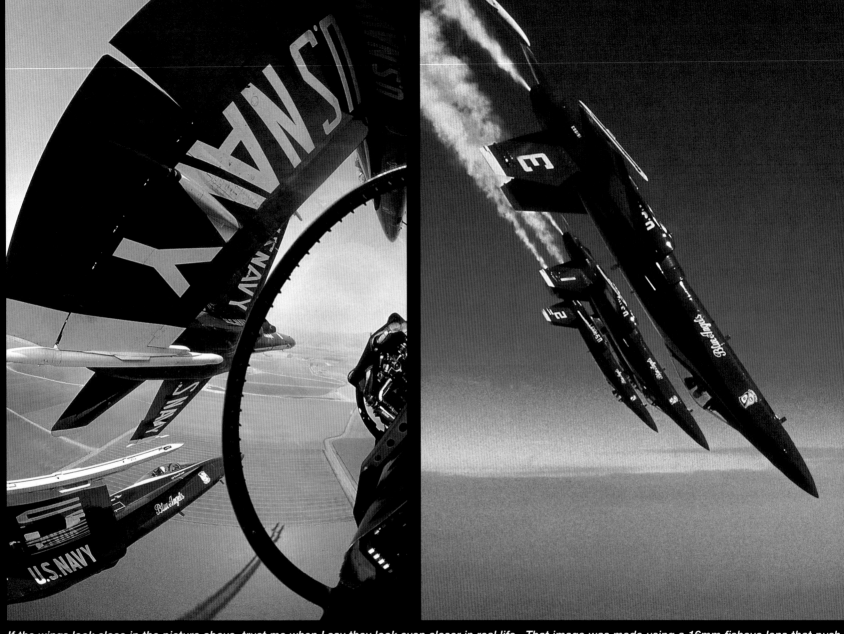

If the wings look close in the picture above, trust me when I say they look even closer in real life. That image was made using a 16mm fisheye lens that pushes everything away to get it into the frame. If that were shot using a normal perspective lens, you would likely switch back to the 16mm like I did and hide behind the camera. The right-hand image shows Tater, BOSS and Gucci to the right of Wolfy and I as we follow the formation down through the back of the line abreast loop. Opposite: A nice moment at Cleveland that captured the Team framed by Fat Albert flying the Stars and Bars.

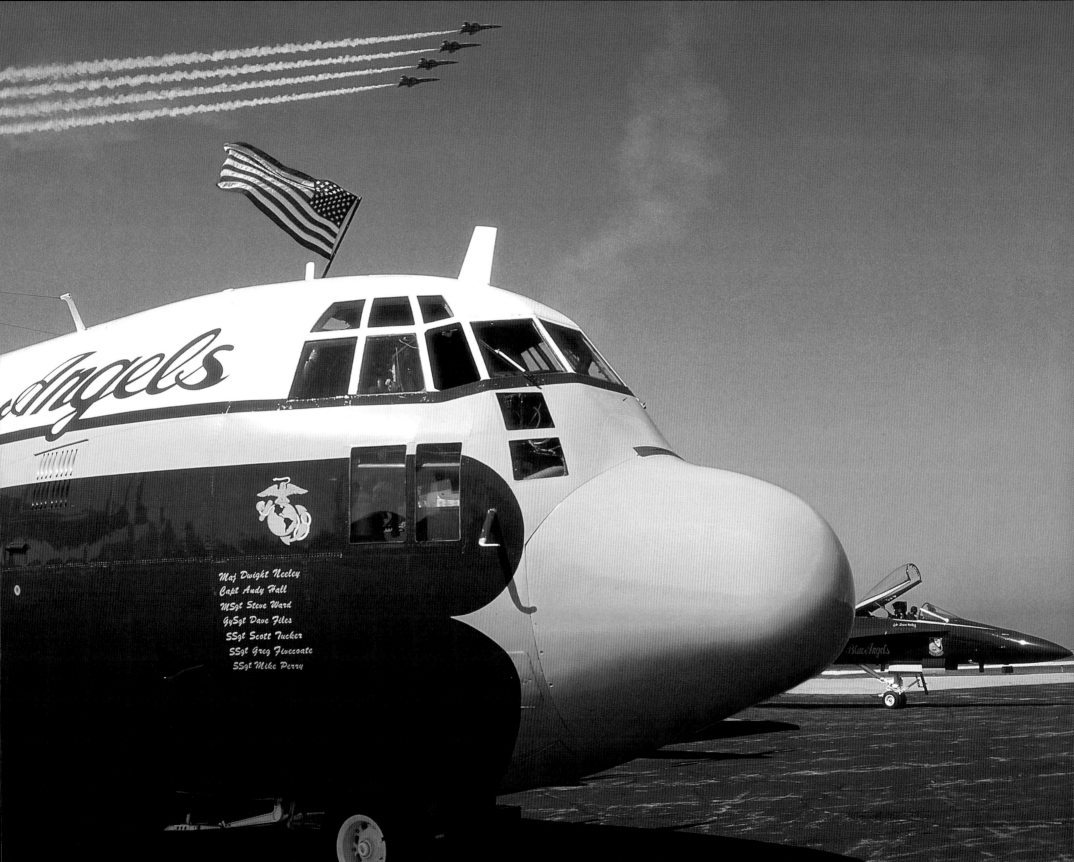

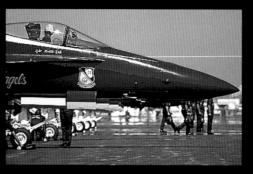

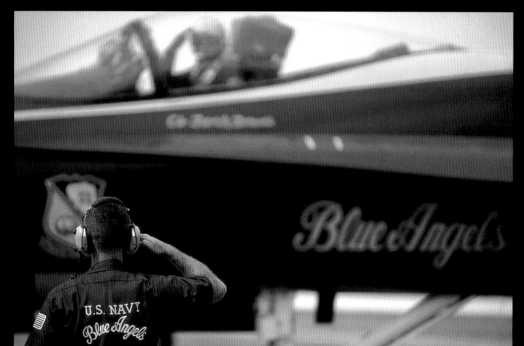

BOSS Voris and BOSS Driscoll together span the complete Blue Angel heritage. Scott Ind taxis back into the line after flying the Cleveland show. Video Supervisor Fanandus Ballard cranes skyward to document every maneuver for the Team debriefs after each flight. Below left: Front Man Steve Hudson sends BOSS Driscoll off with a salute . The "comm cart" on the right is front-row-center for every Blue Angel maneuver. Fat Albert pilot Dwight Neeley, flight surgeon Pat McMahon and Maintenance Office Neal Austin all act as safety observers and weather watchers during the demo flights. Opposite: A quiet parting shot at NAS Oceana.